Praise for the Book

"This book is a priceless historical record of Caribbean coral reefs by a photographer who set out to document all the major reef species in the 1970s when the coral reefs were at their prime. No one will ever do that again, and most of what is shown in his photographs is now gone forever. I can personally confirm the accuracy of this book: I've dived on the reefs shown in this book for more than 65 years and saw the decline from start to finish… No other book available shows Caribbean coral reefs when they were at their best. It is only by comparing the images in this book with what they see now that people can recognize what we have lost. It is far more than they can imagine!"

Thomas J. F. Goreau, PhD, President of the Global Coral Reef Alliance, USA

"The author's excellent photographic skills convey clear concepts of processes and key aspects of species for identification. Bill Sacco is also skilful at writing in an engaging story-telling style while clearly and concisely communicating the essential scientific concepts. He has evidently consulted expert taxonomic specialists to confirm the living organisms in his photos are correctly identified and kept up with the latest scientific literature. As well as being the most up-to-date and accurate record of species names, this book has the best balance between species identification and ecological processes, all in a single pleasantly readable and illustrated guide. I also enjoy reading Sacco's book because the chapters are about important distinct topics, rather than arranged as an inventory. Even after 52 years of research on coral reefs, I continue to learn things from his work!"

Charles Birkeland, PhD, Affiliate Professor in the Graduate Program in Biology at University of Hawai'I Mānoa and Professor Emeritus at the University of Guam, USA

"This book is more than a visual epitaph to the coral reefs that existed throughout the Caribbean in the late 1960s and early 1970s; it is a call to arms. Whether as a science photographer or science teacher, Bill and I are both trying to tell compelling stories about the living world. We are still trying to connect the viewer's heart to the viewer's mind. The book now in your hands is in a publishing genre all its own. Like Haeckel's monograph, it exists at the interface between art and science. Like the subject it portrays, it resists classification. Are corals: animal, mineral, or vegetable? Yes. Should this volume's ISBN number come from the arts or the sciences? Yes. Will this book inspire both hearts and minds? Yes."

James W. Porter, PhD, Meigs Professor of Ecology, University of Georgia, USA

"Bill Sacco is not only a top rank photographer, but he has spent many hours working with, and talking to coral reef scientists. His own knowledge is strong, and he has access to the best coral reef researchers working in the Caribbean. I cannot imagine a person more qualified to write this kind of book. It should also be noted that difficult as fishes are to photograph, the images are amazing. Indeed, the first thing that will strike the reader is the exquisite photography; but the author is in a class by himself. Once the first impact of the astounding photography is accepted, the reader will be struck by the scientific integrity of the book.

The Caribbean Coral Reef is a time machine, taking the reader back to when these reefs thrived. However, it is not simply an elegy to something gone forever; there is optimism that we may see these reefs again as they appear in this book."

Robert A. Kinzie, PhD, Professor Emeritus of Biology at University of Hawai'I Mānoa, USA

The Caribbean Coral Reef

This book is a visual tour of Caribbean coral reefs between 1968 and 1978. They are the world's second largest coral reef community and the most threatened. **The Caribbean Coral Reef: A Record of an Ecosystem Under Threat** offers a priceless historical record made by a photographer who set out to document the major reef species when those reefs were at their prime. Today, coral reefs are under threat as never before and, sadly, most of what is shown in the book's photographs is now gone forever. It is only by comparing the images in this book with what we see now that we are able to fully recognize what we have lost.

With its stunning photography and precise, accurate scientific information, this book offers students of coral reef a wealth of information about this rich, fragile ecosystem. It is also written accessibly for non-academic visitor to the Caribbean reef or anyone interested in the earth's creatures. Many of the invertebrates will be unfamiliar to most people, and the author reveals fascinating insights into these otherworldly creatures and their lifestyles. Enjoy this field guide to the reefs that were, and savor the beauty of this vanishing environment and its organisms.

The Caribbean Coral Reef
A Record of an Ecosystem Under Threat

William K. Sacco

CRC Press is an imprint of the
Taylor & Francis Group, an **informa** business

First edition published 2023
by CRC Press
6000 Broken Sound Parkway NW, Suite 300, Boca Raton, FL 33487-2742

and by CRC Press
4 Park Square, Milton Park, Abingdon, Oxon, OX14 4RN

CRC Press is an imprint of Taylor & Francis Group, LLC

© 2023 William K. Sacco

Reasonable efforts have been made to publish reliable data and information, but the author and publisher cannot assume responsibility for the validity of all materials or the consequences of their use. The authors and publishers have attempted to trace the copyright holders of all material reproduced in this publication and apologize to copyright holders if permission to publish in this form has not been obtained. If any copyright material has not been acknowledged please write and let us know so we may rectify in any future reprint.

Except as permitted under U.S. Copyright Law, no part of this book may be reprinted, reproduced, transmitted, or utilized in any form by any electronic, mechanical, or other means, now known or hereafter invented, including photocopying, microfilming, and recording, or in any information storage or retrieval system, without written permission from the publishers.

For permission to photocopy or use material electronically from this work, access www.copyright.com or contact the Copyright Clearance Center, Inc. (CCC), 222 Rosewood Drive, Danvers, MA 01923, 978-750-8400. For works that are not available on CCC please contact mpkbookspermissions@tandf.co.uk

Trademark notice: Product or corporate names may be trademarks or registered trademarks and are used only for identification and explanation without intent to infringe.

ISBN: 978-1-032-41450-8 (hbk)
ISBN: 978-1-032-41451-5 (pbk)
ISBN: 978-1-003-35814-5 (ebk)

DOI: 10.1201/9781003358145

Typeset in Bembo
by KnowledgeWorks Global Ltd.

For Ada, Elliott, Evelyn, and Lydia

Contents

Foreword by James W. Porter ... ix

Introduction .. xv

1 The Structure of a Reef ... 1

2 The Shallow Reef .. 7

3 Coral ... 15

4 Invertebrates ... 55

5 Fishes .. 127

6 The Back Reef ... 163

7 The Hidden Reef ... 173

8 The Reef at Night .. 185

Afterword/Acknowledgements .. 193

Appendix: Locality List, Common Names, Notes 194

Bibliography ... 198

Index .. 200

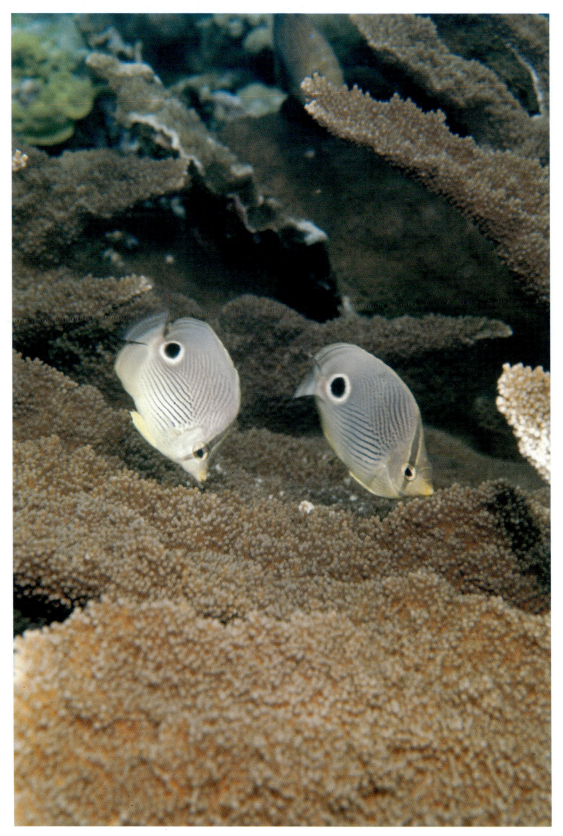

Frontispiece: This idyllic scene of foureye butterflyfish (*Chaetodon capistratus*) foraging over the prominent coral *Acropora palmata* is just one of many such that could be seen on a coral reef in the Caribbean area half a century ago. Today a number of stresses attributable to human activities have upset the ecological balance and led to major changes in the reef's creatures and appearance. This guide depicts those reefs as they were.

Foreword

One Light

Sunlight looks slightly different
On this wall than it does on that wall
And a lot different on this one,
But it is still one light.

Now it is dawn's light
And here, in the splendor of coral,
Is the simple truth of God.

What more could human beings want?

Rumi, *The Book of Love* (1260)

My first dive was with Bill Sacco. The dive itself was an inauspicious affair collecting mud samples from a Connecticut estuary on a cold March day. We were both undergraduates at Yale, and Bill was working on a geology project. What I remember most from this experience was not the ridiculous polar-bear club dimension to our frigid adventure, but the warm and luminous photographs Bill took of lobsterpot floats hanging haphazardly on a boathouse wall next to the dive site. As you will see in the pages of this book, Bill knows how to take good photographs. He always has.

During our last year at Yale, Bill and I created a course in photography. That year, Yale began to fund important courses which it did not already offer, as college seminars organized by students. As scientists and visualists, Bill and I had a pent up desire to portray the natural world in all its glory. Through contacts at our Silliman Residential College, this course, which we titled *The Photographic Essay*, was taught by staff photographers at *LIFE Magazine*, led by their scientific photographer, Fritz Goro. Every lecture, every darkroom exercise, and every assignment was about one and only one thing, making quality images. For Fritz, a good picture was not just an accurate rendition of the subject. It had to tell a story. It had to create an emotional bond between the viewer and the subject. It had to connect the viewer's heart to the viewer's mind. Bill's images do this. Fritz would be proud of this book.

The late 1960s was a tumultuous period in both U.S. and Yale history. In the fall of 1968, Yale students staged a protest to convince the college to admit women. For an entire week, transitory co-eds came to Yale to attend classes and behave like normal Yale undergraduates. When *LIFE*'s editorial board heard of the impending event, in a rather unconventional move (leap of faith?) they asked the students who were planning the spring-term photography course to take pictures of 'Coed Week'. They sent a staff writer to write the story. In the parlance of journalism, we became "*LIFE stringers*." These were heady times. When the staff writer covering the story asked Bill, "Are you getting good pictures?" Bill shot back, "Are you getting good words?" Bill's professional career in photography

started on November 22, 1968 when *LIFE's* story "Yale Takes a Bride" hit the newsstands. Although most of the images in *The Caribbean Coral Reef: A Record of an Ecosystem Under Threat* are of sea creatures, Bill remains in my mind the finest portrait photographer I have ever known. Either in the studio or on the street, Bill has the ability to catch a person's essence in a natural but striking pose that reveals the heart of his subject. As this book shows, Bill does this for his marine subjects too.

Both Bill and I worked as field assistants in the Caribbean, Bill with David Meyer (now at the University of Cincinnati), who was working on the ecology of shallow water crinoids, and I with Gary Vermeij (now at U.C. Davis), who was working on snail morphology. We met up in Curaçao where, between David's knowledge of the coral reef and Gary's knowledge of the Dutch language, Bill and I felt that a tropical paradise had just opened its doors to two kids from the snow-belt.

This book is more than a visual epitaph to the coral reefs that existed throughout the Caribbean in the late 1960s and early 1970s; it is a call to arms. In those early days, the environmental movement in the U.S. was just taking off. Like many young scientists, Bill and I dedicated our lives to studying the natural world. Bill expressed this love through a career in art, and I through a career in science. Although art and science are historically considered diametrically opposed disciplines (e.g., as described in C.P. Snow's *Two Cultures*), neither Bill nor I see these career trajectories as different. Whether as a science photographer or science teacher, we are both trying to tell compelling stories about the living world. We are still trying to connect the viewer's heart to the viewer's mind.

Many of the images in this book come from the coral reefs of Discovery Bay, Jamaica. Viewed from the air, these fringing reefs look like a lapis lazuli necklace laid out beneath an emerald jungle. Discovery Bay was chosen by Dr. Thomas F. Goreau, an earlier graduate of Yale's doctoral program in biology, to typify Caribbean coral reefs, and to become the home of the laboratory he founded there, the Discovery Bay Marine Laboratory. Neither Bill nor I realized at first that Fritz Goro, the lead instructor in our photography course, was the father of the world-leader in coral reef ecology, because Fritz had changed the spelling of his name to create a professional pseudonym. I am working now with Dr. Thomas J. Goreau, Tom's son, and Fritz's grandson, to curate the extensive coral collection that Tom made at Discovery Bay. Three generations of this family have influenced us greatly.

The Discovery Bay coral reef was perhaps the finest coral reef in the Caribbean. Over the next decade, it also became the best known coral reef in the world. As many of Bill's photographs show, the dense profusion of overlapping coral branches meant that, in some places, coral cover actually exceeded 100 percent. The number of coral species found in Discovery Bay was the highest in the Caribbean, and during the time that the images in this book were being taken, more than a half dozen new coral species were discovered there. Many of these new species (such as *Agaricia grahamae*, *Mycetophyllia aliciae*, and *M. reesii*) were spectacular and prolific members of the coral reef community. In the captions describing these photographs, we can now use their proper scientific nomenclature, but Bill photographed them all before any of them had Latin names.

Images in this book reveal a dizzying array of life forms found nowhere else on the planet. While it

is true that tropical rainforests house the greatest number of species, coral reefs support the greatest number of higher taxonomic levels, such as phyla, classes, and orders. Only nine phyla inhabit the rainforest, but 32 phyla live on the coral reef. Reefs are also where the evolution of the highest forms of life occurs. Eighty-five percent of the higher taxa listed above appeared first in the geological record on coral reefs. Between a quarter and a third of all marine species are found there. This proportion of tropical marine species is expected to rise dramatically as more systematic work is concentrated on the least studied environment on Earth. We must protect these cradles of evolution. As goes the success of coral reefs, so goes the history of life on Earth.

The economic value of coral reefs is staggering. Some estimates place the net worth of coral reef ecosystem services, as they are now called, at nearly 9.9 trillion U.S. dollars per year. This may be conservative. Some of these benefits, such as the provision of protein and jobs to the impoverished people of tropical countries, are essential and irreplaceable. Others, such as tourism, provide much needed foreign capital and investment. As a coral reef conservation bumper sticker in Montego Bay, Jamaica announced to all cars that fell in line behind it: *Hard Corals = Hard Currency*.

In addition to food from the sea are drugs from the sea. Approximately one-quarter of all drugs in a modern pharmacy come from the natural world. Aspirin is a prime example of this kind of natural homeopath from the terrestrial environment. Increasingly, however, a sophisticated array of powerful cancer-fighting chemicals and antibiotics have been discovered (bio-prospected) on coral reefs. Coral reef creatures have been developing their immune systems and defending themselves from attacks from bacteria and other sea creatures for hundreds of millions of years. Once in a while this chemical warfare produces a compound that is beneficial in defending human cells against our bio-invaders. Drugs from coral seas are now used to cure cardiovascular diseases, ulcers, leukemia, lymphoma, and skin cancer. Anti-cancer Prostaglandin© (from sea whips) and Bryostatin© (from coral reef bryozoans) are examples of these novel compounds. Recently discovered compounds include *Nef*-inhibitor-11 from coral bacteria, that kills the AIDs virus more effectively than AZT. All of these come from marine invertebrates depicted in this volume.

As if food and medicine were not reasons enough, the world also needs healthy coral reefs for shoreline protection. During the great Indonesian Tsunami of 2005, villages with intact coral reefs offshore fared better than those with degraded reefs. Intact coral reefs act as hurricane "speed bumps," or, as they are called in Jamaica, "sleeping policemen." Because these coastal barriers are living structures, they are self-repairing, self-healing. When we protect these living marvels, we protect ourselves.

To all the scientists who have contributed to this book, and to all its readers, this book is that call to arms. It presents sharply focused images of the way it used to be. It is a visual antidote to denial, and to apologists and prevaricators who say that things have stayed the same. Over the last half century, we have witnessed the loss and diminution of our coral "field of dreams." This loss began in earnest at the time that Bill and I began working in Jamaica. It has continued there, and throughout the Caribbean, unrelentingly, ever since. At the time, all of us thought that these coral gardens were timeless, immutable, everlasting. My first grant proposal to the *National Science Foundation* was to study

"Coral Reef Dynamics on the Fore-Reef of Discovery Bay, Jamaica." I proposed using photographs taken annually at fixed locations on the reef to monitor coral community change – or as Bill more succinctly put it, "Oh, you mean really slow time-lapse!" Yes, that is what I meant. I proposed to monitor reefs, not because I expected to measure "Coral Loss and Change on a Caribbean Coral Reef," (the title of one of my first papers), but because, instead, I actually expected to measure "Coral Growth and Reef Expansion," the title of a paper I have never been privileged to write. My *NSF* proposal was turned down flat. In the words of one reviewer, "Everyone knows that coral reefs do not change." Now, as I approach the end of my professional career, and after a half century of documenting coral decline, I cherish that rejection letter. It is a pure expression of how oblivious we all were to what was to come, what none of us would have wanted to happen, but which happened just the same.

Burning fossil fuel (coal, oil, and natural gas) releases massive amounts of carbon dioxide into the Earth's atmosphere. Rising CO_2 levels threaten the existence of coral reefs in two ways. By trapping heat (the greenhouse effect), increased CO_2 concentrations cause rising temperatures (global warming), which can kill coral. Rising CO_2 concentrations also force more carbon dioxide into the ocean. This lowers the pH of seawater (ocean acidification), and this in turn dissolves coral skeletons. Global warming and ocean acidification are the evil twins of climate change. They are the coral reef's worst nightmare. Humankind is to blame.

One of the greatest ironies of life on Earth is that tropical organisms are very sensitive to high temperatures. Tropical corals cannot survive summers that are just 1.5°C above normal for a few months, or 2.0°C above normal for even a few weeks. Cities across the world have seen an increase in the intensity, duration, and number of "killer heat waves." Coral reefs are also experiencing these kinds of thermal events, causing massive die-offs of reef-building corals whenever and wherever they occur. Because of human-induced global warming, the tropics are becoming too hot.

A warmer world will be a sicker world. Our studies indicate that corals stressed by heat are more susceptible to disease. Human beings are the same. Almost invariably, warmth favors the microbe. Our data showing a statistically significant increase in the number of diseases plaguing coral reefs is troublingly congruent with our observations of a warming ocean.

A warmer world will also be a more violent world. Hurricanes are powered, in part, by the heat energy stored in the tropical ocean. A logical prediction of global warming models therefore is that hurricanes will be more frequent and more intense (a higher occurrence of Hurricane Class 3s, 4s, and 5s) than in the past. The fore-reef of Discovery Bay was devastated by Class 5 Hurricane Allen in 1980, but unlike previously studied coral reefs that bounced back quickly from hurricane damage, coral reefs there are still struggling to recover. A rapid succession of high-temperature years and an onslaught of invertebrate diseases, overfishing, and coastal pollution have contributed to its slow recovery.

Climate change has not been, and will not be, kind to coral reefs. The airheaded denials seeping perfidiously out of Washington will not stop these effects. Perhaps this book will raise awareness among its readers. Our completely inappropriate and totally unnecessary reliance on fossil fuels

is causing us to lose the oldest and most biologically diverse ecosystem on Earth. Any individual action or government policy that reduces CO_2 emissions will help coral reefs. In one form or another, coral reef assemblages have been around for more than 100 million years. In the next 100 years, less than a blink on the geological time scale, we could lose them all. By speaking out, readers can express their support for coral reefs and their protection.

Humans have much to learn from coral reefs. If we are to prosper, rather than just survive into the next millennia, then we must learn how coral reefs have survived for so long. We must adopt their survival strategies as quickly as possible. From the beginning, two great enigmas have puzzled coral reef scientists. First, coral reefs are zones of high productivity in a nutrient-poor ocean (as the photographs in this book attest, you can see through tropical water because there is almost nothing in it). Second, coral reefs maintain this high productivity while simultaneously maintaining their extraordinary biodiversity. This book shows in loving detail the myriad of ancient and bizarre life forms that inhabit one of the most productive environments on Earth.

How do coral reefs achieve these seemingly incompatible and contradictory feats? How is it possible for a coral reef community to produce so much with so little? How is it possible to maintain this high productivity while still retaining thousands of less-productive members of the community? Human communities cultivate highly productive environments too, such as corn fields and rice paddies. But we create our productivity hot spots in exactly the opposite way from coral reefs. We add tons of fertilizers and, through the use of pesticides, herbicides, and fungicides, exclude all but the most productive species from these environments. Coral reefs are productive and teeming with life; agricultural lands are productive but depauperate. Our productivity is at the expense of the natural world; coral reef productivity is because of it.

The successful strategy used by coral reefs is the same one that businesses striving for profitability use: efficiency. Coral reefs do more with less. Corals are animals, but many of the vibrant coral colors seen in this book hide a secret. These colors are plant pigments, not animal pigments. By growing algae within themselves, corals maintain their own salad bar. No standing in line, no hunting and gathering. All that is required is sunshine. Each partner in this symbiosis needs what the other produces, and gives what the other needs. As a by-product of photosynthesis, the resident algae (zooxanthellae) produce oxygen, fats, and oils (which the coral needs). In return, these algae receive carbon dioxide, nitrogen, and phosphorous (which are "fertilizers" to the plant, but "wastes" to the coral). Corals are the only animals on earth that can survive being sealed in a jar. With their interstitial algae, they bring along their own renewable oxygen supply. It's a perfect symbiosis.

In addition to this high transfer efficiency between plant and animal, coral reefs also exhibit high filtration efficiency. Water that flows over and off a reef has considerably less material in it than the water that flows onto it. It should come as no surprise that coral reefs are master recyclers. With their ability to reuse and recycle, coral reefs have lasted for millions of years. With an emphasis on consumption and waste, how will human communities fare?

Humankind needs coral reefs. We need them for the fact that they provide us with food and shelter from the storm. What can be more primal than this? But we also need them to inspire the next

generation of explorers, scientists, and conservationists who will lead the fight to preserve life on Earth.

Although it is not well known, coral reefs inspired almost all of the greatest biological thinkers of the 18th and 19th centuries. These are not the historically noted but relatively unknown experts that make up the scientific workforce of all eras; these are household names: Darwin, Lamarck, Haeckel, Linnaeus, Agassiz, and Dana. Your spellchecker has them all. They all wrote books or treatises on corals and coral reefs. Almost twenty years before the appearance of *The Origin of Species*, Darwin wrote *The Structure and Distribution of Coral Reefs*. The only taxonomic group of organisms that these intellectual giants have in common is the Order Scleractinia (stony corals within the Phylum Cnidaria). My working hypothesis is that this stunning convergence on one taxonomic order within an obscure, predominantly marine phylum is no coincidence. To an 18th-century scientist, sailing vessels were their manned space flights, and corals their lunar rocks. Their beautiful shapes and exotic origins inspired Haeckel to feature corals prominently in his book, *Kunstformen der Natur*.

The book now in your hands is also about *Art Forms in Nature*. It too is in a publishing genre all its own. Like Haeckel's monograph, it exists at the interface between art and science. Like the subject it portrays, it resists classification. Are corals: animal, mineral, or vegetable? Yes. Should this volume's ISBN number come from the arts or the sciences? Yes. Will this book inspire both hearts and minds? Yes.

James W. Porter, Ph.D.

Meigs Professor of Ecology
University of Georgia
Athens, Georgia

Introduction

"I sometimes think that general and popular Treatises are almost as important for the progress of science as original work." – Charles Darwin, in a letter to T. H. Huxley, January 1865.

This book is a visual tour of Caribbean coral reefs as they were in better times, roughly 50 years ago. Today, coral reefs are under threat as never before. Storm-generated wave action is a major randomly acting force of coral reef destruction and ecological change that will be exacerbated by climate change. The unexpected Caribbean-wide mass mortality of the long-spined *Diadema* urchin in 1983-1984 removed an important control on algal growth and caused a major ecological shift leading to coral decline. In many areas, warming of the oceans causes coral bleaching, in which the symbiotic algae harbored by the corals, the zooxanthellae, are expelled. The corals may recover, or they may die. Greater CO_2 concentration in the atmosphere acidifies the ocean water and threatens all organisms that make calcium carbonate shells or skeletons, as corals do. Pollutants from human activity impose stresses on these organisms that affect their ability to survive and thrive, and a number of coral diseases unknown in better times are now prevalent in many areas.

The photographs in this book show the Caribbean coral environment as it was between 1968 and 1978, perhaps not pristine everywhere, but certainly healthy and thriving. The healthy reef environments depicted in this book have been lost in most of the Caribbean. Efforts are being made to find more resilient strains of coral and transplant them to damaged reefs, but even if all stresses were removed and protections established for reefs today, it would probably take at least a hundred years, if not several hundred, for the reefs to return to the conditions seen in these photographs.

This book was originally envisioned as a preview for students of coral reefs in an academic setting, for the experienced visitor to the reef who wanted to learn more about this rich, fragile ecosystem, or anyone just interested in the earth's creatures. It is the book I wish I had. I did have the benefit of diving initially as a student assistant to marine scientists and later in their company as a friend and visitor. I am primarily a photographer, but with a scientist's perspective. But the healthy reefs that are shown here may not exist anywhere in the Caribbean now, or if they do, it may not be for long. So consider this a historical record, a field guide to the reefs that were, and enjoy the beauty of this vanishing environment and its organisms. For a brief disheartening comparison of Caribbean reefs then and now, visit [https://biospherefoundation.org/project/coral-reef-change/].

This work does not pretend to be a guide to all the reefs of the Caribbean, though it draws from several areas and would serve for most areas of 50 years ago. Nor does it claim to be comprehensive in its species coverage. The reef fish are covered very well in standard reference books, and there are certainly omissions in this selection (no sharks). Many of the invertebrates are completely unfamiliar to most people, but I have tried to provide a look at these interesting creatures and their lifestyles.

The contents are arranged to give an overall and then a closer look at the reef's organisms, so the reader can see them in context and then examine them in greater detail.

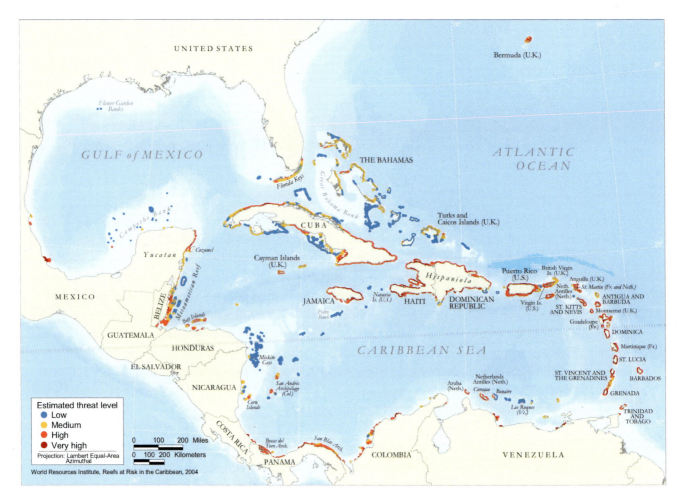

A map of the Caribbean area, showing both the locations of coral reefs and degree to which they are threatened. In general, the more remote from humans a reef is, the healthier it is, but it is safe to assume that the present situation is even more dire, as warming and acidifying seas affect even remote areas. From *Reefs at Risk in the Caribbean*, ©2004 World Resources Institute.

Common names are given for the fish only, along with the scientific names. The invertebrates occasionally have common names given to them, but since it is the exception, scientific names only are used here. They are subject to change, as discussed in the text, but at least there are conventions for their creation and use. Common names may vary from one locale to the next, and there is no arbiter to their creation and use. (For those who may know some common names, there is a short list in the appendix.) This is a visual guide, so in most cases I will only identify species to the level that can be distinguished visually. Finer distinctions are left to the laboratory.

A word on pronunciation of scientific names. The first one you will see is *Acropora palmata*. The British tend to use the Latin antepenultimate rule; that is, the syllable before the next-to-last is accented: "ah-CROP-or-uh", while Americans say "ack-row-PORE-uh." (Oddly enough, it is "pahl-MA-tuh" to both, perhaps because there are only three syllables.)

Water depth is given in feet in chapter 1, but in meters later. Sizes of organisms are given in metric units. For those not facile in one or the other, 3 meters = 10 feet, and 10 cm = 4 inches should be close enough for rough conversion; depths and organism sizes given are approximate.

xvi

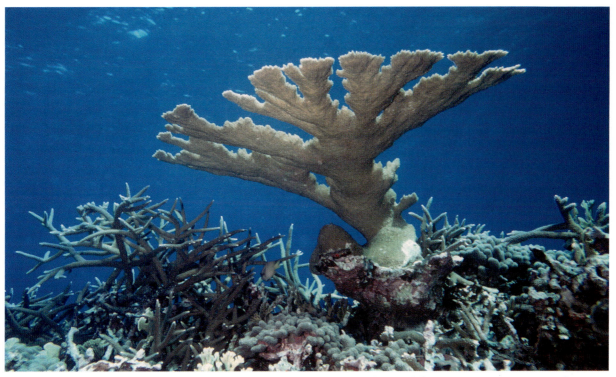

1.1 Two corals that define reef zones: tall and robust *Acropora palmata* and more delicate *Acropora cervicornis*.

The Structure of a Reef

A familiar view along tropical shores: light turquoise water indicates shallow water with a mostly sandy bottom. Beyond is a sharp transition to deep blue: the crest of a reef and the slope to deeper water.

Coral reefs do not just happen. They are built by generation upon generation of tiny colonial invertebrate animals, mostly scleractinian corals, that secrete a home of calcium carbonate to support their soft tissues. Under the right conditions, coral thrives and gradually builds massive structures that we call a reef.

The photosynthesizing symbiotic algae in the soft tissues of reef-building corals use the abundant light of shallow, clear water to produce an excess of nutrients that allow corals to build these massive skeletal structures, so reefs occur in the shallow water along coastlines. Sometimes they form barriers some distance from the mainland, but more often they fringe the shore. Charles Darwin correctly deduced the development in the Pacific of coral atolls, rings of reef without an adjacent land mass, from volcanic peaks that had subsided out of sight while the fringing reefs grew upwards to maintain their depth, but in the Caribbean, reefs fringing islands are the norm.

Various elements of the geological history and morphology of the shore determine the exact nature of the reef's development. The coral animals require clear water both to allow light penetration and to avoid loading with water-borne sediment and pollutants. The locations of major coastal elements like beaches, headlands, and river mouths, and the nature of wave action, determine the exact configuration.

What most of these reefs share is a similar overall zonation of the types of coral based on depth (and therefore light) and wave action. These factors determine the morphology of the coral, and this in turn determines what environment is available to other reef organisms.

The Caribbean Coral Reef: A Record of an Ecosystem Under Threat

1.2 Looking from shore toward the reef at Discovery Bay, Jamaica. The reef crest marks the transition to deep water.

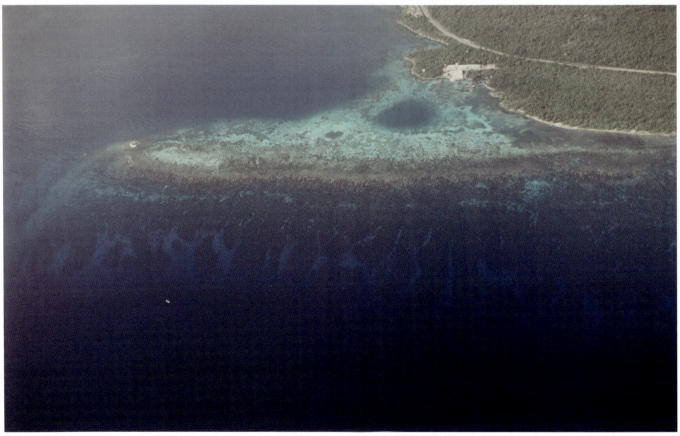

1.3 Aerial view of the reef at Discovery Bay, Jamaica, looking south (inland). The reef fringes the shore at the west (right) end of the picture, but extends toward the deeper bay to the east, forming a reef crest (horizontal brown area) between the shallow, sandy back-reef and the lobes and intervening sand channels of the fore-reef terrace sloping toward deep water (lower part of picture).

Chapter 1 The Structure of a Reef

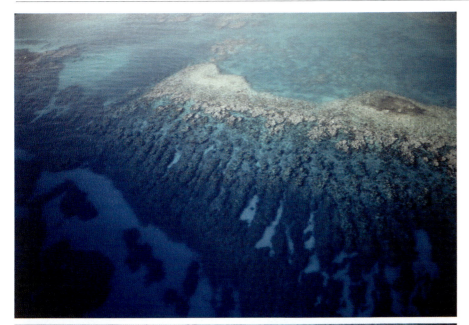

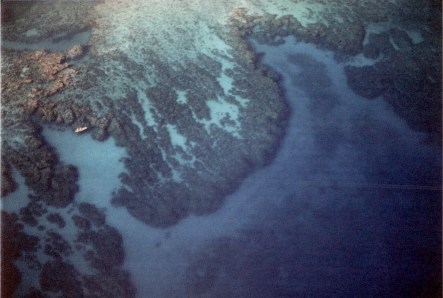

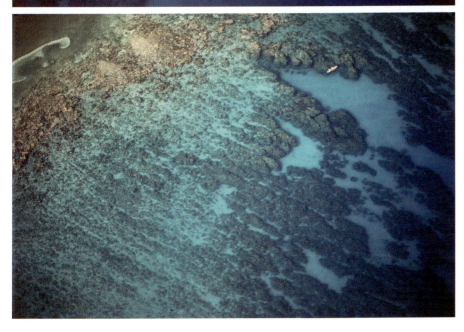

1.4a (top), **1.4b** (middle), and **1.4c** (bottom) Three aerial views of the reef west of Montego Bay, Jamaica, looking south (inland). The bottom two are adjacent and slightly overlapping (same boat in both) and show the variability of overall structure that is possible within a small area. Several features are common to all three areas, however.

The reef crest lies just inches below the water's surface and the brown color of the coral is not obscured by the water depth. (The water absorbs the red and yellow wavelengths of light, leaving green and blue. The color shift depends on the total distance the light travels through the water, making things seen from above deep blue in deeper water.) The reef crest is also called the palmata zone from the *Acropora palmata* that is the only species robust enough to withstand wave action in the shallowest zone. In the palmata zone the coral bases may be several feet below the surface, but the height of the tops is limited only by their need to stay submerged in the water at the lowest tide.

Seaward of the crest is the cervicornis zone, named for the dominant species, *Acropora cervicornis,* a slightly less robust species well adapted to this slightly deeper and less wave-stressed zone. This zone ranges from 20 feet below the surface to a depth of about 50 feet, depending on conditions.

Deeper still, and grading with the cervicornis zone, is a region of regular reef patches separated by sandy areas. These so-called "spur and channel" or "spur and groove" structures align toward the open sea. When shallow, the spur tops are dominated by *Acropora cervicornis*. Conditions on deeper spurs are more suited toward other corals, in particular the very common species *Orbicella faveolata,* which can form large masses.

The seaward edges of the spurs form a fore-reef slope from a depth of 40-50 feet to a sandy slope at 60-80 feet that continues to even greater depths. In some areas there is a major drop-off at about 180 feet to an even deeper slope several hundred feet below. In a few places a vertical wall forms from the first drop-off straight down to the deep slope.

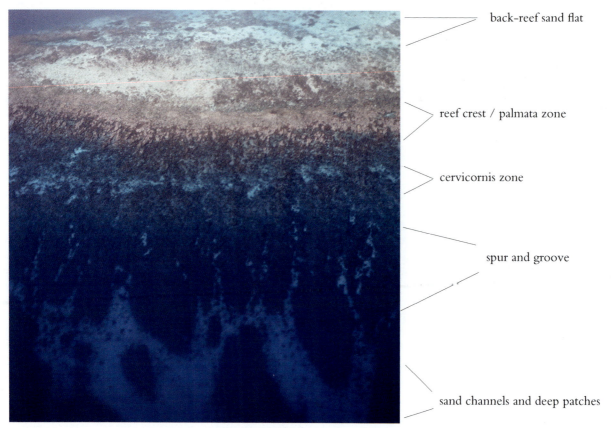

1.5 Aerial view of part of the reef at Discovery Bay, Jamaica, looking south toward shore (see fig. 1.3). Depth increases toward the bottom of the picture. Zones are shown approximately at right. Actual zones are very variable, but these labels do describe generally recognizable reef environments.

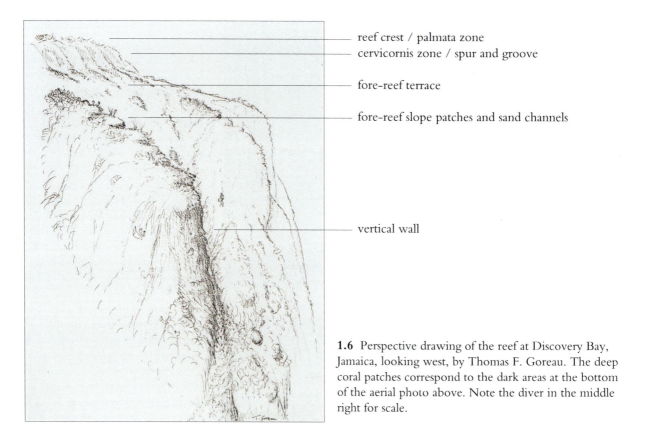

1.6 Perspective drawing of the reef at Discovery Bay, Jamaica, looking west, by Thomas F. Goreau. The deep coral patches correspond to the dark areas at the bottom of the aerial photo above. Note the diver in the middle right for scale.

Chapter 1 The Structure of a Reef

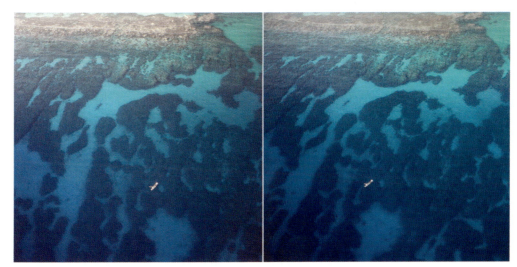

1.7 A stereo pair of successive aerial photos shows the reef in 3-D perspective when viewed with a stereo viewer. Despite the loss of resolution in the printing process, it is possible to get a sense of the raised reef patches with sand channels between them, and the greater water depth beneath the boat can be perceived. Compare and identify zones shown in fig. 1.5.

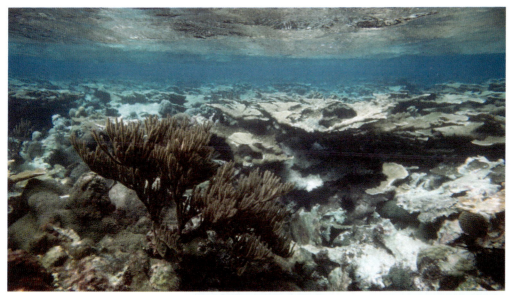

1.8 The underside of the water's surface is visible just above the *Acropora palmata* that dominates the reef crest. In this environment of occasional breaking storm waves, the coral takes a sturdy, flattened form. In the foreground, a robust, bushy alcyonacean, or soft coral, also thrives in this often turbulent zone.

1.9 In slightly deeper water, away from the greatest wave action, *Acropora palmata* branches grow at more of an angle to the surface. A large *palmata* toppled by a storm can be seen at the far right. In the foreground are branching *Acropora cervicornis*, knobby *Porites porites* and a smooth massive species.

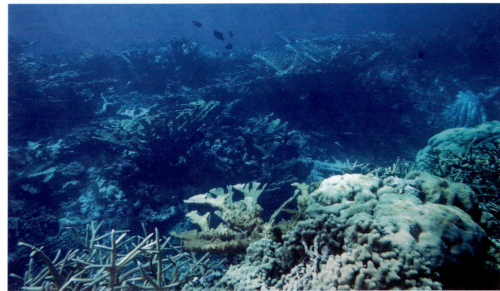

 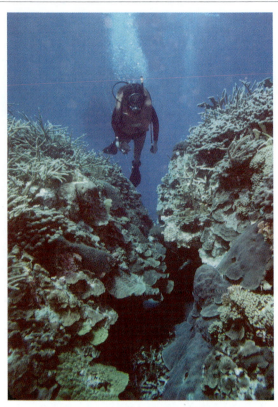

1.10 (left) *Orbicella faveolata* forms flattened plates that protrude from the buttress sides. Sand channels allow wave action to remove broken coral and other material. **1.11** (right) *Acropora cervicornis* tops these spurs that have almost merged but which nevertheless have a sand channel between them. Green *Porites astreoides* in the left foreground and *Orbicella faveolata* on the right protrude into the gap. Depth is 20-30 feet.

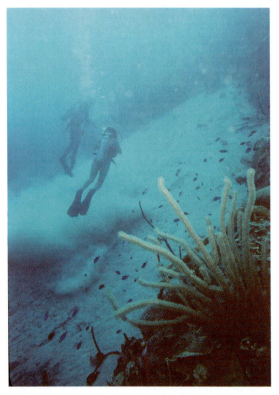 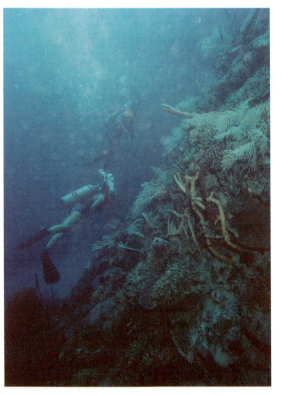

1.12 (left) The fore-reef slope. Sand from the reef channels above, made up of broken bits of coral, shells, and calcareous algae, flows downslope to settle in deeper water. Here, the divers have stirred it up into the water as a major storm might. **1.13** (right) Fingerlike *Madracis* coral and flattened plate-like corals, cylindrical sponges, and bushy alcyonaceans inhabit the deeper sloping reef. Depth is 60-80 feet. View is lateral, along the face of the reef.

2

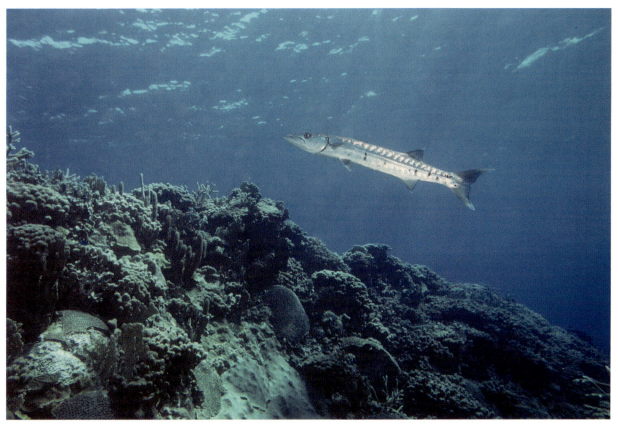

2.1 A 4 ft. (1.2 m.) long *Sphyraena barracuda* cruises over a coral buttress about 20-30 ft. below the surface. It is a streamlined predator, but wary of humans and difficult to approach. Wave action at this depth is gentler than in shallower zones, light is abundant, and corals cover the bottom. The dominant coral is massive, knobby *Orbicella faveolata*. Other corals common in this zone include *Agaricia agaricites*, *Colpophyllia natans*, and *Porites porites*.

The Shallow Reef

The classic reef structure described in the preceding chapter, with reef crest and progressively deeper clearly defined zones, is only fully developed when waves of the appropriate strength come from a dominant direction. Where wave energy is less and also less directional because of wind shadow or other physical factors, corals can be found very close to the shore. Here the dominant physical effect of wave action is felt as a "wave surge," essentially a sloshing back and forth of the water mass as small waves roll in.

These are the places often visited first by snorkelers and scuba divers, because the water may be safely entered directly from shore. The very shallowest zone is often bare and scoured by wave-borne sand, and may be frequented by long-spined black *Diadema antillarum* urchins (common in the past, rare now). Even in this zone small corals may find a place to settle and grow, their larvae perhaps establishing themselves during periods of quiet water.

Farther out is a mixed zone of small to medium size masses of a variety of coral species, and also bushy alcyonaceans, commonly called soft corals, usually surrounded by sand but anchored fast to the hard bottom beneath. The sandy spots are good places for the diver to settle to take a closer look without damaging the fragile coral.

In some places great thickets of *Acropora cervicornis* and various species of *Porites*, a stubby branching coral, developed, providing a relatively protected environment for fish and bottom-dwelling invertebrates. (In many places these conditions have now changed dramatically.) Deeper parts of the mixed reef and classic spur and groove reef are similar, as wave action gives way in influence to the effect of light as the water depth increases.

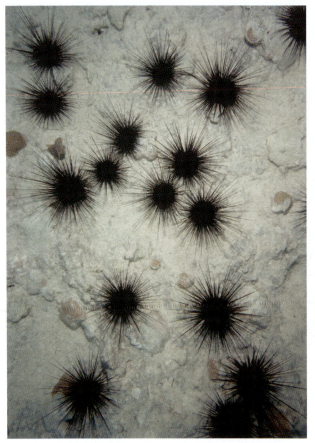

2.2 Spines of the urchin *Diadema antillarum* (rare today) are barbed, break off easily, and contain an irritant, making them a hazard to divers/snorkelers swimming in shallow water near shore. The brown coral is probably *Siderastrea radians*.

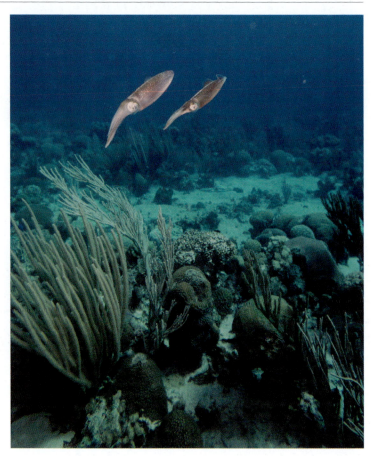

2.3 Two squid cruise over a typical mixed shallow reef. Without a dominant wave surge direction, a mix of small branching and rounded corals and bushy alcyonaceans are anchored on the sand, utilizing the abundant light and suspended plankton and other organic particulates.

2.4a (left) and **2.4b** (right) Two views of *Gorgonia sp.* responding to the back-and-forth motion of the wave surge, the dominant physical factor on the shallow reef. *Gorgonia* is a colonial filter feeder whose growth orients it across the surge direction. There are three species, two of which are distinguishable only by microscopic differences.

2.5 Not all alcyonaceans grow in a flat form. This *Antillogorgia* has a bushy form that is more adapted to multi-directional wave action.

Chapter 2 The Shallow Reef 9

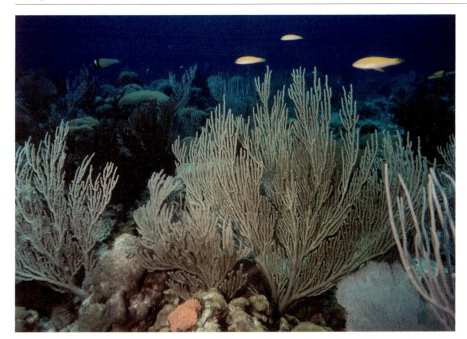

2.6 Branching alcyonaceans stand above the rounded corals in the shallow reef.

2.7 (right) A meter long trumpetfish, *Aulostomus maculatus*, swims head-down in the camouflage of an alcyonacean, moving with the surge and hoping to go unobserved by prey.

2.8 Fan-shaped *Gorgonia* and bushy *Antillogorgia* compete for space in the surge zone. The physical interference of the mobile branches of the latter has inhibited growth of the sea fan. *Orbicella annularis* and stubby branched *Madracis formosa* are common corals.

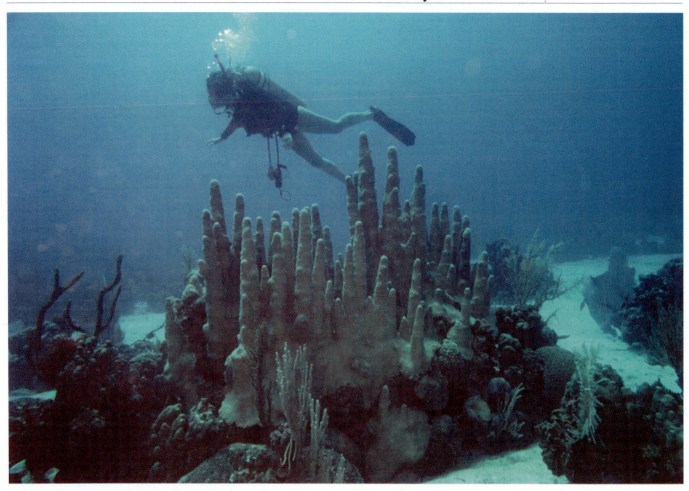

2.9 An easily recognizable coral that can grow to great size is *Dendrogyra cylindrus,* which forms massive, thick upright columns. An active feeder and photosynthesizer, it is clearly overgrowing old coral here.

2.10 Unlike most hard corals, *Dendrogyra cylindrus* extends its tentacles for feeding in the gently turbulent currents in the daytime, giving it a fuzzy appearance and making it the functional equivalent of a big alcyonacean.

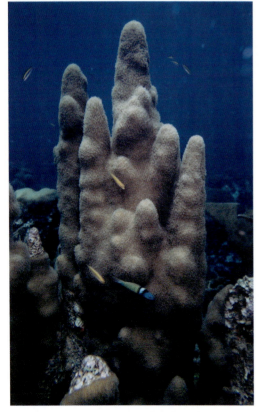

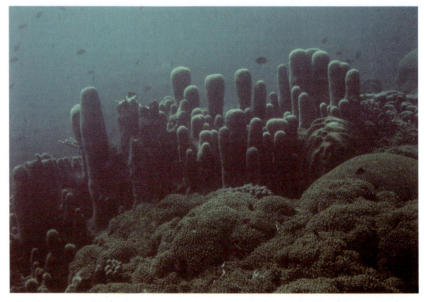

2.11 Extensive *Madracis auretenra* in the foreground, upright *Dendrogyra cylindrus,* and a massive rounded coral at right (possibly *Colpophyllia natans),* indicate a rich environment for coral growth and minimal disturbance from storms or humans.

Chapter 2 The Shallow Reef 11

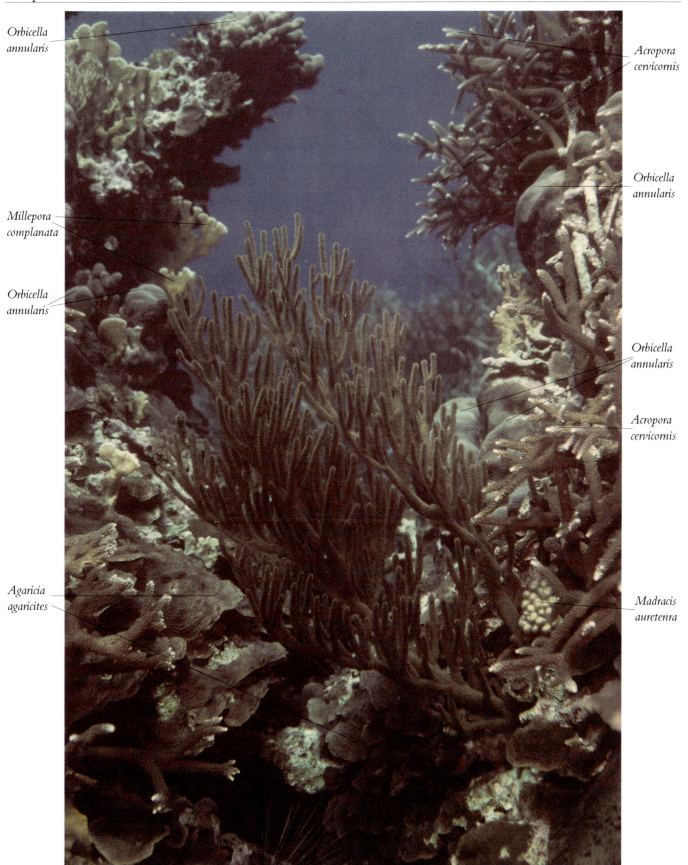

2.12 The tranquility of the coral reefscape masks the intense competition between corals to grow in such a manner as to collect the light from above. Symbiotic algae living in the coral tissue produce nutrients for the coral, and a coral that can grow over its neighbor can continue to receive this extra nourishment. The neighbor cannot. A *Plexaura homomalla* alcyonacean benefits from the water channeled between the coral patches.

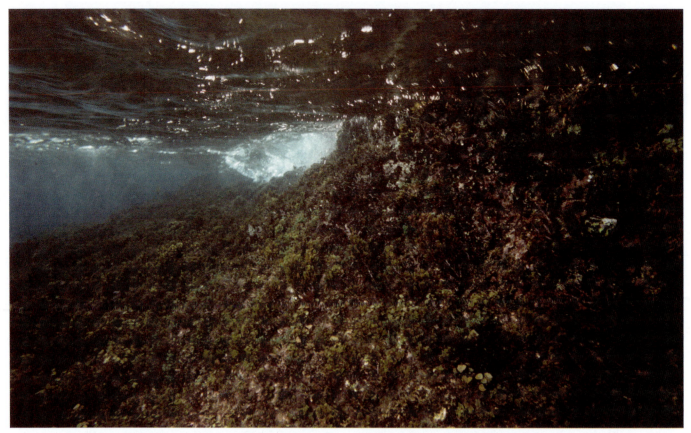

2.13 Here, the bottom slopes away from a calcified shoreline of beachrock. In this well-lit turbulent zone, red calcareous algae and larger, bright green *Halimeda* calcareous algae cover the bottom. They will contribute material to the sandy portions of the reef.

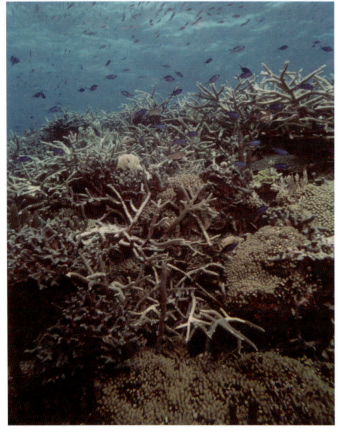

2.14 An *Acropora cervicornis* thicket near the seaward edge of the reef. Thick *Porites porites* and *Madracis auretenra* fill the foreground.

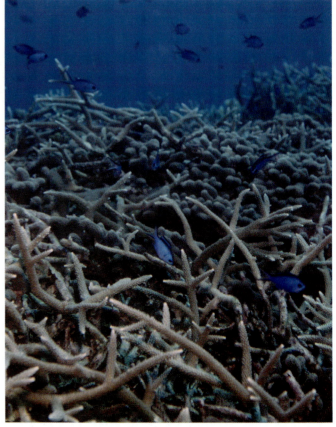

2.15 *Acropora cervicornis*, and *Porites porites* in the middle distance. Blue chromis, *Chromis cyaneus*, commonly forage above the reef.

Chapter 2 The Shallow Reef 13

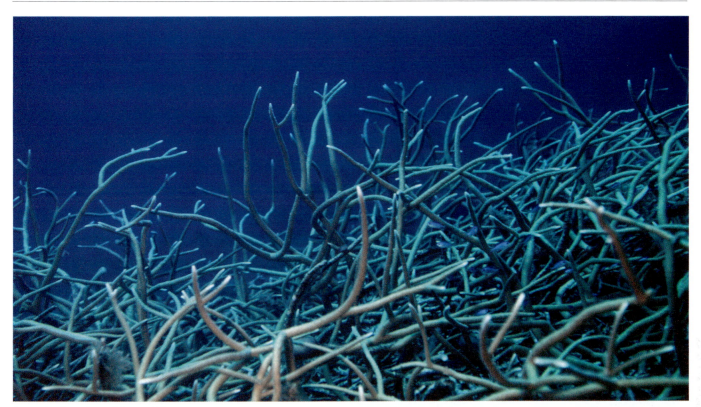

2.16 At the edge of the reef front, *Acropora cervicornis* grows fewer, longer branches that grow up toward the light while shading its lower supporting growth as little as possible. Such growth indicates reduced light as well as gentler wave action at greater depth.

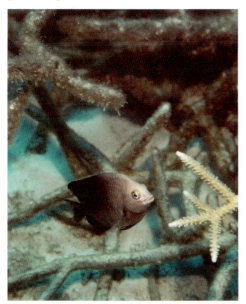

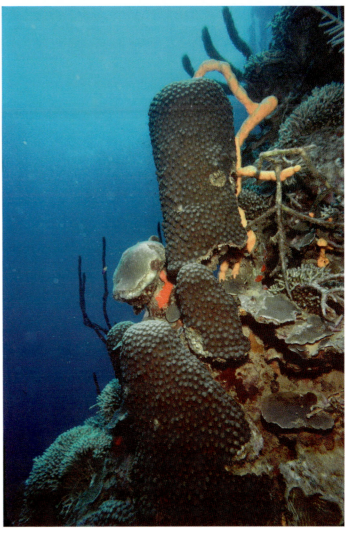

2.17 A damselfish, *Stegastes planifrons*, grazes on algae growing on dead *Acropora cervicornis* (live *cervicornis* is to right of fish.) It is fiercely territorial, even attacking divers (with little consequence) that come too close. See fig. 5.4.

2.18 A large cluster of *Montastrea cavernosa* colonies grows on the fore-reef slope. It is easily recognizable by the large individual corallites. The red and orange is sponge. The clumps of finger-like coral at top right and bottom left are *Madracis auretenra*.

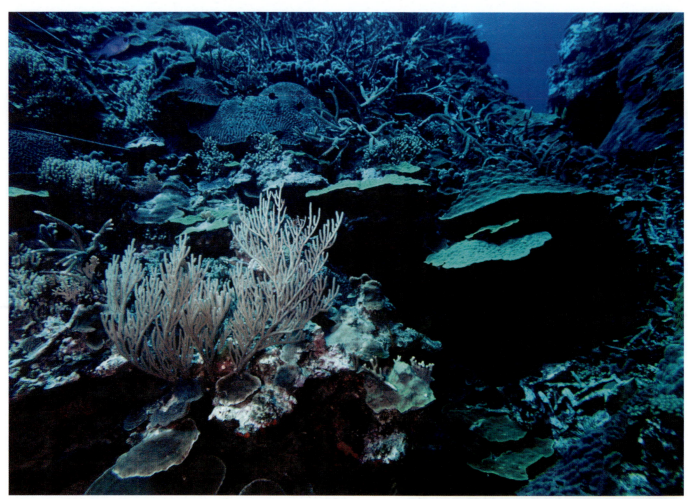

2.19 As one visits deeper patches of reef, one sees the same species that have a rounded form in shallow water assume flatter forms aimed at maximizing the collection of sunlight coming from directly above. A massive skeleton is not necessary to coral sheltered from wave action by the water depth, and at the same time, less light is available to fuel the building of one. Here on the seaward-facing fore-reef slope the shallow branching *Acropora cervicornis* and *Porites porites* give way with greater depth to species with flatter forms. In the upper left center is a flattened *Colpohyllia natans*, which is a rounded brain coral in the shallows. Below it are several bright green flattened plates of *Porites astreoides*. Thin plates of *Agaricia* extend out from the vertical wall below the alcyonacean. Above the dark shadowed area on the right are a knobby, flattened *Orbicella faveolata*, and below that two colonies of *Porites astreoides*.

2.20 Since reef-building corals need light for the symbiotic algae in their tissues to thrive and provide nourishment in the otherwise nutrient-poor tropical water, their growth forms are largely dependent on depth and light exposure. This single large colony of knobby *Orbicella faveolata* shows both a massive, rounded growth form at the top, where light is abundant and multidirectional, and also a flattened, platelike form on its seaward-facing slope side, as its need to collect as much of the reduced light in this location dictates.

3

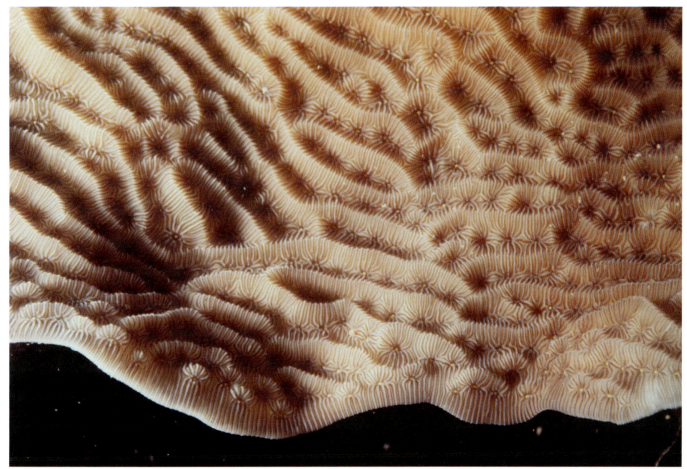

3.1 Rows of individual polyps make up the colonial coral *Agaricia agaricites* in this close view. One or more polyps share furrows with thicker walls between them. Here the polyps are withdrawn in the daytime. Each furrow is only 3-5 mm across.

Coral

Here we will look in detail at the common reef-building stony corals, or scleractinians. The soft tissues of corals that grow massive colonies and form tropical reefs harbor zooxanthellae, symbiotic algal cells which photosynthesize using sunlight, providing a nutrient bonus over that obtained only by feeding on plankton. Corals without zooxanthellae are generally small and can inhabit poorly lit places on the reef. They are also known to live in deep and cold water throughout the world.

Corals reproduce sexually, with eggs released and fertilized in the water or fertilized internally and retained until the larvae mature. Once a planktonic larva finds a suitable place to settle, it begins to secrete its skeletal base and then grows by budding off new individual polyps laterally. The coral grows thicker as well as wider in abundant light. In limited light, growth produces thin, flat skeletons to maximize light capture.

The Caribbean is home to about 65 species of scleractinian corals. Different locations will be home to slightly different lists of species, and distinguishing some species requires detailed examination of skeletons from which the soft tissues have been removed. This chapter will present the most common ones that can be clearly distinguished visually and also describe distinguishing features of some species that look similar on first examination.

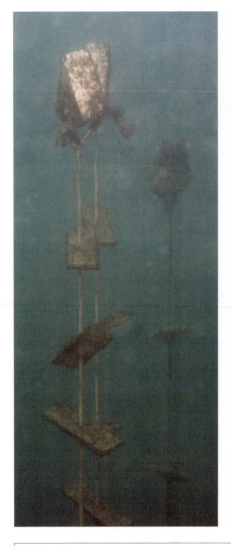
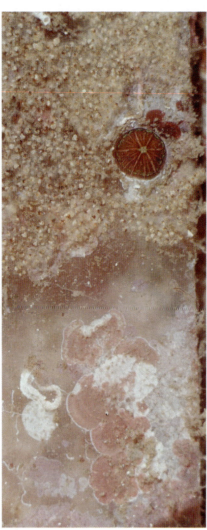
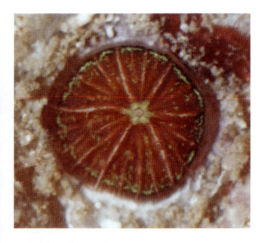

3.2a (far left) Most planktonic coral larvae end up as food for other organisms. A lucky few find a fresh bare surface to settle on and establish a new colony. These acrylic plastic plates have been set out to collect the larvae of corals and other organisms.

3.2b (left) A single coral polyp, red and pink calcareous algae, and brown colonial tunicates (resembling sand) have settled and are growing on a collecting plate.

3.2c (above) The settled coral polyp has laid down six primary septa and smaller secondary and tertiary septa between them. The brown color and green pigmentation at the mouth and outer margin suggest it may be an *Agaricia* species or *Orbicella faveolata*.

Coral Terminology

polyp — bag-shaped soft body with mouth surrounded by tentacles
septum — radiating wall in the skeleton, plural septa
corallite — the skeletal cup formed by the coral polyp, in which it sits
calyx — the inner surface of the corallite
theca — the ridge surrounding one or more corallites
columella — central cylindrical bit of skeleton, has appearance of a dot
stomodaeum — the mouth of the polyp
tentacle — structure carrying stinging cells
mesenterial filament — digestive structure also used for competition
coenosarc — the soft tissue between polyps
pedunculate — standing on a pedestal base
bifacial — growing upright with polyps on both sides
encrusting — growing in a thin layer on its substrate
ramose — having finger-like branches

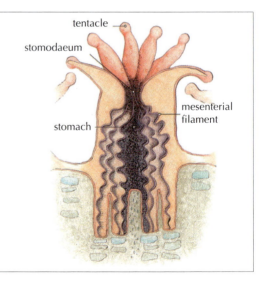

3.3 (opposite page) An example list of scleractinian corals from one Caribbean island. Such a list shows the familial relationships of all the species ever collected there and named by scientists. Many of the families and species were first described in the mid-nineteenth century from specimens dredged from the bottom by ships a century before scuba gear made it possible to visit their environments. A few live in relatively turbid estuaries and are not common on the reef. Some are small, solitary ahermatypes that are also rarely seen. Such a list gives no indication of how common a species may be or in what environment it may be found. Adapted from a list made by J.W. Wells and J.C. Lang in 1972. Some species names have changed since this list was compiled and have been updated, as have some

Chapter 3 — Coral — 17

Jamaican Shallow-Water Scleractinia: Class Anthozoa / subclass Hexacorallia / order Scleractinia

family Acroporidae
- *Acropora cervicornis*
- *Acropora palmata*
- *Acropora prolifera (hybrid)*

family Agariciidae
- *Agaricia agaricites*
- *Agaricia fragilis*
 - forma *fragilis*
 - forma *contracta*
- *Agaricia grahamae*
- *Agaricia lamarcki*
- *Agaricia tenuifolia*
- *Agaricia undata*
- *Helioseris cucullata*

family Astrocoeniidae
- *Stephanocoenia intersepta*

family Caryophylliidae
- *Caryophyllia* sp. cf. *antillarum*
- *Colangia immersa*
- *Paracyathus pulchellus*
- *Phacelocyathus flos*
- *Phyllangia americana*
- *Rhizosmilia maculata*
- *Thalamophyllia riisei*

family Dendrophyliidae
- *Balanophyllia floridana*
- *Tubastrea coccinea*

family Gardineriidae
- *Colangia simplex*
- *Gardineria minor*

family Guyniidae
- *Guynia annulata*

family Meandrinidae
- *Dichocoenia stokesii*
- *Dendrogyra cylindrus*
- *Eusmilia fastigiata*
- *Meandrina danae*
- *Meandrina jacksoni*
- *Meandrina meandrites*

family Merulinidae
- *Orbicella annularis*
- *Orbicella faveolata*
- *Orbicella franksi*

family Montastraeidae
- *Montastraea cavernosa*

family Mussidae
- *Colpophyllia natans*
- *Diploria labyrinthiformis*
- *Favia fragum*
- *Isophyllia rigida*
- *Isophyllia sinuosa*
- *Manicina areolata*
- *Mycetophyllia aliciae*
- *Mycetophyllia danaana*
- *Mycetophyllia ferox*
- *Mycetophyllia lamarckiana*
- *Mycetophyllia reesi*
- *Mussa angulosa*
- *Pseudodiploria clivosa*
- *Pseudodiploria strigosa*
- *Scolymia cubensis*
- *Scolymia lacera*

family Oculinidae
- *Oculina diffusa*
- *Oculina valenciennesi*

family Pocilloporidae
- *Madracis auretenra*
- *Madracis decactis*
- *Madracis formosa*
- *Madracis pharensis*
 - forma *luciphila*
 - forma *pharensis*

family Poritidae
- *Porites astreoides*
- *Porites branneri*
- *Porites divaricata*
- *Porites furcata*
- *Porites porites*

family Rhizangiidae
- *Astrangia solitaria*

family Siderastreidae
- *Siderastrea radians*
- *Siderastrea siderea*

species with uncertain placement (incertae sedis):

- *Cladocora arbuscula*

- *Solenastrea hyades*
- *Solenastrea bournoni*

(fig. 3.3 cont.) of the family placements. Suborders and superfamilies are in flux and those given in the original list, correct at the time, have been omitted. Normally the name of the first describer and the year of the first description are part of the species name, but they have been omitted here as well. A list such as this is subject to constant revision as new relationships between species are revealed.

Acropora palmata

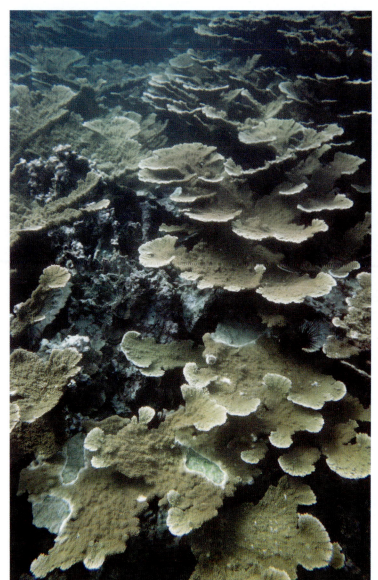

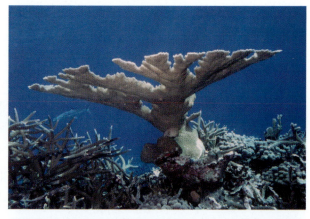

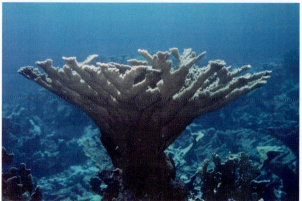

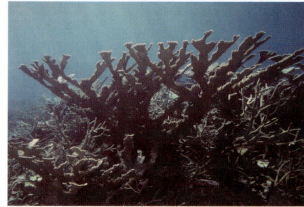

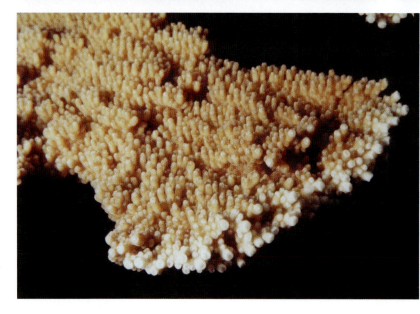

3.4 (above left) Looking down from the surface at extensive *Acropora palmata* growth on the reef crest.

3.5a (above top), **3.5b** (above middle), **3.5c** (above bottom) Three examples show the variability possible in *Acropora palmata* growth form. As noted earlier, large colonies of this species make massive structures in the shallow reef crest zone where wave action is strongest.

3.6 (left) A close view of the end of an *Acropora palmata* branch about 15 cm across shows the elevated tubes in which the individual polyps live. This surface can become a dangerous flesh-grater for a swimmer thrown against the coral by wave surge. (Also see skeletal view, fig. 3.14a.)

Acropora cervicornis

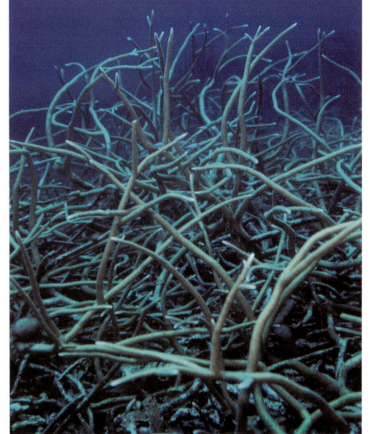

3.7 (right) At night the polyps of *Acropora cervicornis* extend to feed on plankton. The elongated, tubular corallites are typical of this genus.

3.8 (far right) A thicket of *Acropora cervicornis* shows the typical elongated branches of this species. As the colony grows into the open water above, light and wave-borne food become more available, encouraging growth, but the lower, older parts of the colony are overshadowed, eventually dying off and becoming overgrown with algae. (Also see fig. 2.17.)

3.9 (below) A closer view of branching *Acropora cervicornis*. Fish that graze on the algae growing on the understory also find shelter from predators among the branches. (Also see fig. 2.16.)

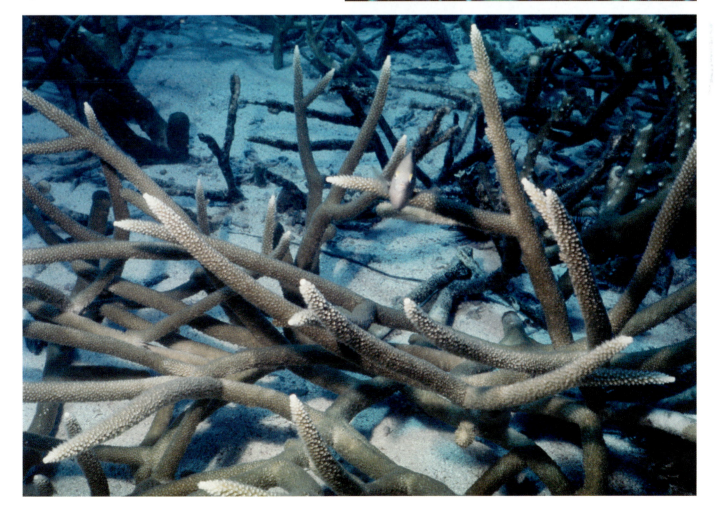

20 The Caribbean Coral Reef: A Record of an Ecosystem Under Threat

Acropora prolifera

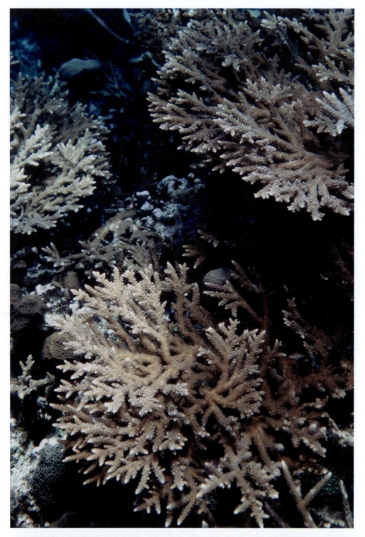

3.10 (left) *Acropora prolifera* has the same extended tubular corallites as *palmata* and *cervicornis* but produces a colony shape with thinner and more prolific branches. It is listed here as the third species of this genus, but genetic research has shown it to be a hybrid of the other two species. Though coral colony growth is by asexual reproduction of new polyps, environmental cues indicating favorable conditions cause coral species to release eggs and sperm into the water at the same time, and it is believed that many hybrid fertilizations between different species, of varying viability, may occur. *Acropora prolifera* is a very successful result of one combination. This is the palmate growth form, having more flattened branches reminiscent of the overall shape of *palmata*.

3.11 (below) *Acropora prolifera* is most abundant where the habitats of *A. palmata* and *A. cervicornis* overlap. It forms more compact branching masses than *cervicornis* and does not grow up into the water as its bigger parents do. This variant shape is successful at capturing light and plankton, and it holds its own against its parent species. Perhaps it has found a niche that a fully independent species might have evolved to fill. This is the bushy growth form.

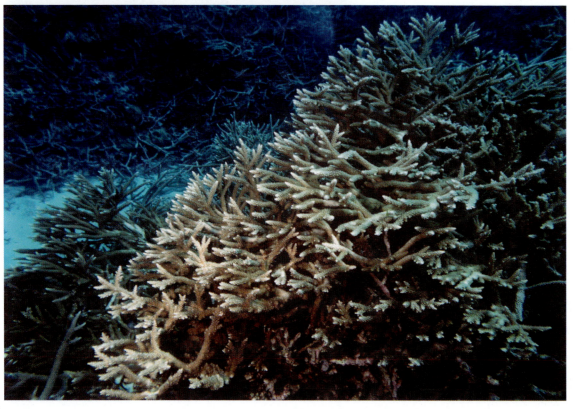

Chapter 3 Coral 21

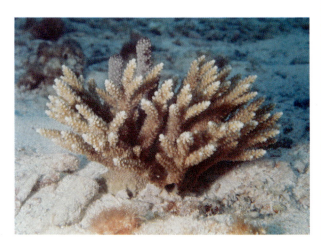

3.12 A small *Acropora prolifera* in shallow water near shore. At this point in its growth it is difficult to say whether it is the palmate or bushy variant of this hybrid. Genetic analysis has shown that the bushy examples of *prolifera* in the other views result when the egg has come from the *cervicornis* parent, and palmate forms have *palmata* as the "mother."

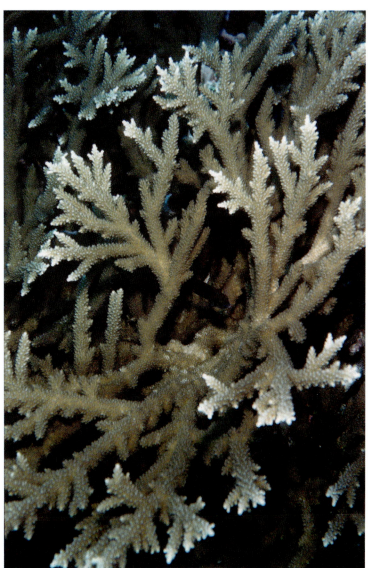

3.13 A closer view of a portion of a bushy *Acropora prolifera* colony.

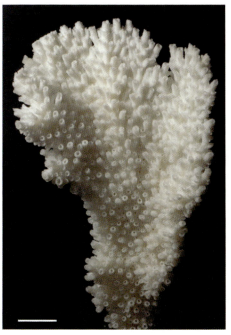

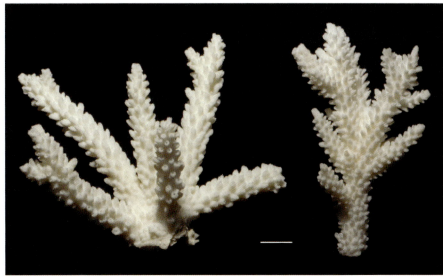

3.14a (left) and **3.14b** (above) Skeletal specimens show similarity of the fine features of *Acropora palmata* (left) and two variants of *Acropora prolifera* (above). The major differences are in growth form. Scale bar is 1 cm.

Orbicella faveolata

(formerly ***Montastraea faveolata***)

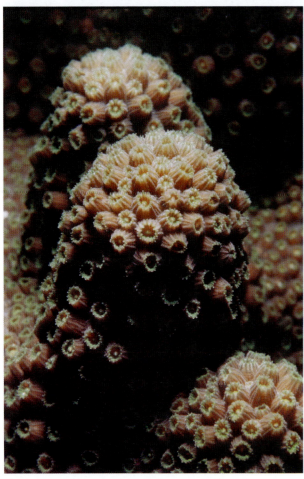

3.15 *Orbicella faveolata* forms skirted mounds with upright projections. Little ribbed mountainous corallites with walls that are steeper and closer to vertical than those of *O. annularis* and *O. franksi* are characteristic. The ribs, called costae, are extensions of the septa on the outside of the corallite.

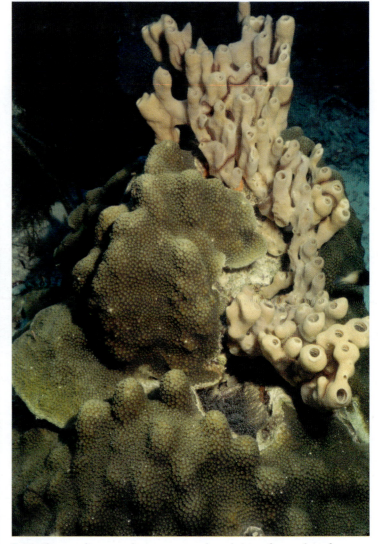

3.16 From a distance, the green mouth and ring of tentacles of *Orbicella faveolata* can mask the brown color visible in a close view. The corallites are 3-4 mm wide.

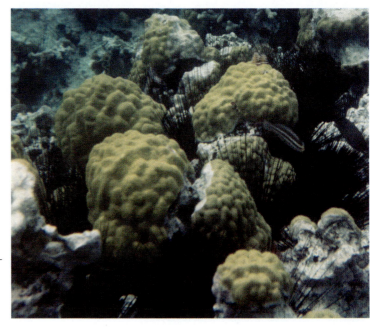

3.17 (right) *Orbicella faveolata* can cover a significant area of the reef in some places. The green color and knobby round shape is typical in shallow water. In deeper water on the fore-reef slope, the skirted edge is more prominent, as the colony grows to maximize exposure to light. Fig. 2.20 shows an example of both growth modes in a single large colony.

Orbicella franksi

(formerly *Montastraea franksi*)

3.18 (right) and **3.19** (below) *Orbicella franksi* is similar in overall appearance to *Orbicella faveolata*, but the corallites have less pronounced septal ribs and a smoother appearance and the surface has scattered bumps with polyps that are larger and paler than those in the area between them. There are both large and small corallites at the growing edge, contrasted with those of *Orbicella faveolata*, which are more uniform in size. *Orbicella faveolata*, *O. franksi*, and *O. annularis* were for a time considered variants of a single species, *Montastraea annularis* (now *Orbicella annularis*, next page), but they have been separated again according to their original descriptions (and modern supporting information).

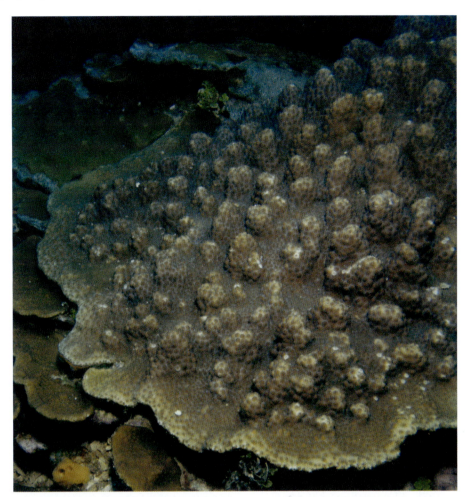

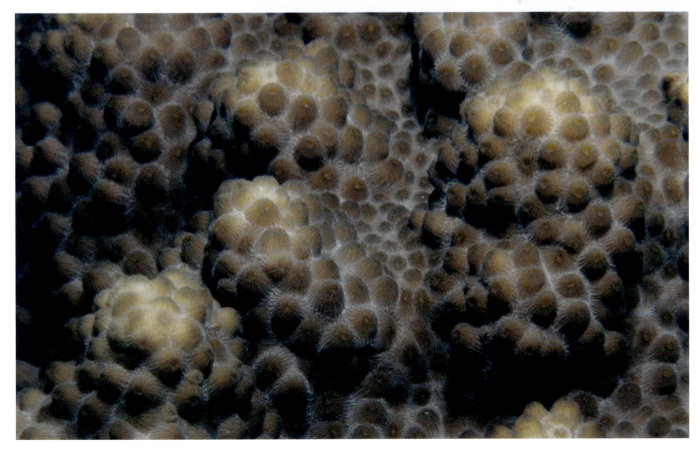

Orbicella annularis

(formerly *Montastraea annularis*)

3.20 (right) The growth pattern of *Orbicella annularis* is rounded or irregular, but not lumpy or knobby. Often a colony consists of several closely spaced masses, as in this view. The corallites are not as prominent as those of *Orbicella faveolata*, and the color is more tan than green or brown. The twin spiral trees are breathing structures of *Spirobranchus gigantea* serpulid worms (p. 101). The black spines belong to a *Diadema antillarum* urchin.

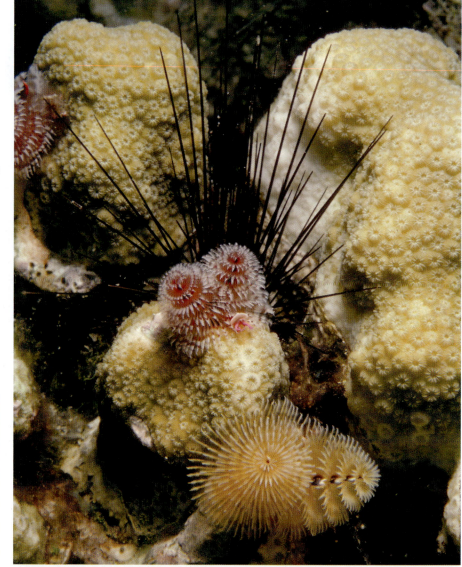

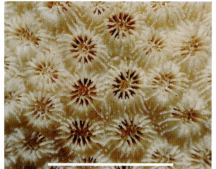

3.21 *O. annularis* skeleton enlarged to show details of the corallites. Scale bar is 1 cm.

3.22 Comparison of skeletons of *Orbicella annularis* (left) and *Montastraea cavernosa* (right) to show relative size of corallites. The rounded colony shape is typical of *annularis*. The *cavernosa* specimen was growing around the pencil-shaped remains of an alcyonacean or antipatharian, giving it this radially compact, elongated shape. Scale bar is 1 cm.

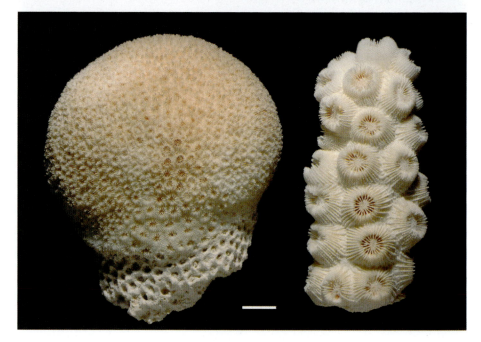

Montastraea cavernosa

3.23 (right) *Montastraea cavernosa* has corallites that have the same mountainous shape as those of *O. annularis, faveolata,* and *franksi,* but they are much larger. It is not easily confused with any other coral. The colony shape can be quite variable depending on the shape of the substrate it grows on. Also see fig. 2.18.

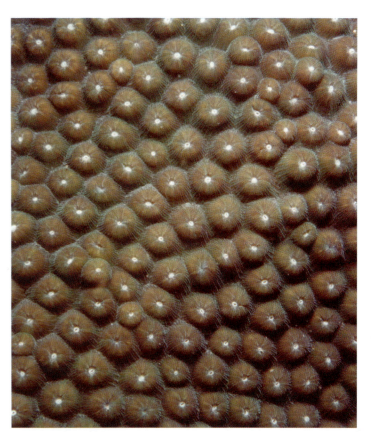

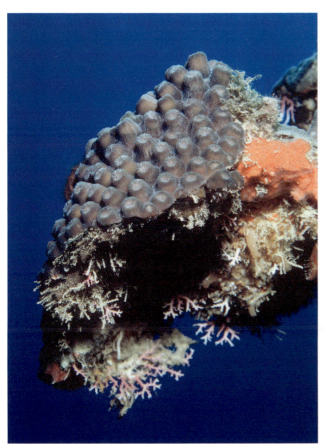

3.24 This *Montastraea cavernosa* encrusts a projection of dead coral on the reef slope. The colony can continue to expand and thrive as long as it does not grow too heavy and break away.

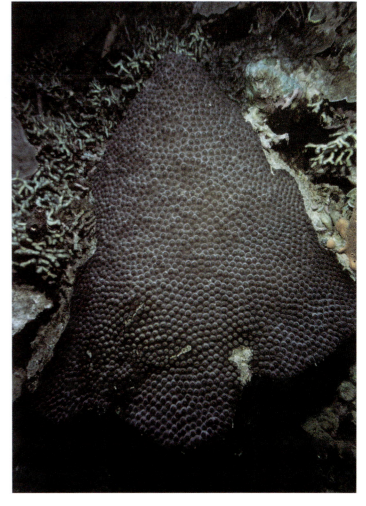

3.25 *Montastraea cavernosa* can form large encrusting masses, or flattened colonies in locations with lower light. The dark brownish color and large raised corallites are characteristic.

Porites astreoides

3.26 *Porites astreoides* forms colonies similar in shape to those of *Orbicella faveolata*, but the corallites are much smaller, about 2 mm in diameter, and the overall texture is smoother.

3.27 (right) *Porites astreoides* can be found in green and greenish gray color varieties. The largest of these examples is about 12 cm across.

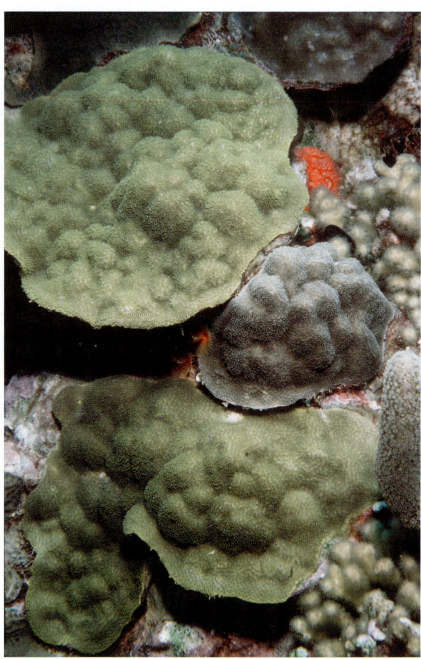

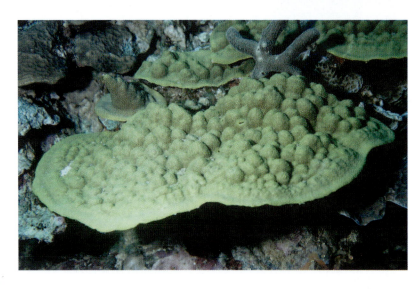

3.28 A flattened *Porites astreoides* colony extends out from the reef surface at a greater depth than those shown in fig. 3.27. It is smaller and thinner than most *O. faveolata* colonies at similar depth.

Chapter 3 — Coral

Porites porites

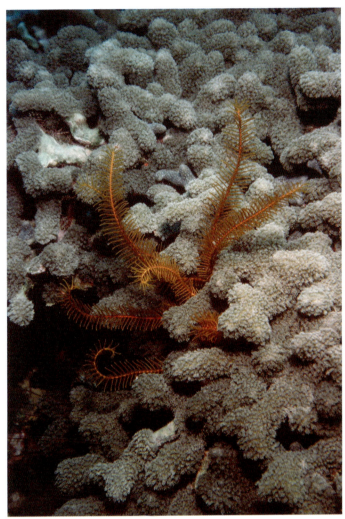

3.29 A crinoid extends its arms into the water column from the protection of a thicket of *Porites porites*.

3.31 (right) In this view, with tentacles retracted, the branching shape can be better seen. The gray or gray-green color is typical.

3.32a (left) and **3.32b** (right) Two views of the *Porites porites* skeleton show the overall relative smoothness, small size, and close spacing of the corallites. Scale bar in both is 1 cm.

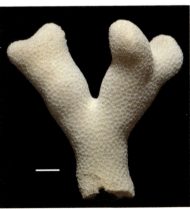

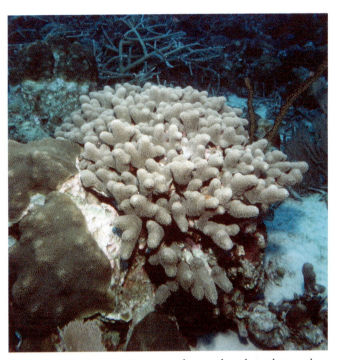

3.30 (above) *Porites porites* grows short, robust branches, and is common in the same relatively high wave energy environment as *A. cervicornis*. The tentacles are extended, giving a fuzzy appearance.

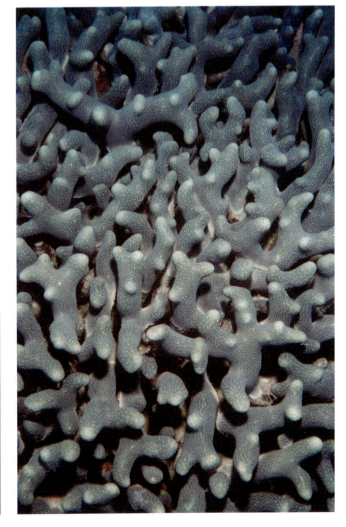

Madracis auretenra (formerly *Madracis mirabilis* - see note 1, p.197)

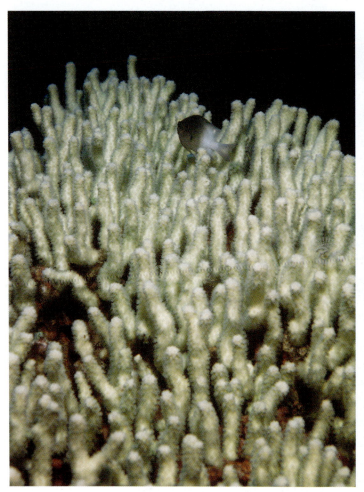

3.33 *Madracis auretenra* is a yellowish-tan coral with thin branches that create a large surface area in a relatively small volume.

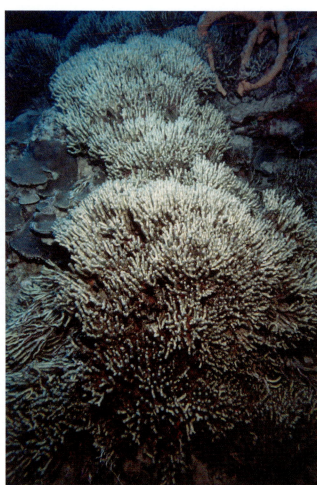

3.34 *Madracis auretenra* can form very large but fragile colonies at moderate depths of 10-20 meters on the reef slope.

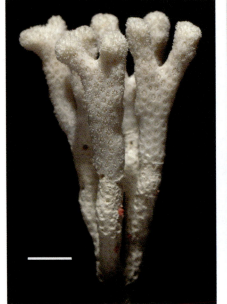

3.35 The skeleton shows the open space between polyps. Scale bar is 1 cm.

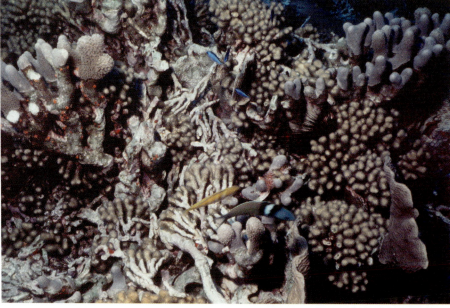

3.36 Though fragile, *Madracis auretenra* often lives in shallow water, here in the wave shadow of *P. porites*. Several broken but still-living branches are visible. Also see fig. 2-11.

Chapter 3 Coral 29

Madracis formosa and *Madracis decactis*

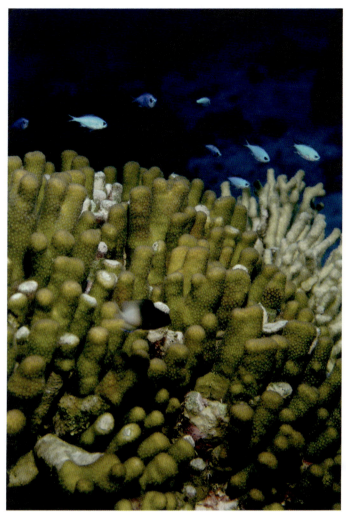

3.37 *Madracis formosa* has thicker fingerlike branches than *Madracis auretenra* and resembles *Porites porites* superficially, but its branches are smaller and the corallites are spaced farther apart.

3.38a and **3.38b** (inset) *Madracis decactis* can be encrusting or ramose, with short, knobby branches. Like *M. auretenra*, it has 10 septa per corallite, not 8 or 9. Scale bar is 1 cm.

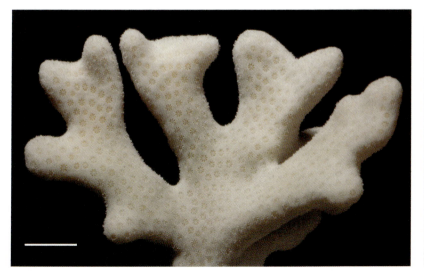

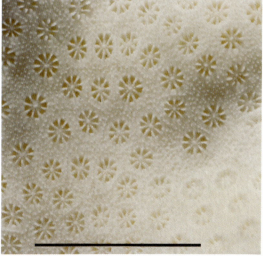

3.39a (left) and **3.39b** (right) Two skeletal views of *Madracis formosa*. Note the considerable distance between the corallites, compared with the close corallite spacing of *Porites porites* (fig. 3.32a), and that there are 8-9 septa per corallite, not 10. Scale bar in both is 1 cm.

Eusmilia fastigiata

3.40 (right) *Eusmilia fastigiata* is a branching coral with large corallites and distinctive septa that form a ring of protruding sharp blades around the perimeter of each corallite. This colony is about life-size.

3.41 A large colony of *Eusmilia fastigiata* with heavy algal growth between the branches.

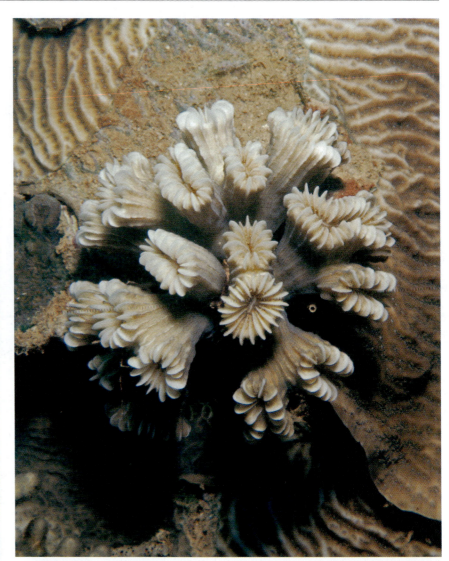

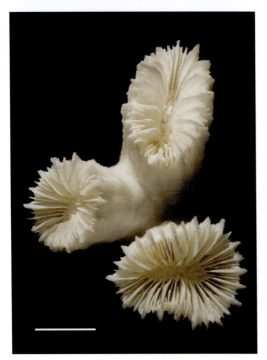

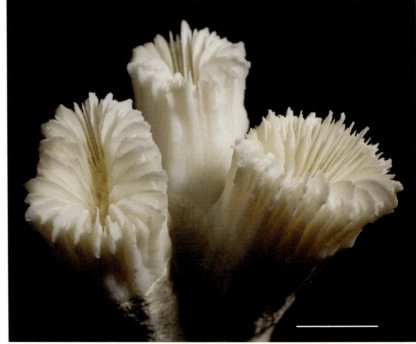

3.42a (left) and **3.42b** (right) Two views of a *Eusmilia fastigiata* skeletal specimen show the septa visible in live coral. Scale bar is 1 cm.

Chapter 3 Coral 31

Dendrogyra cylindrus

3.43 (right) *Dendrogyra cylindrus* is easy to recognize on the reef. Its massive upright cylindrical columns appear furry from the tentacles extended for feeding in the daytime. They are well arranged both for gathering light to fuel photosynthesis in the coral's symbiotic zooxanthellae and for capturing plankton in the water swirling around them. Both sources of nutrition provide ample energy to deposit a skeletal structure that not only is massive but also has a large surface area. (See figures 2.9 through 2.11 for other examples.)

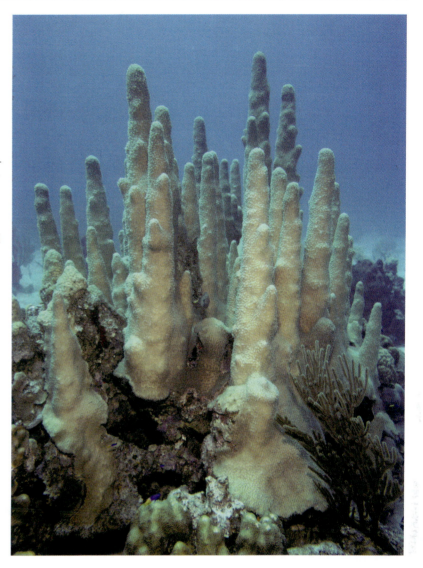

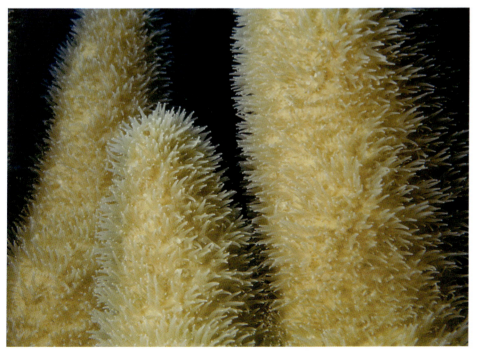

3.44 *Dendrogyra cylindrus*, showing tentacles extended for feeding, day or night.

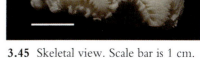

3.45 Skeletal view. Scale bar is 1 cm.

Colpophyllia natans

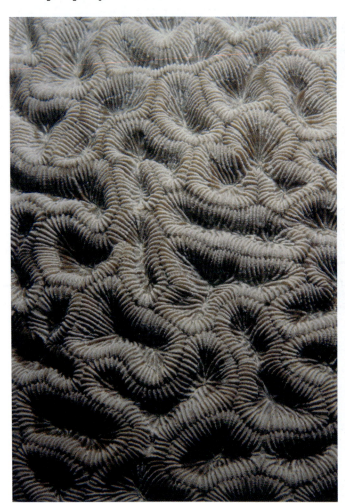
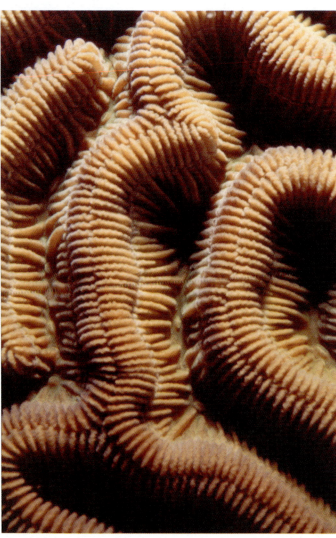

3.46a (left) and **3.46b** (right) *Colpophyllia natans* can grow to massive size and is the largest of the so-called "brain" corals. Several corallites share a valley between elongated ridges that have a slight but distinct groove running down the middle. Also see figs. 2.11 and 2.19.

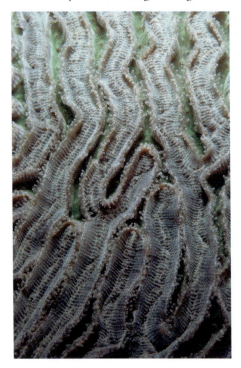
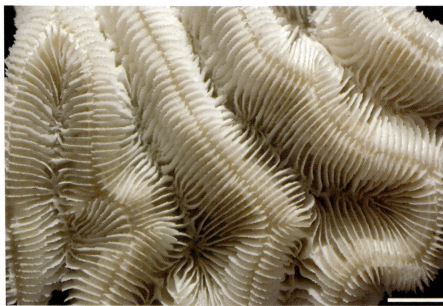

3.47 Skeletal view shows the groove in the middle of each ridge. Scale bar is 1 cm.

3.48 (left) *Colpophyllia natans* seen at night with tentacles extended for feeding.

Chapter 3 Coral 33

Diploria labyrinthiformis

3.49 (right) *Diploria labyrinthiformis* is another rounded, massive coral. Its ridges are angular and thick with a distinctive dip in cross-section, making a broad furrow down the center of each ridge.

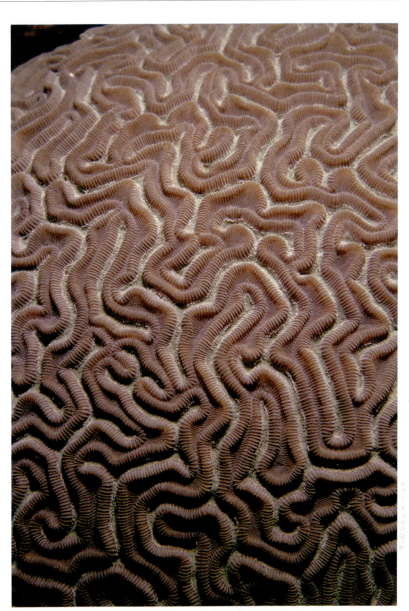

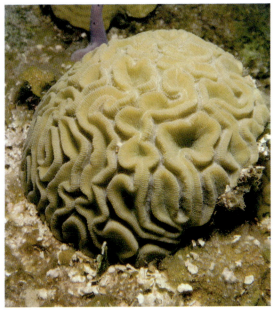

3.50 A small *D. labyrinthiformis* in shallow water. The furrows are particularly deep in this individual.

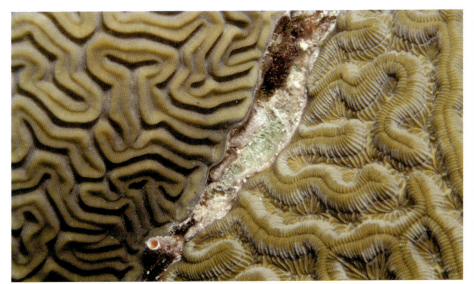

3.51 A comparison of *D. labyrinthiformis*, smooth and with a broad furrow, and *C. natans*, with more prominent septa and a narrow groove in the thecal ridge, growing side by side.

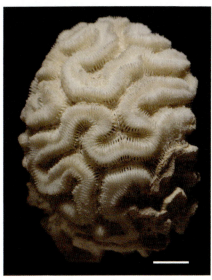

3.52 Skeletal view of a small *Diploria labyrinthiformis*. Scale bar is 1 cm.

Pseudodiploria strigosa (formerly *Diploria strigosa*)

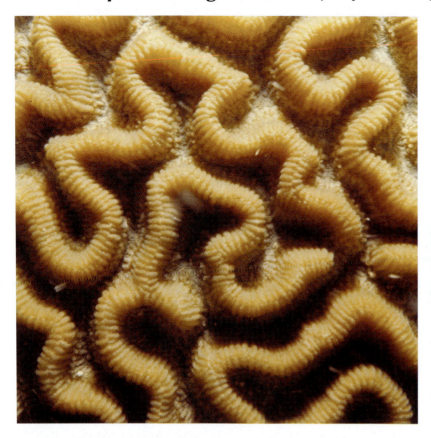

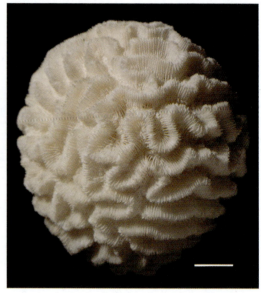

3.53 (left) *Pseudodiploria strigosa* has ridges that are rounded in cross section and about half the thickness of those of *D. labyrinthiformis*. It is common on the shallow reef.

3.54 Skeletal view of a small *Pseudodiploria strigosa*. Scale bar is 1 cm.

Meandrina meandrites

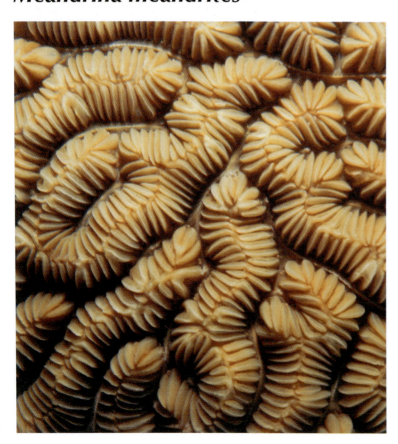

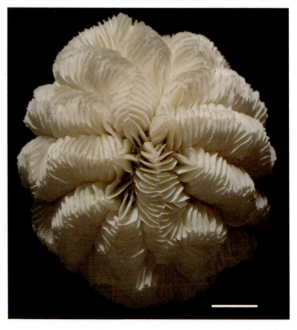

3.55 (left) Large, well-separated septa give *Meandrina meandrites* a coarse appearance. It has ridges similar in size to those of *Colpophyllia natans* and also grows in a flattened form on the reef slope.

3.56 Skeletal view of *M. meandrites*. Scale bar is 1 cm.

Agaricia agaricites

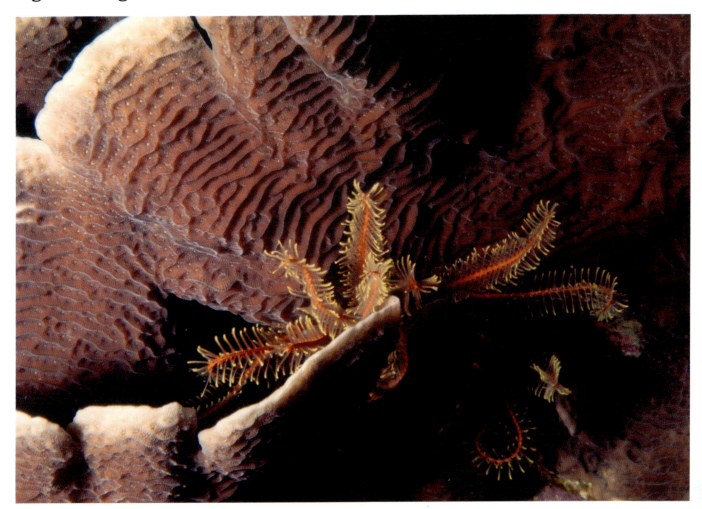

3.57 (above) *Agaricia agaricites* is one of several closely related and similar species. It also occurs in several growth forms. It can be encrusting in very shallow water, as in the skeletal specimen in fig. 3.58b on this page. It can also form upright, bifacial blades in medium depth, as in the view above with a *Davidaster rubiginosa* crinoid. And it can be thin and leaf-like in deeper water. Some agariciids are large and distinctive, but the features of agariciids are small, and identification requires a close view. *A. agaricites* has close-set ridges and mouths and fine closely set alternating thick and thin septa. Ridges often surround a number of greenish mouths. See also the *Agaricia agaricites*, fig. 3.1 at the opening of this chapter.

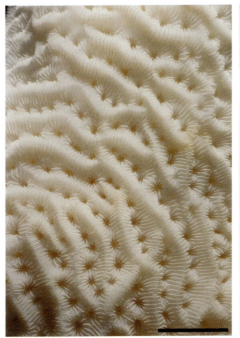 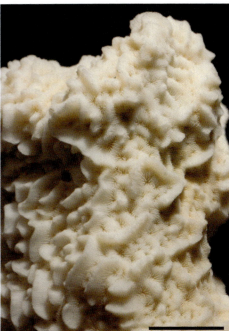

3.58a (left) and **3.58b** (right) Skeletal views of platy and more massive *Agaricia agaricites*. Scale bar is 1 cm.

Agaricia undata

3.59 *Agaricia undata* inhabits the fore-reef slope, where the dominant coral form is thin plates oriented to maximize light exposure. It typically forms plates arranged as thin, cabbage-shaped expanding circles up to 1-2 meters across. In this view of only part of one of these assemblages, an 8 cm. damselfish gives scale. The mouths are small, appearing as dark dots between the ridges.

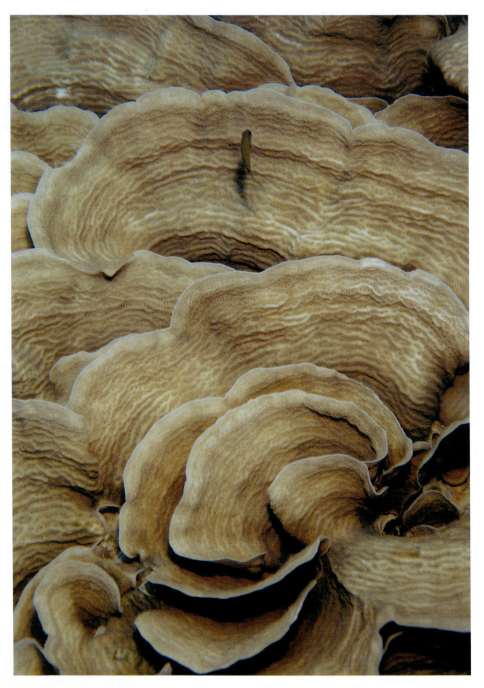

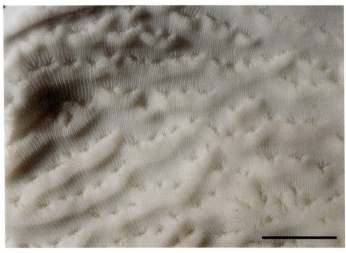

3.60 *Agaricia undata* skeletal view. The ridges show the roundness visible in the live view. The mouths are nestled at the side of the ridge facing the growing edge, rather than centered in the valley between ridges. Scale bar is 1 cm.

Chapter 3 Coral 37

Agaricia lamarcki

3.61 (right) *Agaricia lamarcki* is another deepish, platelike species. It forms a dense skeleton and grows as a flat basin shape from a central stalk. (It is "pedunculate" rather than encrusting.) The white dot in the center of the corallite and the white tips of the septa are characteristic of *lamarcki*.

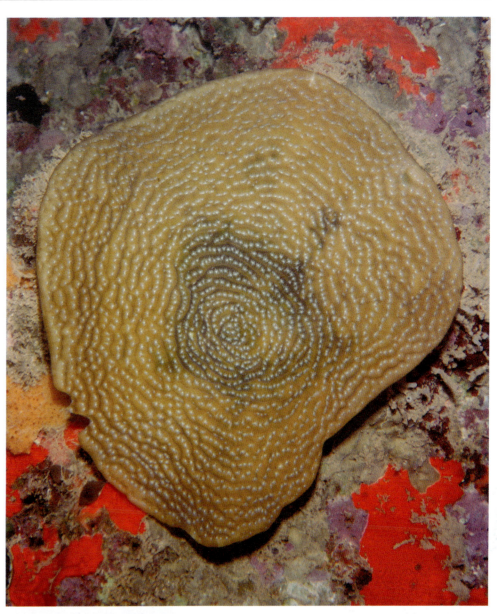

3.62 (below left) A close view of *Agaricia lamarcki* shows the typical white corallite markings. The thin alternate septa are not visible in the living individual. The thicker septa are prominent and raised above the surface more than in some species.

3.63 (below right) A skeletal view shows the alternating thick and thin septa and the columella (dot at the center of each corallite). Scale bar is 1 cm.

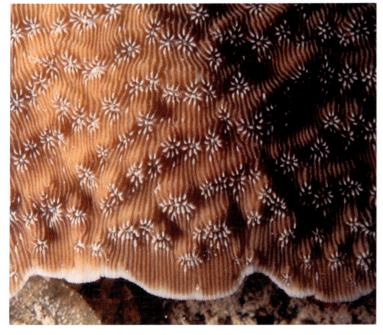
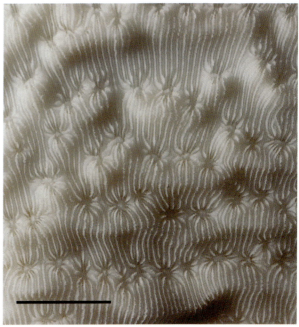

Agaricia grahamae

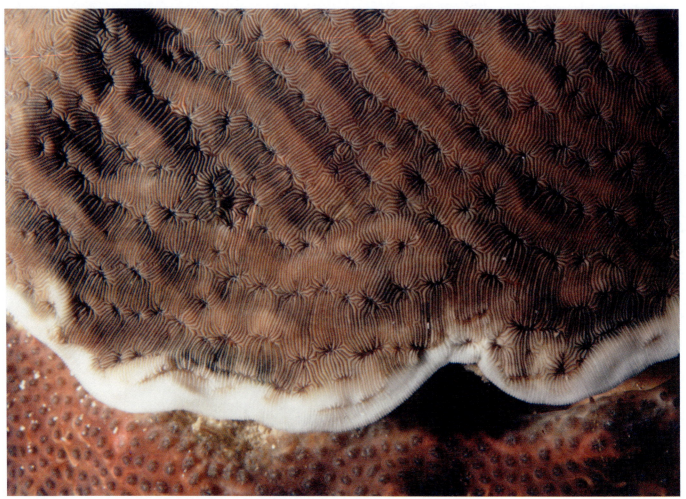

3.64 A close view of *Agaricia grahamae* shows the similarities and differences between it and *A. lamarcki*. There are thick and thin alternating septa, but the septa surrounding the corallite are not raised, the ridges are smooth, and the color is uniform. Approx. 2x life-size.

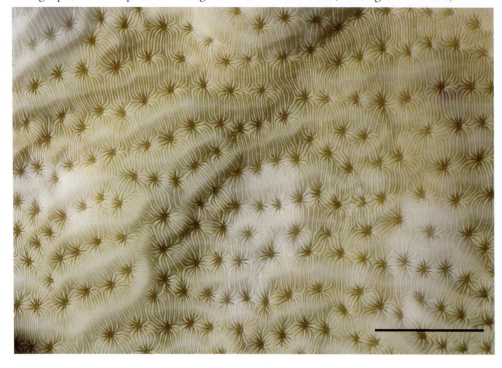

3.65 A close skeletal view of *Agaricia grahamae* shows features visible in the living coral. Scale bar is 1 cm.

Chapter 3 Coral 39

Helioseris cucullata
(coarse / shallow water form)

3.66 (right) *Helioseris cucullata* is a member of the same family as the agaricias and is often mistaken for one of them. It grows similar platy structures in deeper, shaded parts of the reef. It often has a fluorescent green color. The diagnostic features of this form are the coarse, irregular ridges, with corallites angled toward the growing edge, and the absence of a visible dot (the columella) in the center of the corallite. Approximately 2x life-size.

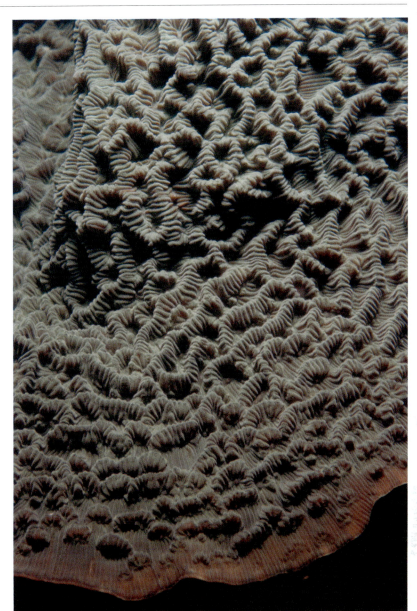

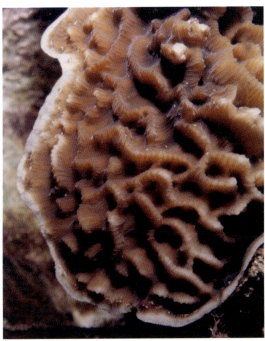

3.67 A small brown *Helioseris cucullata*. The overall characteristics are the same as the larger example in fig. 3.66.

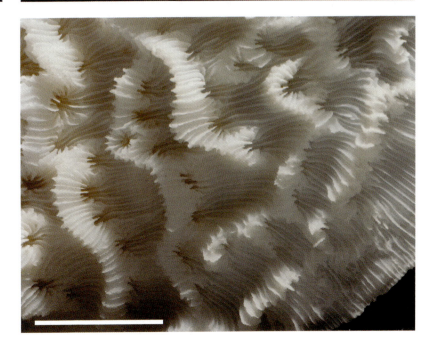

3.68 A portion of a *Helioseris cucullata* skeleton. Note the absence of a columella. Scale bar is 1 cm.

Helioseris cucullata (fragile / deep water form)

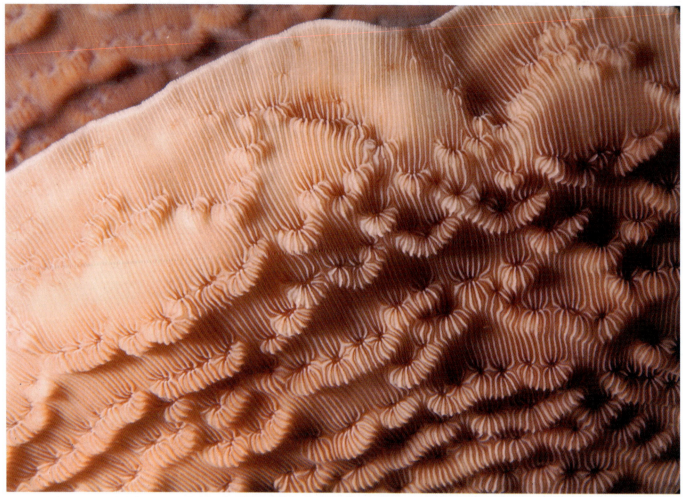

3.69 A close view of *Helioseris cucullata* from 20-30 m deep on the fore-reef. The corallites sit facing the growing edge, but the corallites and ridges are gently rounded, smaller, and spaced farther apart. Thick and thin septa alternate. Approximately 2x life-size.

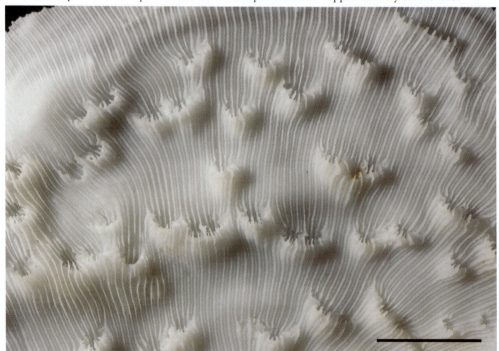

3.70 A skeletal view shows the same features visible in the living coral. In this deep-water specimen, the skeleton is extremely thin. Scale bar is 1 cm.

Chapter 3 — Coral — 41

An Agariciid Gallery

The agariciids, which include *Helioseris*, are similar and easily confused. Each of these two pictures shows two or three similar agariciids growing in close proximity. Refer to the preceding pages for the distinguishing features. The magnifications are similar in both views.

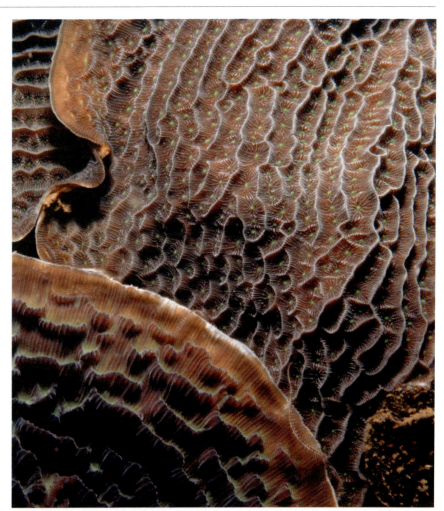

3.71 (right) *Helioseris cucullata* is at the lower left and *Agaricia agaricites* is at upper right in this view from 15-20 m on the fore-reef.

3.72 (below) *Agaricia lamarcki* is at left and *Helioseris cucullata* (deepwater form) is growing over part of it at right, at 20-30 m depth. Compare the spacing of the corallites of the *Agaricia lamarcki* with the specimen in shallower water, fig. 3.63. *Agaricia grahamae* is the species in the background.

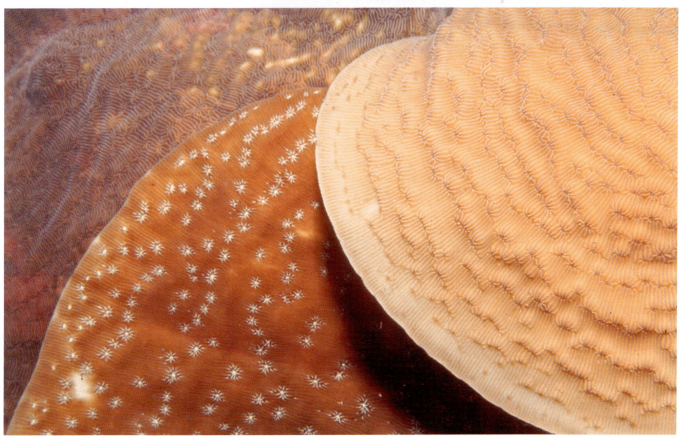

Mussa angulosa

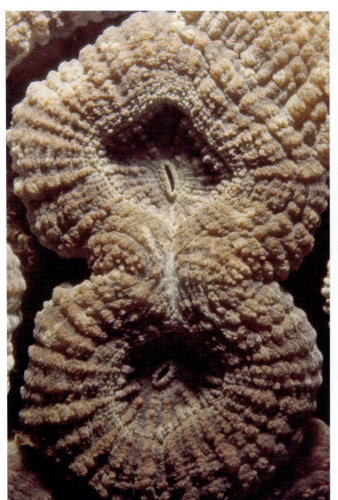

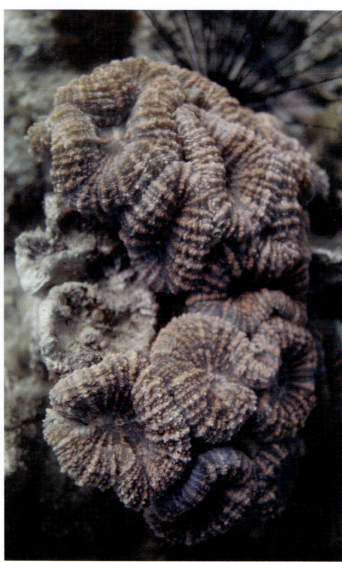

3.73 (above, left) *Mussa angulosa*, of the family Mussidae, has large polyps and prominent septa with deeply serrated edges that give the coral a rough, coarse appearance. It forms thick branching colonies, and the large polyps divide as it grows, forming new single polyps. Here the process of dividing into two new polyps is almost complete.

3.74 (above, right) An available-light photograph of *Mussa angulosa* in shallow water shows a color variant with bands of red. Brown and gray are other common colors. Two of the polyps in this colony have died.

3.75a (right) and **3.75b** (far right) Oblique and overhead views of a single *Mussa angulosa* skeletal polyp show the prominent septa and growth form that characterize this species. Scale bar is 1 cm.

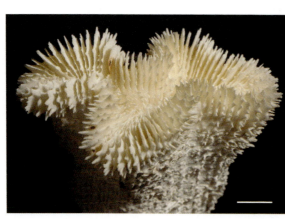

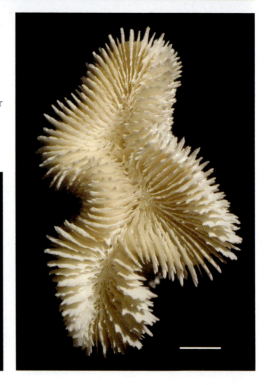

Chapter 3 — Coral

Scolymia lacera

These two species were for a time put in the genus *Mussa* but have been returned to *Scolymia*.

3.76 *Scolymia lacera* is a solitary polyp that resembles a round *Mussa angulosa* in its color variability and rough, coarse appearance. This view is approximately 1.5x life-size.

Scolymia cubensis

 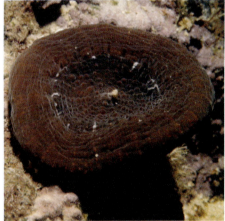

3.77a (left) and **3.77b** (right) *Scolymia cubensis* is also solitary and round, but smaller and smoother than *Scolymia lacera*. The color tends to be deep and uniform. A green and a brown variant are approximately life-size here.

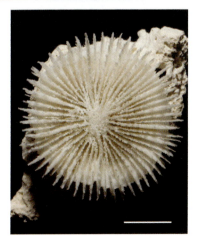

3.78 A small skeletal specimen of *Scolymia cubensis*. Scale bar is 1 cm.

Mycetophyllia aliciae

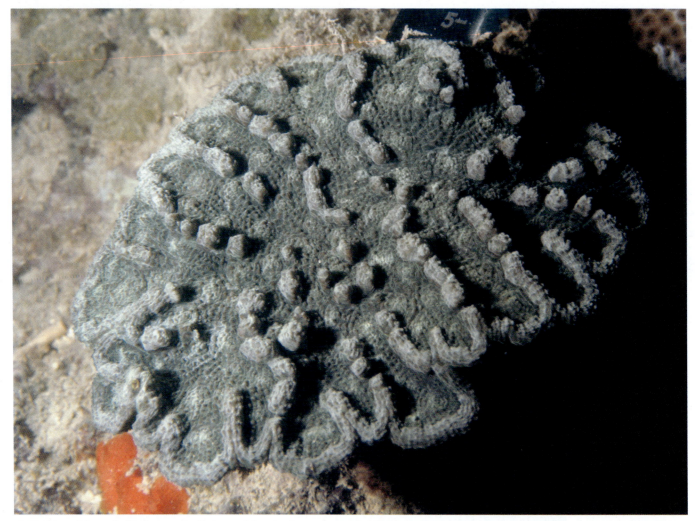

3.79 Most *Mycetophyllia* show a similarity to *Mussa* in the coarse surficial texture from spines on the underlying septa. *Mycetophyllia aliciae* forms flat or slightly domed plates. The edges are ridged, and the ridges extend in toward the center but are often interrupted, forming solitary bumps, as in this example, which is close to life-size. The ridges and bumps are usually light in color.

3.80a (below, left) and **3.80b** (below, right) Two color variants of *Mycetophyllia aliciae* show similar ridge patterns. Between the ridges there are several polyps, each slightly raised and lighter in color than the surrounding area.

3.81 (below) A close view of the multiple raised polyps between ridges shows the coarse texture. About life-size.

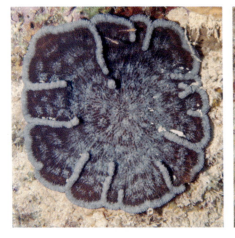
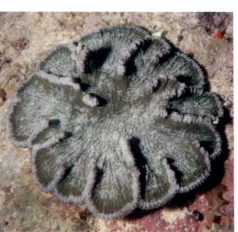
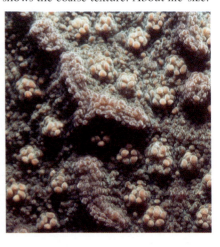

Mycetophyllia ferox

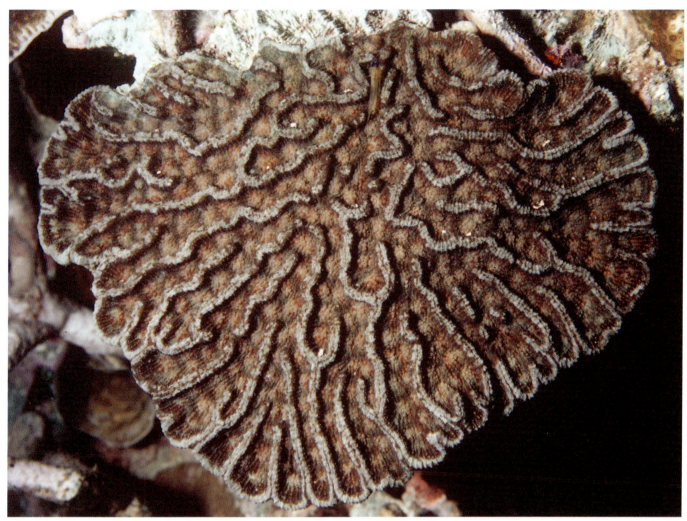

3.82 *Mycetophyllia ferox* forms flat plates with ridges that cover the entire surface. The ridges are thinner than in *M. aliciae*, squarish in cross section, and have a conspicuous groove along the top. There is usually only a single row of polyps in the valley between the ridges.

3.83 The ridges can form a reticulated pattern with closed valleys. This is an identifying feature of *Mycetophyllia ferox* that no other *Mycetophyllia* has.

3.84 A close view shows the thin, grooved ridges and single rows of polyps. Approximately life-size.

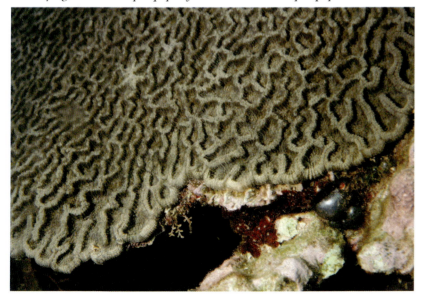
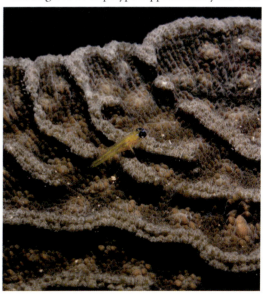

Mycetophyllia danaana/ lamarckiana

3.85 (right) *Mycetophyllia danaana* resembles *aliciae* and *ferox,* but is smaller and more massive. Its main distinguishing features are the thickness of the ridges and the depth of the valleys. Size is about 25 cm.

3.86 (below, left) The ridges of *Mycetophyllia danaana* extend across the entire surface but are not continuous and do not form closed valleys. The valleys have a single row of corallites. Size is about 25 cm.

3.87 (below, right) This individual resembles a fifth *Mycetophyllia* species, *M. lamarckiana,* in that it is mounded in form rather than being the more typical raised plate, but it lacks multiple corallites between ridges characteristic of *M. lamarckiana* given in some descriptions. Some workers in the field think that the domed forms are *M. danaana* and the larger, flatter form is *M. lamarckiana*. Distinctions can be very subtle, and in this instance the taxonomy is not at all settled. Size is slightly smaller than the others.

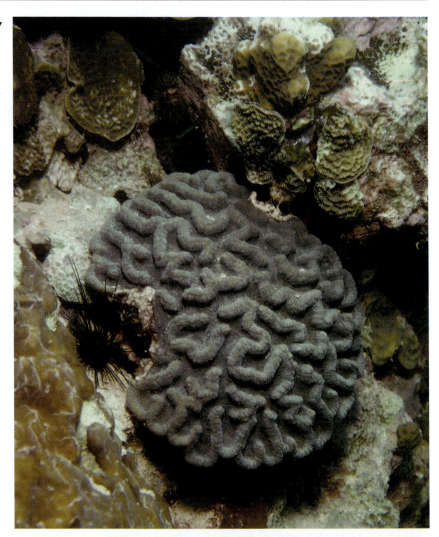

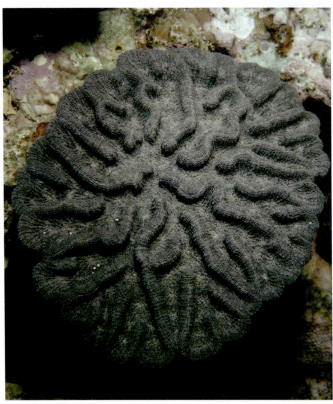

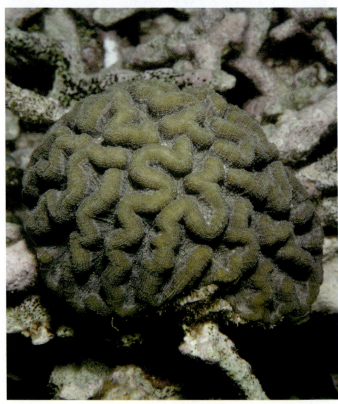

Chapter 3 Coral 47

Mycetophyllia reesii

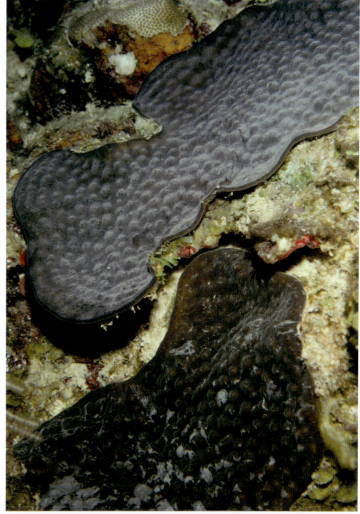

3.88 (right) *Mycetophyllia reesii* is a species of deeper water on the fore-reef slope. It forms thin flat plates without ridges. The polyps are large and form low mounds on the surface. It looks somewhat like a smooth, flattened *Montastraea cavernosa* from the dark color and polyp size, but the polyp shape is quite different.

3.89 (below, left) The color of *Mycetophyllia reesii* is usually dark and uniform, but it can sometimes have a mottled or piebald pattern. Here two colonies, probably genetically identical, have grown against each other.

3.90 (below, right) *Mycetophyllia reesii* does not encrust, but is pedunculate, growing its thin plate out from an attachment point at the center. In this view a few *Montastraea cavernosa* polyps (lower left) and an *Agaricia grahamae* (upper right), give a size comparison.

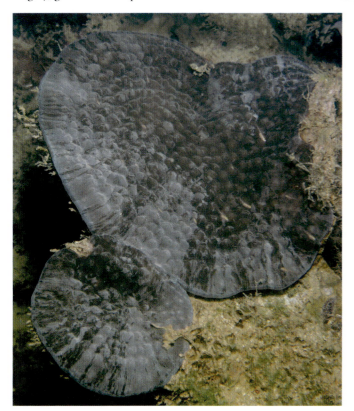

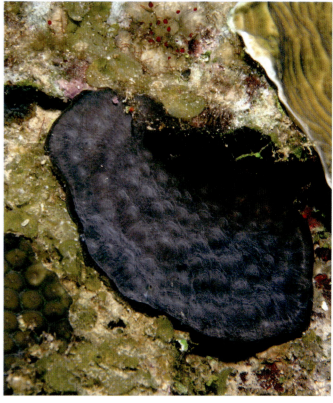

Isophyllia sinuosa

3.91 (right) *Isophyllia sinuosa* resembles *Mycetophyllia danaana* in having slightly grooved sinuous ridges separating the valleys, but it has a much fleshier appearance. It might also be confused with *Colpophyllia natans*, since the valleys and ridges are similar in size, but *Isophyllia sinuosa* has prominent teeth on the septa, fleshier tissues, and it does not form large colonies. It occurs on the shallow reef in sheltered habitats.

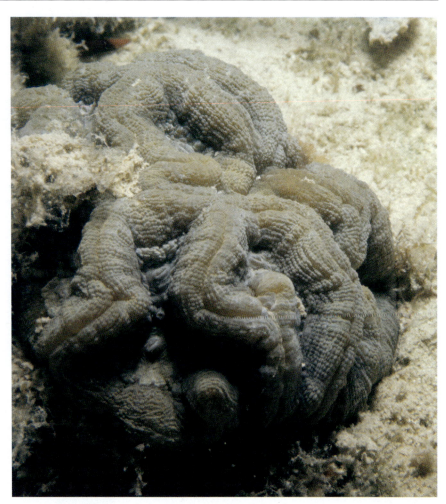

Isophyllia rigida
(formerly *Isophyllastrea rigida*)

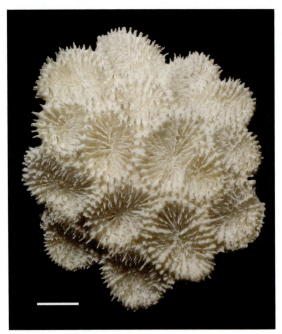

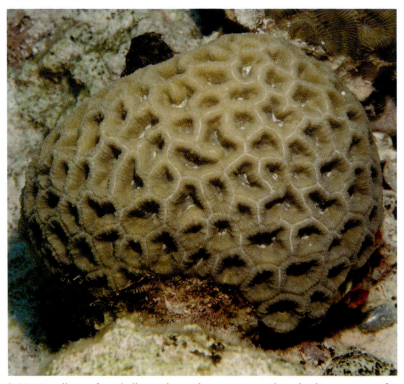

3.92 A skeleton of *Isophyllia rigida* shows the sharp teeth on the septa. Scale bar is 1 cm.

3.93 Corallites of *Isophyllia rigida* are deep, connected, and solitary, except for dividing ones. Robust, it is found in surge channels on the shallow reef.

Chapter 3 Coral 49

Dichocoenia stokesi

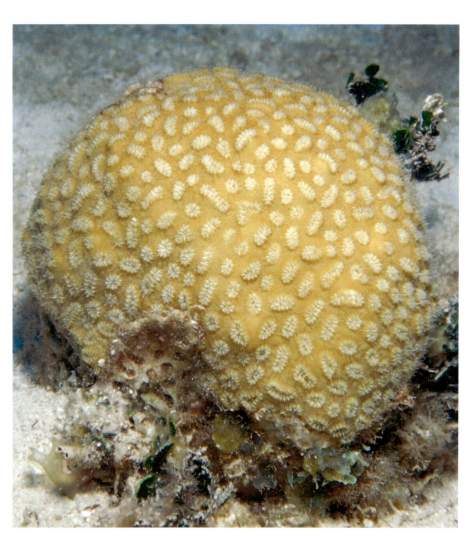

3.94 (right) *Dichocoenia stokesi* forms rounded masses and has distinct, slightly elongated corallites. Size is approximately life-size.

3.95a (below, left) and **3.95b** (below, right) Two examples of *Dichocoenia stokesi*, showing variation in the forming of new polyps. At left they appear to originate between existing polyps. In the specimen at right, polyps seem to elongate and then divide to form new ones. This distinction was once used to define another species, but intermediates are common and more molecular information is needed before the question is settled. Shown about 2-3x life-size.

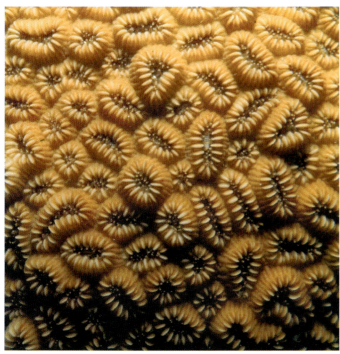

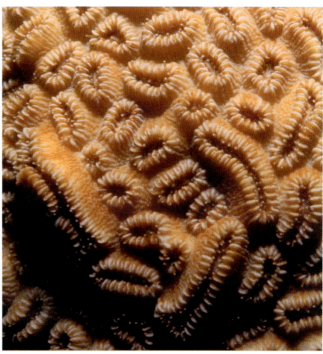

Stephanocoenia intersepta

3.96 (right) The corallite of *Stephanocoenia intersepta* is small and simple and easy to recognize in its shallow reef habitat. There are usually twelve larger septa and twelve smaller ones, and there is a columella that appears as a light dot at the center. This species extends short tentacles in the daytime and withdraws them when touched (as seen here). The brown tissue gives the polyps a dark appearance, allowing the septa to stand out.

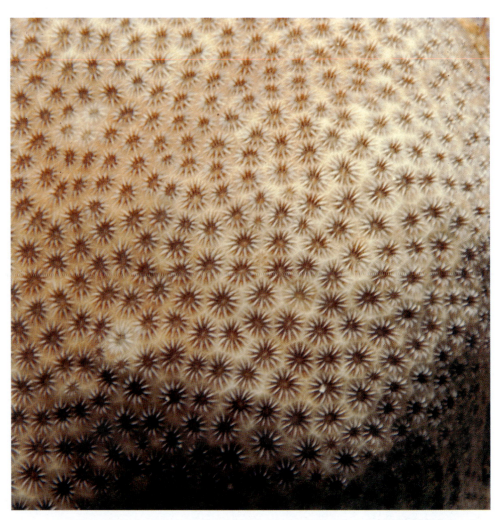

3.97 (below) A close view of the skeleton shows the larger and smaller septa and the columella. Note also the distinct polygonal boundary between corallites, which can also be seen in the live view. The scale bar is .5 cm. Specimen courtesy of Yale Peabody Museum.

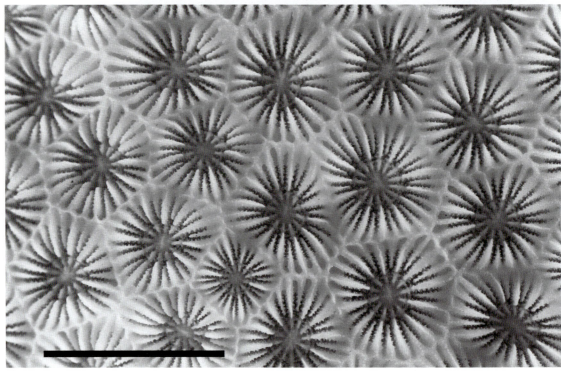

Chapter 3 Coral 51

Siderastrea siderea and *Siderastrea radians*

3.98 (right) *Siderastrea siderea* has small corallites with very many fine septa. The corallites are small deep dimples. This species encrusts or forms pink-tan mounds in shallow water with abundant wave surge.

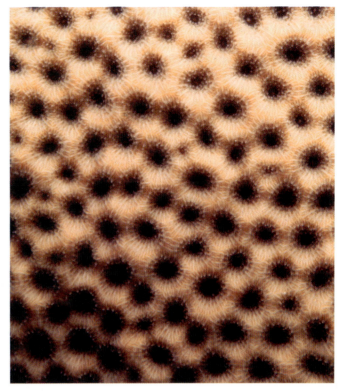

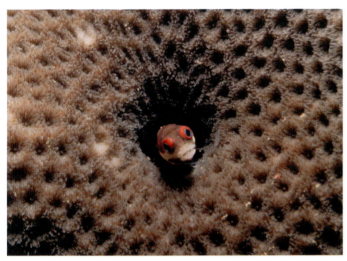

3.99 An *Acanthemblemaria rivasi* peeks out from a hole in a *Siderastrea siderea* colony whose tentacles are extended.

3.100 (right) *Siderastrea radians* has fewer septa. It has a rougher appearance and does not form large colonies. The grains of sand, which are fragments of calcareous algae, pink foraminifera, and coral, give scale.

3.101a (below left) and **3.101b** (below right) Close skeletal views of *Siderastrea siderea* (left) and *Siderastrea radians* (right) show the overall smoother surface and finer, more numerous septa of *siderea*. In *radians*, the septa do not extend as far toward the center of the corallite, making the corallite more open and giving it more of a "bottom". Scale bar is 1 cm.

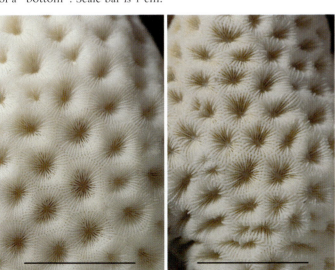

Tubastrea coccinea
(formerly *Tubastrea aurea*)

3.102 (right) The small but distinctive bright orange coral *Tubastrea coccinea* occurs on reefs around the world, and is now thought to be a highly successful invasive species that came to the Caribbean from the Pacific.

It is azooxanthellate: it does not have symbiotic photosynthesizing algae in its tissues. It is also ahermatypic: it does not contribute to building the reef framework. (Some small corals may be zooxanthellate but ahermatypic. They are not synonymous terms.)

Tubastrea coccinea forms bright orange clumps of a few polyps, and is found under overhanging coral plates or as here, on the side of a clump of *Porites porites* at the edge of a vertical wall, where the reef suddenly drops off to deeper water. Also see fig. 7.7.

3.103 Polyps of *Tubastrea coccinea* open at night to catch plankton with tentacles armed with stinging cells. Also see figs. 8.4–8.6.

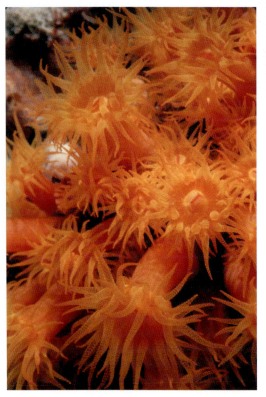

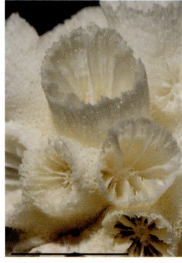

3.104 The skeleton of *Tubastrea coccinea* is delicate and lightweight, constructed with minimal skeletal material. Scale bar is 1 cm.

Chapter 3 Coral 53

Balanophyllia species

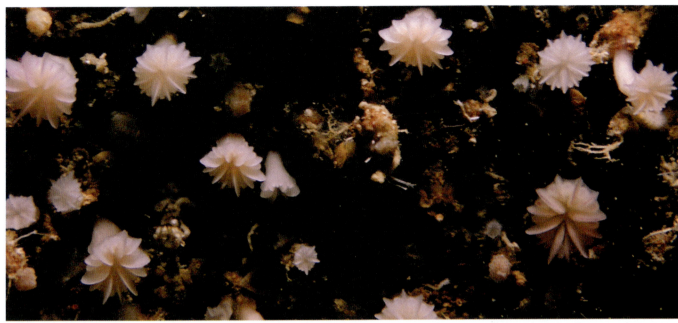

3.105 Up to a centimeter in size, the solitary individuals of *Balanophyllia* species have no symbiotic zooxanthellae, and live in dark places under overhangs and in caves. The six primary septa are prominent. Color can be pink, orange, white, or green.

3.106 Though solitary, *Balanophyllia* can grow in substantial numbers and densities, sharing the substrate with encrusting sponges.

Coral Competition

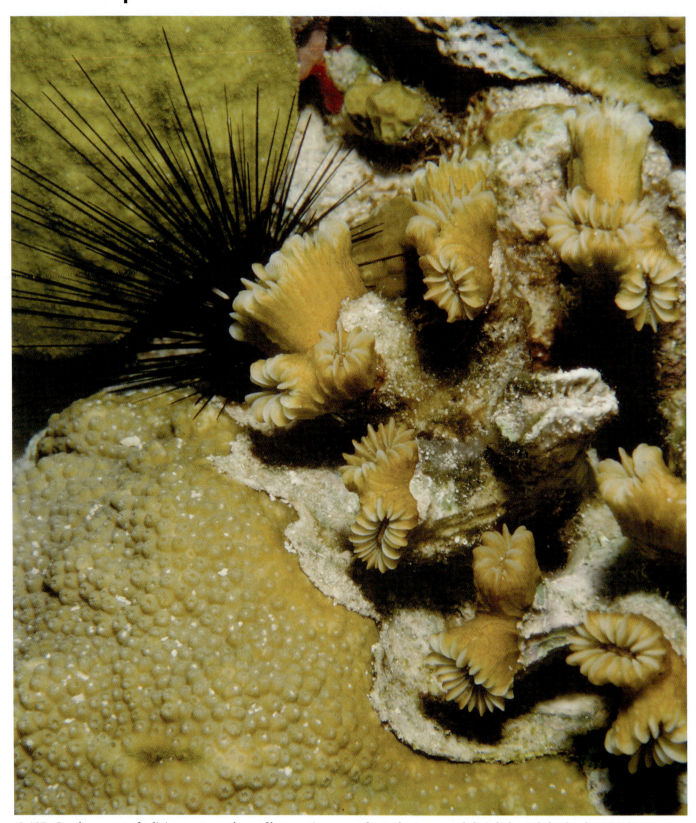

3.107 Corals compete for living space on the reef by growing over other colonies to steal their light and also by direct active aggression toward growing neighbors. Here, a *Eusmilia fastigiata* has attacked and established a killed zone on an *Orbicella annularis*. Corals may attack others by extending digestive mesenterial filaments at night when tentacles are also extended or by using specialized "sweeper" tentacles. There is a hierarchy of aggressive dominance, with some coral species always prevailing over others.

4

4.1 The commensal shrimp *Periclimenes yucatanicus* is immune to the stinging cells of the anemone *Condylactis gigantea*. About 2x life-size.

Invertebrates

There is not a group at any taxonomic level called Invertebrata, but it is convenient to draw a distinction between the vertebrate animals of the reef, the fish, which are relatively familiar to most people, and all the other diverse non-vertebrate groups of animals whose habits and relations are mostly unfamiliar to us. The scleractinian corals of the previous chapter that build the reef are invertebrate animals of the phylum Cnidaria. Other groups of cnidarians and representatives of other invertebrate groups also live in the reef framework, and they give the reef much of its color, activity, and interest. The visual aspects of their design are as striking to us as their modes of life are strange.

Filter feeders collect plankton and other edible particles in the water either passively by entrapping it, as basket stars and crinoids do, or actively, by pumping the water through a filtering structure, as sponges do. Anemones, like corals, capture various sized organisms with special stinging cells on their tentacles. Spiny urchins graze on algae that grows on dead coral. Holothurians, or sea cucumbers, pass sand through their bodies and extract nutrients. Crabs scavenge. Some molluscs are active predators. Some groups have been very successful at making a living on the reef, and that fact is reflected in the number of examples from each group you will see in this section.

A Simple Taxonomy of Reef Organisms

Taxonomy is the branch of biological science that deals with classification of living things into convenient groups, or taxa (singular: taxon). Originally the similarity of physical features defined these groups, but modern taxonomy, while still descriptive, relies on developmental and genetic evidence to classify living species based on their evolutionary relationships and descent from common ancestors. Analysis of DNA and other molecules of living organisms has become the major means of determining evolutionary, and therefore taxonomic, relationships. The traditional Kingdom-Phylum-Class-Order-Family-Genus-Species hierarchical classification has given way to a set of relationships which are not totally different, but, in some details, are based on new criteria. As new evidence is discovered, our view of the branching points in the tree of life change.

Species are formally designated by a binomial, or two-part, name consisting of both a genus and a species name. (The full scientific name also includes the name of the person making the formal description and the year of publication, but they are omitted here.) A newly discovered species may fit neatly into an existing genus or it may define a new genus or higher-level group, even one containing only that single representative if it is different enough. New evidence may justify placing a known species in a different or new group. If new research reveals that a species was described more than once, and therefore has more than one official name, the name given first has priority and must be the accepted name. A famous case is the dinosaur Brontosaurus. Another dinosaur, discovered earlier, had been named *Apatosaurus*. When it was later determined that they were the same species, the name *Brontosaurus* became invalid (except as a common name). Taxonomy is a field of rules and endless debate.

Changes in the understanding of these relationships can also occur for major and fundamental groups. In recent decades new ways of organizing the large, high-level groupings have been proposed, and now five kingdoms of life are generally recognized instead of the traditional two. Further, within the animal kingdom, different characteristics and features of development determine intermediate groupings, designated by 'super', 'sub', or 'infra' added to the basic group name. The pigeonholes of the traditional system do not represent evolutionary relationships well, as they ignore the fact that one group may have evolved from another at the same taxonomic level. For our purposes, the traditional pigeonholes will suffice, but they are only part of the story.

One relatively recent change in our view of these relationships that has an effect on our reef taxonomy is the division of the former phylum Coelenterata into two, Ctenophora and Cnidaria. Another is the distinction made between the Ctenophora and Cnidaria, grouped as the Radiata, and a number of phyla grouped as the Bilateria, including the Echinodermata, which has bilaterally symmetrical larval forms, although most adult organisms appear radially symmetrical.

In spite of recent developments, the concept of the phylum as a major group has remained useful, no matter how these major groups are organized within the animal kingdom. Members of a given phylum may have very different appearances, but usually share common features of their embryonic development, if not their adult form. Inferred relationships between phyla are based on developmental details.

This is all very interesting, but here is the simple part for our purposes: the overall hierarchy of the list on the opposite page is a modern one, but only the groups represented by reef organisms (and a few for reference points) are included, and many taxa both familiar and obscure are simply left out.

This chapter will illustrate the characteristics of these groups with examples seen on the reef, with emphasis on their diversity of structure and lifestyle as well as their position in the taxonomic scheme. We will look first at the cnidarians other than the scleractinian reef-building corals, starting with those that make calcareous skeletons, and then at other phyla found on the reef, in no particular order.

Chapter 4 — Invertebrates

Kingdom Animalia
 Subkingdom **Parazoa** (lack tissues organized into organs; have indeterminate shape)
 Phylum **Porifera** (sponges)
 Subkingdom **Eumetazoa** (have tissues organized into organs and organ systems)
 Radiata (have radial symmetry)
 Phylum **Ctenophora** (comb jellies - have no stinging cells)
 Phylum **Cnidaria** (have stinging cells)
 Class Anthozoa
 Subclass Octocorallia
 Order Alcyonacea (sea fans and sea whips)
 Subclass Zoantharia (or Hexacorallia)
 Order Ceriantharia
 Order Actiniaria (sea anemones)
 Order Corallimorpharia
 Order Scleractinia (stony corals)
 Order Antipatharia (black coral)
 Order Zoanthidea
 Class Scyphozoa (jellyfish)
 Class Hydrozoa (hydroids)
 Bilateria (bilaterally symmetrical animals with three germ layers)
 Phylum **Echinodermata**
 Class Crinoidea (feather stars and sea lilies)
 Class Ophiuroidea (brittle stars)
 Class Asteroidea (sea stars)
 Class Holothuroidea (sea cucumbers)
 Class Echinoidea (sea urchins and sand dollars)
 Phylum **Chordata**
 Subphylum Urochordata (tunicates)
 Subphylum Vertebrata
 Infraphylum Gnathostomata (jawed vertebrates)
 Class Sarcopterygii (lobe-finned fishes and four legged vertebrates)
 Class Actinopterygii (ray-finned fishes)
 Class Chondrichthyes (sharks, rays, sawfish and chimeras)
 Phylum **Arthropoda** (also includes insects, spiders, millipedes, horseshoe crabs, and others)
 Subphylum Crustacea (also includes brine shrimp, copepods, barnacles, etc.)
 Class Malacostraca
 Order Decapoda (crabs, lobsters, shrimp)
 Order Euphausiacea (krill)
 Order Stomatopoda (mantis shrimp)
 Order Peracarida (amphipods, isopods, mysids)
 Phylum **Annelida** (bristle worms, feather-duster worms, and many more)
 Class Polychaeta
 Subclass Palpata
 Order Canalipalpata
 Suborder Sabellida
 Family Sabellidae
 Family Serpulidae
 Phylum **Mollusca**
 Class Bivalvia (clams, mussels, etc.)
 Class Gastropoda (snails, slugs, limpets, nudibranchs)
 Class Cephalopoda (octopus, squid, nautilus, etc.)

Millepora complanata

Hydrozoans

Hydrozoans are cnidarians characterized by small polyps with stinging cells. Many are colonial.

The hydrocorals form a hard calcium carbonate skeleton that contributes to reef building. These include the orders Milliporina and Stylasterina. A third order, the Hydroida, does not make a calcareous skeleton.

4.2 *Millepora* is commonly called fire coral. Though scleractinian corals may irritate human skin if they are touched, their nematocysts do not penetrate it. Those of *Millepora* will penetrate human skin and inject toxins that cause a burning sensation. Upright, smooth flat blades grow up from an initial encrustation and are characteristic of *Millepora complanata*. The coral is *Orbicella annularis*.

Chapter 4 Invertebrates 59

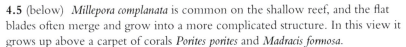

4.3 The close spacing and small size of the individuals give *Millepora* its smooth appearance. The scale bar in this closeup skeleton view is 1 cm.

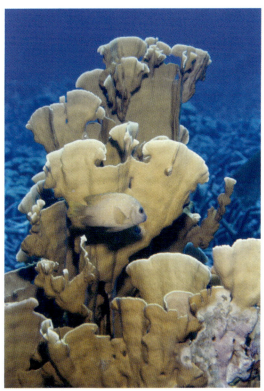

4.4 (above) *M. complanata* grows in shallow water where waves bring plankton to its stinging cells. The brown color is from zooxanthellae in the tissue.

4.5 (below) *Millepora complanata* is common on the shallow reef, and the flat blades often merge and grow into a more complicated structure. In this view it grows up above a carpet of corals *Porites porites* and *Madracis formosa*.

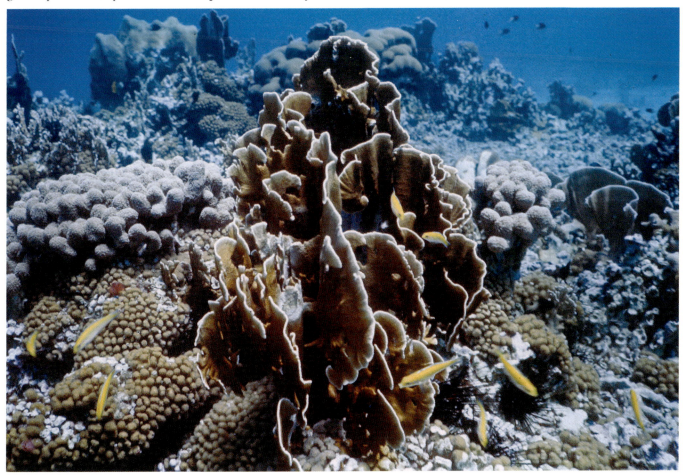

Millepora alcicornis

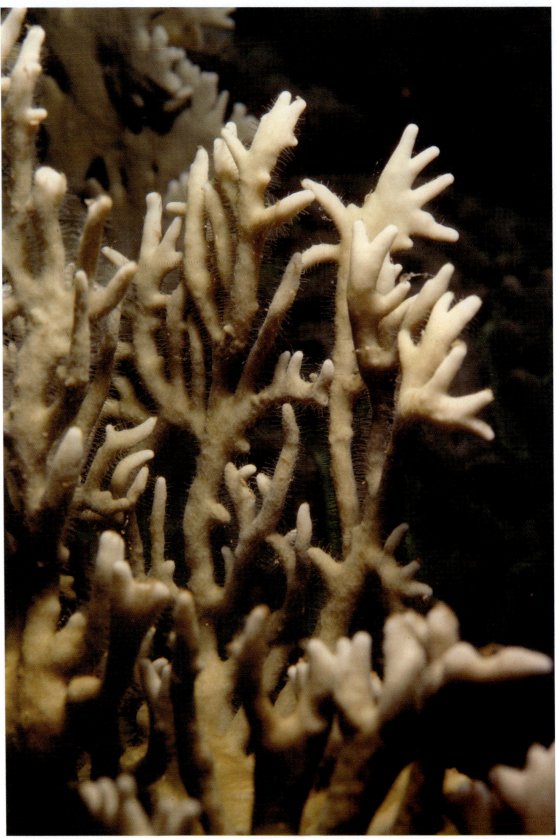

4.6 *Millepora alcicornis* is a branching form. The hairlike stinging cells that cover the surface and wait to inject toxin into plankton or the careless diver are visible against the dark background. This colony is approximately 1.5 times life-size as shown here.

Chapter 4 Invertebrates 61

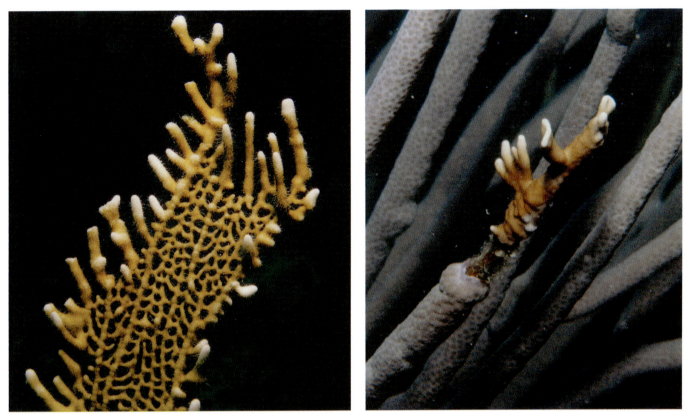

4.7a (left) and **4.7b** (right) Growth of these *Millepora alcicornis* colonies began as an encrustation on a dead *Gorgonia* sea fan and a smooth branching alcyonacean and then assumed the typical upward-growing branching form. Both are close to actual size here.

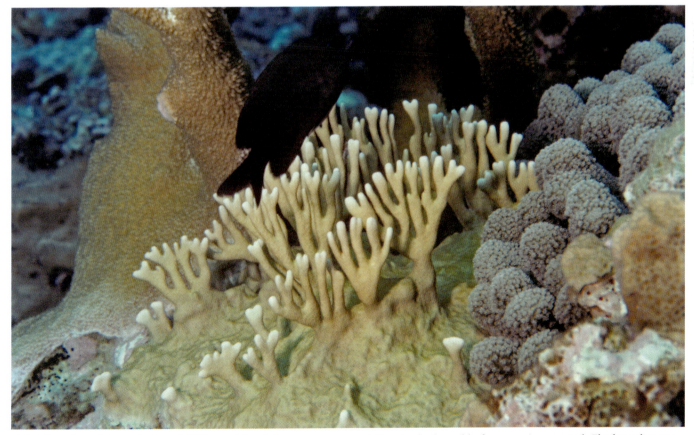

4.8 These branching colonies of *Millepora alcicornis* began as an encrustation on dead coral before growing upward. Flat branches are oriented across the dominant water flow direction to create turbulence that brings plankton into greater contact with the stinging cells.

Stylaster roseus

4.9 *Stylaster roseus* forms small branching colonies in sheltered places such as the undersides of platy corals on the fore-reef slope. The color varies from white to lavender-purple. Shown approximately 2x life-size.

4.10 The lack of brown pigmentation indicates that *Stylaster roseus* does not possess zooxanthellae. The small size and sheltered habitat is consistent with the absence of zooxanthellae, in marked contrast with the milleporas, which grow large in the ample sunlight of the shallow reef top. Shown approximately life-size. See also fig. 3.24.

Hydroids

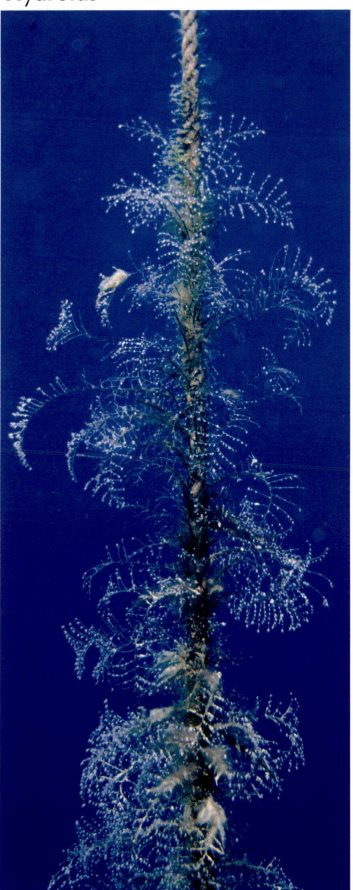

4.11 Hydroids are feathery hydrozoans with stinging cells. These have grown on a buoy anchor rope in open water.

Nomenclature alert: There are doubtless many species of hydroids, but their identification by simple visual observation while diving is beyond the ability of most people, including this author. For non-specialists the term "hydroid" will suffice to identify this group.

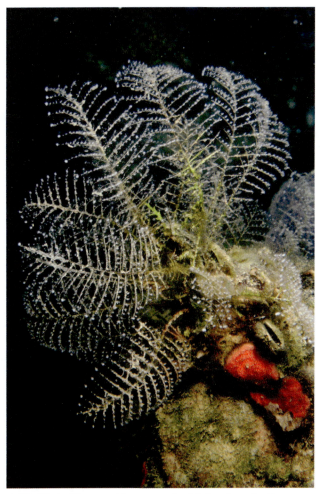

4.12 Hydroids resemble some crinoids (see later in the chapter) in forming a filter fan, but they use stinging cells, not tube feet, to catch plankton. Shown approximately life-size.

Gorgonia species

Alcyonaceans

Many of the most prominent organisms of the shallow reef are members of the order Alcyonacea. These are octocorals, having a symmetry of eight tentacles rather than the six of the stony corals. In the shallow reef their flexible skeletons allow them to follow the wave motion in the same way that trees bend with the wind. The forms vary widely, and some inhabit deeper water on the fore-reef slope. Most of the shallow water species other than *Gorgonia* have a bushy, or branching, though sometimes flattened, form.

Members of the suborder Holaxonia have skeletons formed of horny material called gorgonin, a protein similar to collagen. They are represented here by the genera *Gorgonia*, *Antillogorgia*, and *Pterogorgia*.

All of the alcyonaceans were formerly referred to as gorgonians, although they do not all have skeletons made of gorgonin, so alcyonaceans is a better term for the group in general. Because they do not make calcified skeletons as corals do, alcyonaceans are also referred to as soft corals.

4.13 *Gorgonia* is the sea fan that is often seen dried and rigid in shell shops. In life it inhabits the shallow reef, where wave surge brings food to the polyps that inhabit the interconnected branches. A massive *Dendrogyra cylindrus* fills the background. There are three different species of *Gorgonia*, but two are indistinguishable without microscopic examination. See also figs. 2.4a and 2.4b.

Plexaura homomalla

4.14 *Plexaura homomalla,* an alcyonacean, branches mostly, but not exclusively, in a single plane oriented across the wave surge, functionally similar to the habit of *Gorgonia*. The polyps are brown. They will retract if touched, revealing the black skeletal stalk. The color is diagnostic for this species. In the foreground are *Diploria labyrinthiformis* and *Porites porites*. In the background is *Acropora cervicornis*.

Plexaura flexuosa

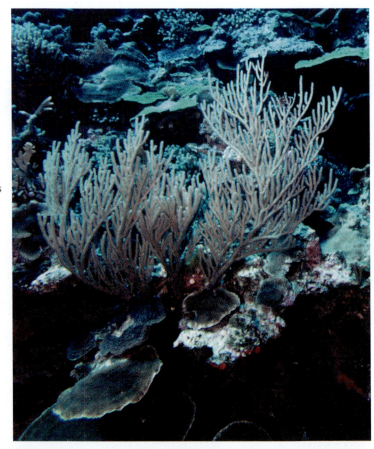

4.15 *Plexaura flexuosa* occurs on the fore-reef slope as well as on the shallow reef. Most alcyonaceans are photosynthetic, and this individual is not as densely branched as the reef-top one shown below.

4.16 *Plexaura flexuosa* forms mostly planar bushes with dense, fine, finger-thickness branches. The stalk as well as the polyps are tan or brown.

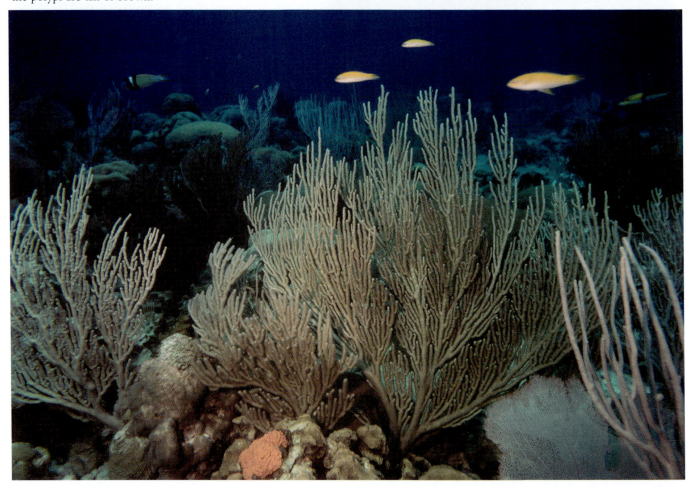

Chapter 4　　　　　　　　　　Invertebrates　　　　　　　　　　67

Plexaurella species

4.17 The characteristic 8-fold tentacle symmetry that defines the octocorals is clear in this close view, approximately life-size, of the end of a *Plexaurella* branch.

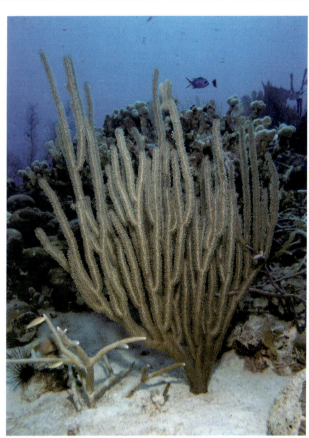

4.18 This *Plexaurella* has longer branches than the individual below, but differentiating species of this genus cannot be done at a distance from overall characteristics.

4.19 *Plexaurella* has larger polyps and thicker branches than the two *Plexaura* species, and also grows in a more bushy, less planar form.

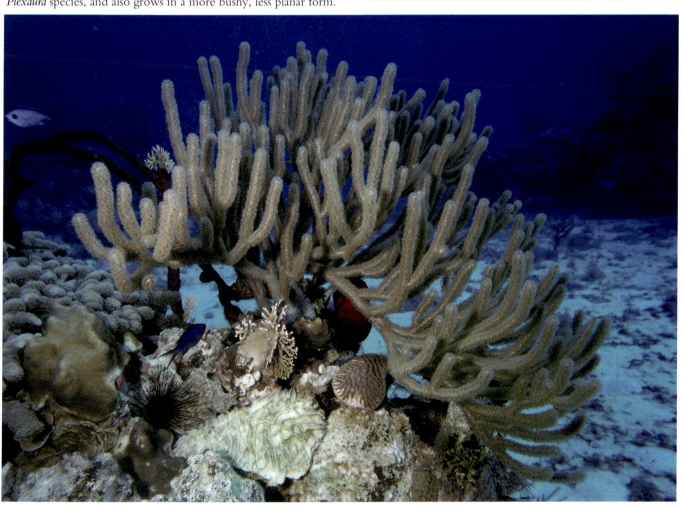

Antillogorgia acerosa (formerly *Pseudopterogorgia acerosa*)

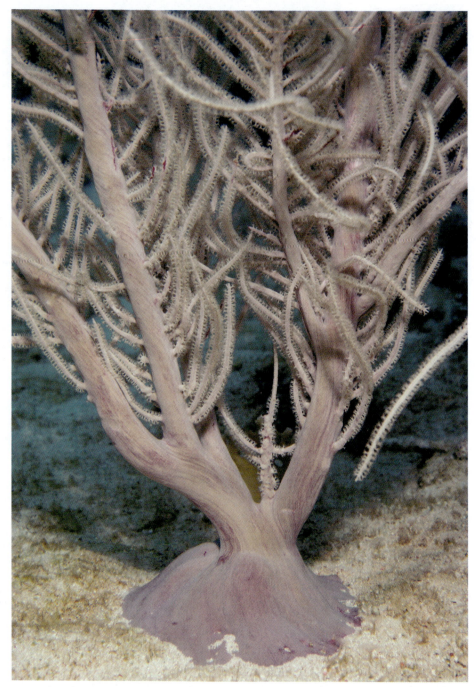

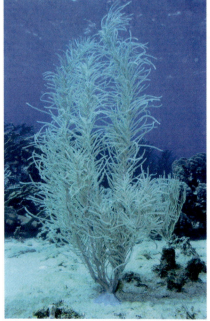

4.20 This close view of the base of a large *Antillogorgia acerosa* also shows the polyps and the arrangement of the branches and branchlets. Although the bottom appears sandy, the base is firmly attached to hard reef rock below a thin veneer of shifting sand. The related species *Antillogorgia americana* is similar but notably secretes large amounts of mucus.

4.21 The same 2-meter individual as in 4.20 seen at a distance. The tall bushy appearance of this gorgonian alcyonacean is characteristic.

Antillogorgia bipinnata (formerly *Pseudopterogorgia bipinnata*)

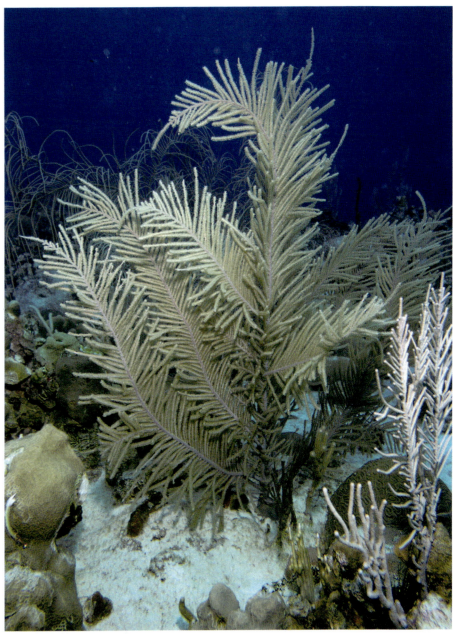

4.22 *Antillogorgia bipinnata* is another gorgonian of the shallow reef with a very bushy appearance, but the branchlets are arranged on opposite sides of the branches in a single plane, like pinnules of a feather.

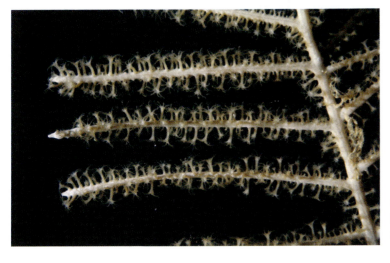

4.23 Polyps on the branchlets of *Antillogorgia bipinnata* form an effective plankton filtering mechanism. About life-size.

Pterogorgia guadalupensis

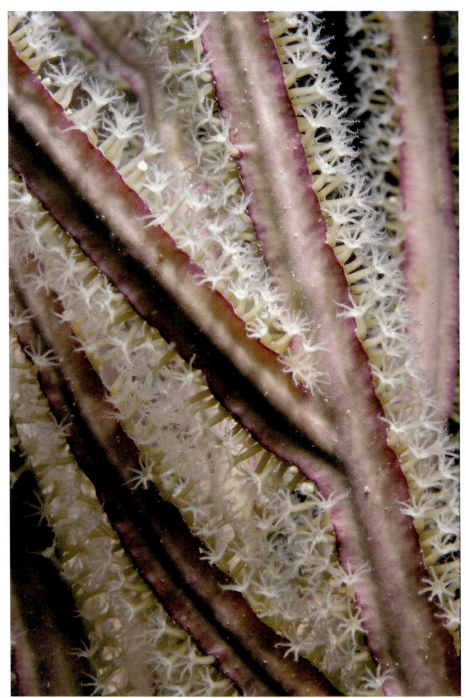

4.24 The branches of *Pterogorgia guadalupensis* are flattened in the same plane as the overall growth form, and the polyps grow out from the edges of the branch. A related species, *Pterogorgia citrina,* has similarly flattened branches but is generally smaller in overall size and yellow in color.

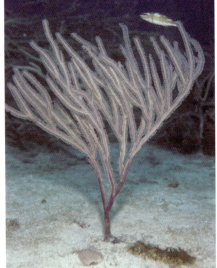

4.25 *Pterogorgia guadalupensis*, like many other alcyonaceans, assumes a planar form.

Briareum asbestinum

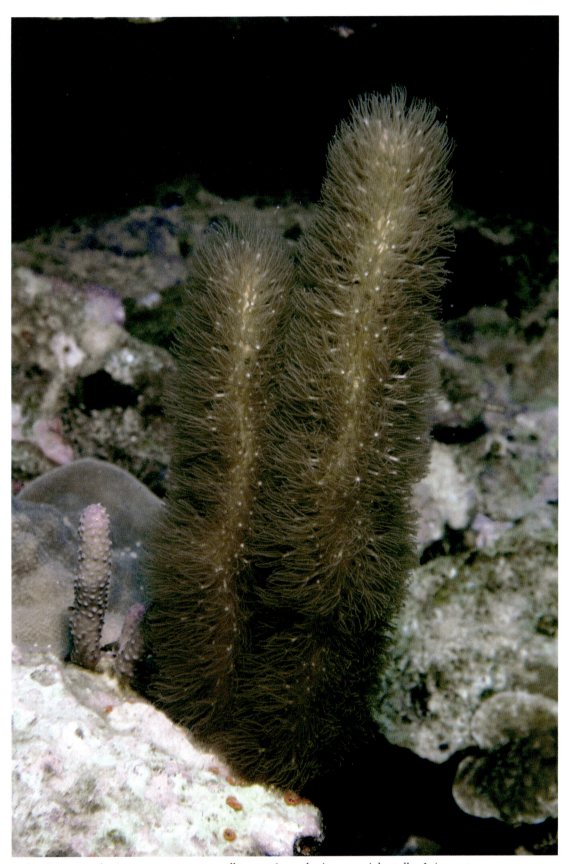

4.26 *Briareum asbestinum* may occur as small encrusting colonies or upright stalks. It is most common on coral rubble and in back-reef localities. The polyps are large and slender with long thin tentacles and easily move in unison with water movement. This view is close to actual size.

Iciligorgia schrammi

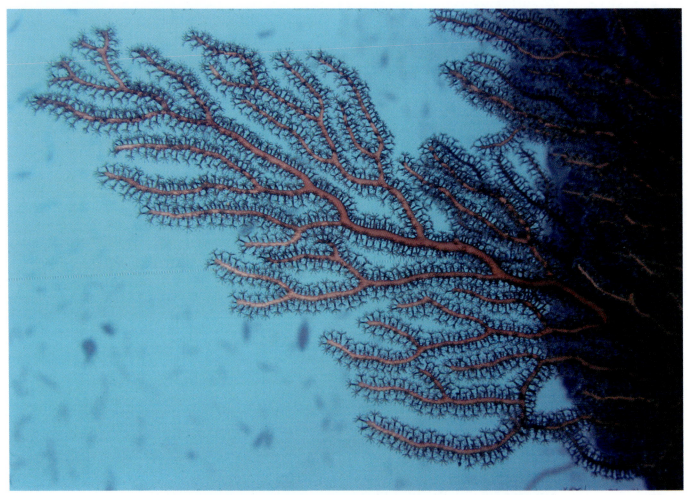

4.27 The robust fan-shaped skeleton of *Iciligorgia schrammi* is well adapted to protrude into strong currents that may occur where the deeper parts of the reef meet open water. It is a little smaller than actual size in these views. Also see fig. 7.1.

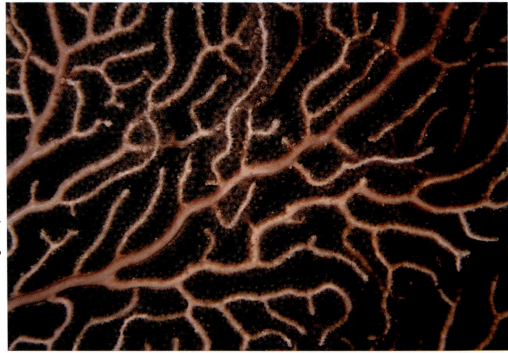

4.28 The skeleton of the alcyonacean *Iciligorgia schrammi* grows in a single plane and branches so that plankton-grabbing polyps along the edges fill the spaces between branches. It occurs on steep slopes, vertical walls, and under coral overhangs.

Chapter 4 — Invertebrates — 73

Antipathes species

Antipatharians

Antipatharians resemble bushy alcyonaceans and also have a hard but not calcareous skeleton similar to that of alcyonaceans, but they are hexacorals. As a group they are at the same taxonomic level as alcyonaceans and scleractinians (see p. 57).

The skeletal material of this and related "black corals" has been prized for jewelry, leading to overharvesting and protection under the Convention on International Trade in Endangered Species (CITES).

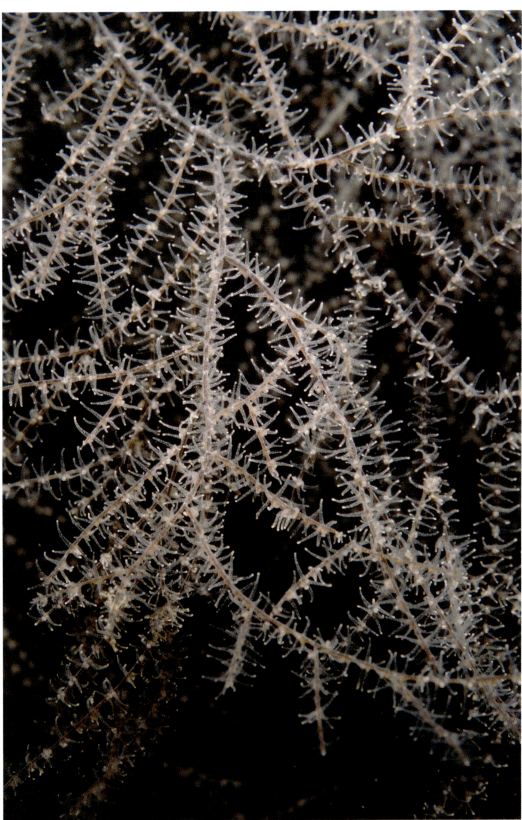

4.29 *Antipathes* inhabits deeper parts of the reef. It does not have zooxanthellae and must use stinging cells on its tentacles to catch its food. This example is probably *Antipathess atlantica*. Exact identification depends on microscopic examination of spines on the stalk in addition to overall form and color. This view is magnified 3 to 4 times actual size.

Condylactis gigantea and *Periclimenes yucatanicus*

Anemones

Sea anemones are members of the group Actiniaria, which is at the same taxonomic level as the Scleractinia, or stony corals, and the Antipatharia, the black corals. These groups are at the order level, as are the alcyonaceans, which are in a different subclass. See p. 57 for the taxonomic relations.

Anemones are entirely soft-bodied, and follow the basic polyp body plan of a central mouth surrounded by tentacles with stinging cells. The larger ones entrap fish, using the stinging cells of many tentacles to disable their prey. Commensal fish and shrimp that are either immune to the stinging cells or do not trigger them live among the tentacles, protected from predation by bigger fish that are not immune to the stings.

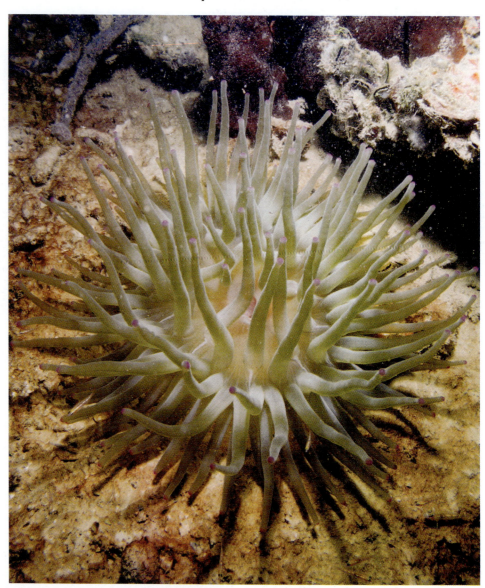

4.30 *Condylactis gigantea* is large and common on the reef. The tentacles are about as thick as fingers and are held up to trap passing fish that venture too close.

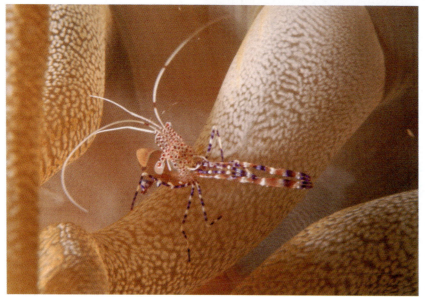

4.31 The commensal shrimp *Periclimenes yucatanicus* lives with this *Condylactis gigantea*. It cleans parasites and dead tissue from fish that it attracts with its white antennae, easily spotted from a distance; the anemone gives protection from would-be predators. It is possible that some prey for the anemone might be attracted by the cleaner. This is a detail of fig. 4.1.

Bartholomea annulata and *Periclimenes pedersoni*

4.32 The stinging cells of *Bartholomea annulata* form a spiral pattern on otherwise nearly transparent tentacles, and the body and central mouth are usually hidden away in a crevice. The commensal shrimp *Periclimenes pedersoni* is often found associated with this anemone. Like *P. yucatanicus,* it is a cleaner.

4.33 *Periclimenes pedersoni* can be enticed to see if there is anything to be cleaned from a finger, which also gives scale. It is not limited to associating with *B. annulata*, and can be seen on other anemones.

Stichodactyla helianthus

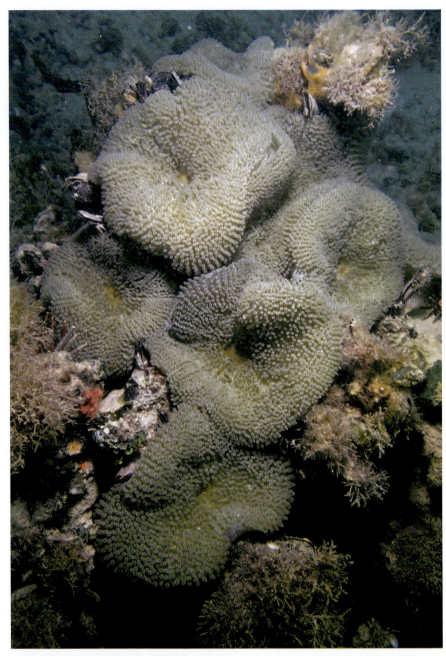

4.34 *Stichodactyla helianthus* is a fairly common anemone of shallow water and often occurs in dense clusters covering large areas. It has hundreds of short tentacles and is green to brown in color. This view is approximately half actual size.

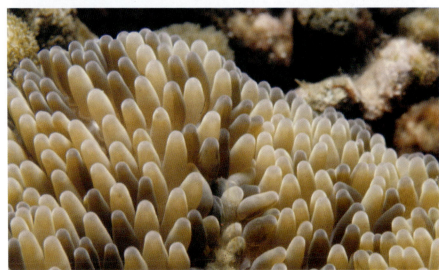

4.35 A close view shows the short, stubby tentacles of *Stichodactyla helianthus* and also the variability in color that may occur. This view is approximately twice actual size.

Telmatactis species

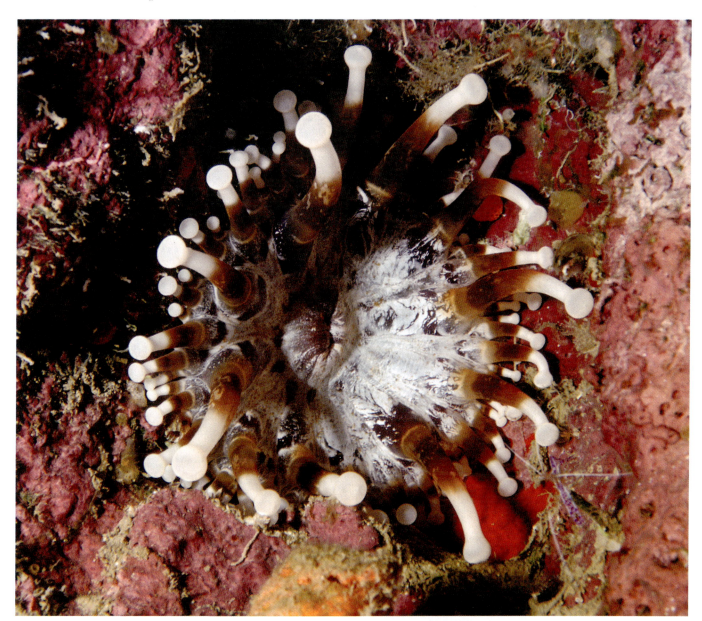

4.36 This anemone may be *Telmatactis cricoides* but the white tentacle tips are not known in this species. Since new species descriptions circulate very slowly outside of specialists' circles, it is possible that this is a newly described or even an as-yet undescribed species. This individual was seen on a deep vertical wall (indicated by the red calcareous algae) and is shown larger than actual size. Note the presence of a *Periclimenes pedersoni* shrimp, slightly out of focus, in the lower right.

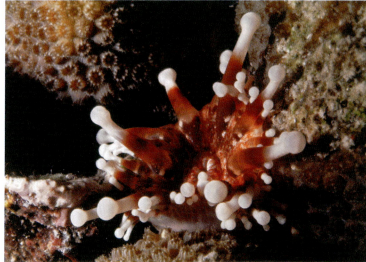

4.37 Another *Telmatactis sp.* individual, photographed at night on a moderately shallow reef top. Note the *Orbicella annularis* characteristic of this reef zone.

Discosoma neglecta

Corallimorphs

Another group at the same taxonomic level as anemones and stony corals is the Corallimorpharia. Corallimorphs are very similar to anemones in being soft bodied, but they have very short tentacles and flattened tops resembling fungus. They also resemble solitary corals and, when occurring in groups, colonial corals.

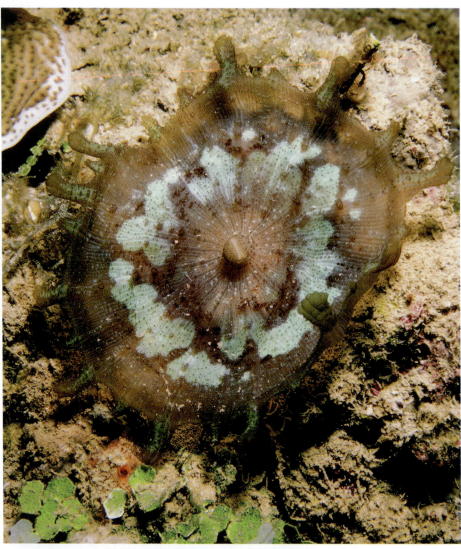

4.38 *Discosoma neglecta*, shown slightly larger than actual size, occurs alone or in small numbers. The projections from the margin of the oral disk are characteristic of this species.

4.39 Another example of *Discosoma neglecta* shows similar coloration but different size and pattern of spots on the oral disk. The corallimorphs seem to be well adapted to settling and growing on dead coral and otherwise disturbed spots on the shallow reef.

Rhodactis sanctithomae

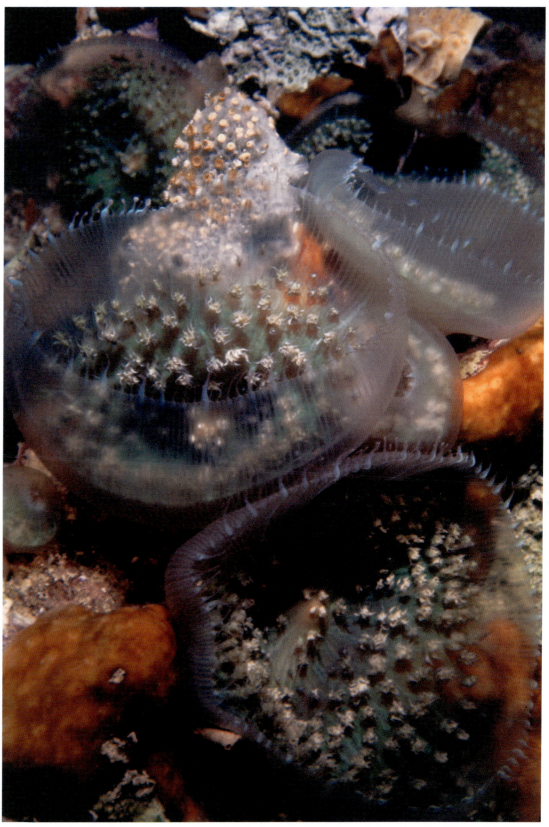

4.40 *Rhodactis sanctithomae* is common on mixed substrates in relatively sheltered parts of the reef. It has zooxanthellae to contribute to its nutrition. The polyp-like bumps are not true polyps, but surround a central mouth on the oral disk. The transparent margins of the oral disk are characteristic. These are shown slightly larger than actual size.

Zoanthus pulchellus

Zoanthids

Yet another order of hexacorals is Zoantharia. The zoanthids' main differentiating characteristic is that the tentacles are arranged in two distinct rows. They are mostly small and colonial.

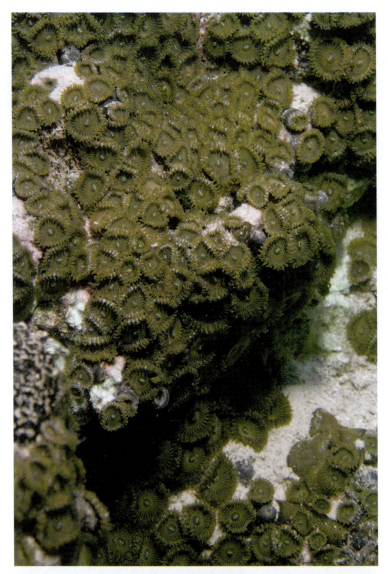

4.41 *Zoanthus pulchellus* grows in extensive colonies on the shallow reef top and fore-reef slope. The oral disk of each individual is approximately 1.5 cm wide. The color is variable and ranges from the green of this group to the blue shown below.

4.42 *Zoanthus pulchellus* is an aggressive competitor for space on the reef. This colony is overgrowing both *Agaricia agaricites* and *Orbicella franksi*.

Chapter 4 Invertebrates 81

Umimayanthus and *Parazoanthus* species

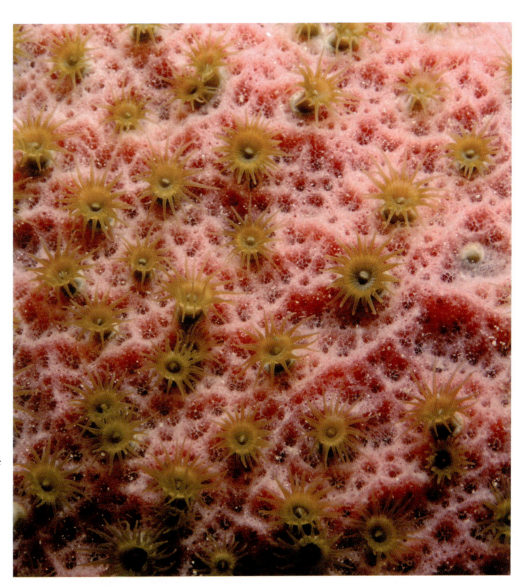

4.43 Small zoanthids are commonly found living symbiotically on sponges. These appear to lack white columns due to calcareous and sand encrustations, which *Umimayanthus parasiticus* (formerly *Parazoanthus parasiticus*) commonly have, but otherwise appear to be the same. See fig. 4.56.

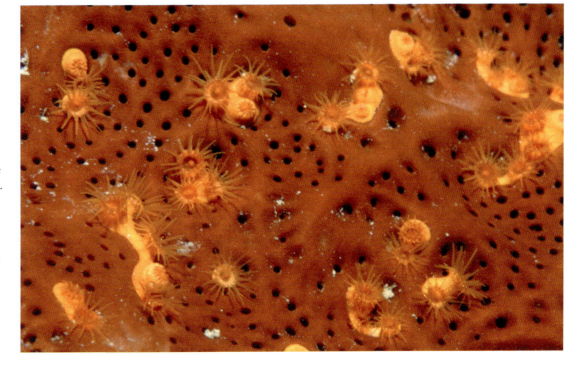

4.44 These bright yellow zoanthids that dot the surface of a smooth brown sponge are *Parazoanthus swiftii*. They are toxic to fish and deter predation on the sponge, and they benefit from the microcurrents that the sponges generate to extract food from the water. This and the view above are 3 to 4 times actual size.

Arachnanthus nocturnus

Cerianthus

The last group of anthozoans we will look at resembles and is at the same taxonomic level (order) as the actinarians, or anemones (See p. 57. Also see fig. 8.7.)

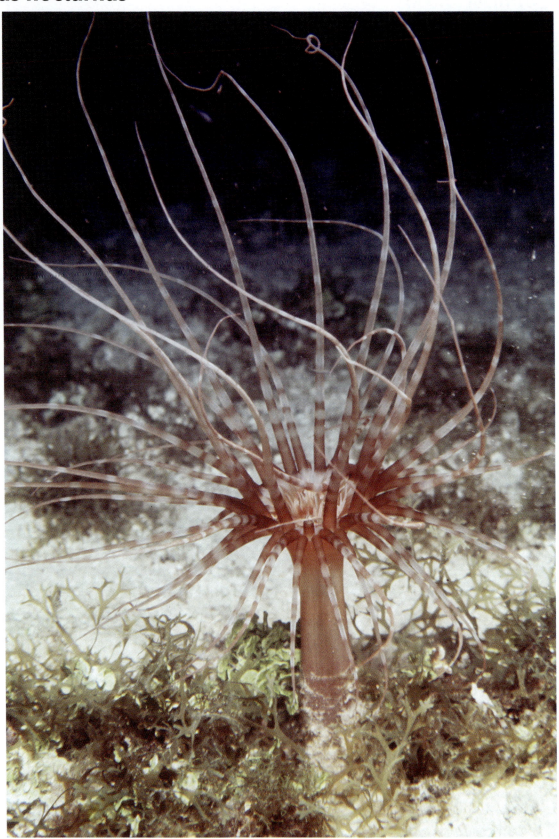

4.45 This cerianthus was photographed at night and is shown approximately life-size. It is hidden during the day in a tube in the sandy parts of the reef. It extends its stalk and long tentacles to feed on plankton at night. When extended, it is very light sensitive and will begin to curl up its tentacles if a light is shined on it.

Chapter 4 Invertebrates 83

Cassiopea species

Scyphozoans

The scyphozoans, or jellyfish, are free-living cnidarians that have tentacles hanging down around a central mouth on the underside of the main body, or bell.

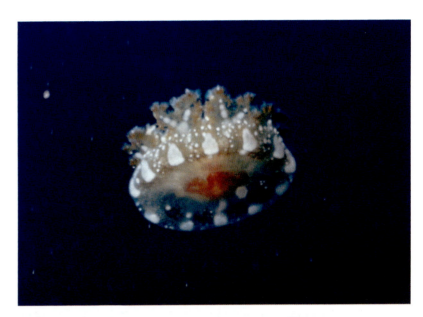

4.46 The only representative of Class Scyphozoa we will look at before leaving the cnidarians is *Cassiopea*, a jellyfish that, unlike others, swims with its tentacles facing up and its bell on the underside.

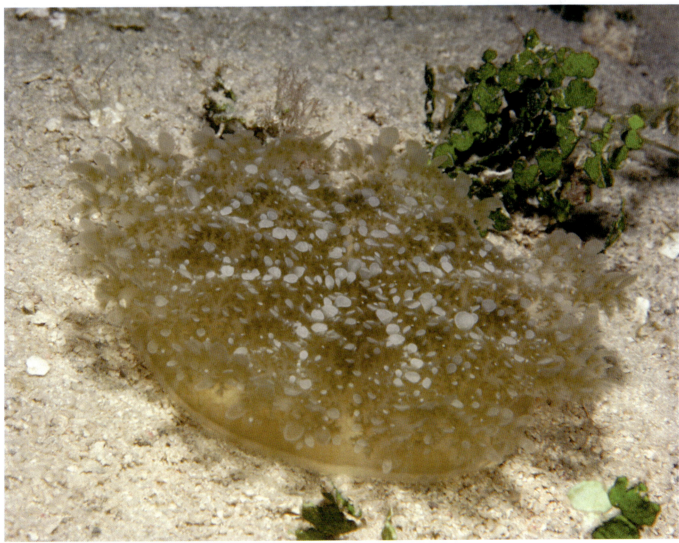

4.47 Though more common in sheltered lagoons and backreef environments, *Cassiopea* can also be seen on the reef. It swims but settles on the sandy bottom to catch passing food. Though from a different group, when on the bottom it assumes the lifestyle of an anemone. It also derives some nourishment from zooxanthellae. Slightly larger than actual size.

Amphimedon compressa (formerly *Haliclona rubens*)

Sponges

Here are a few of the many sponges, members of the phylum Porifera. Sponges get such a high-level classification because they are so different from other animals. They do not move, and do not even have parts that move visibly. They derive nutrition by using microscopic organelles to move water through their tissue and by filtering plankton from it. The outer surface is the source, and water exits from one or more openings, called oscules. Often the overall structure is a tube, with the opening being the outlet.

As one example of potentially useful substances made by reef organisms, a chemical produced by some sponges has been shown in laboratory experiments to be able to make antibiotic-resistant bacteria vulnerable to antibiotics again, a discovery with enormous possible benefits.

Sponge identification is the province of specialists, and names are subject to change, but those shown here are fairly reliably recognizable.

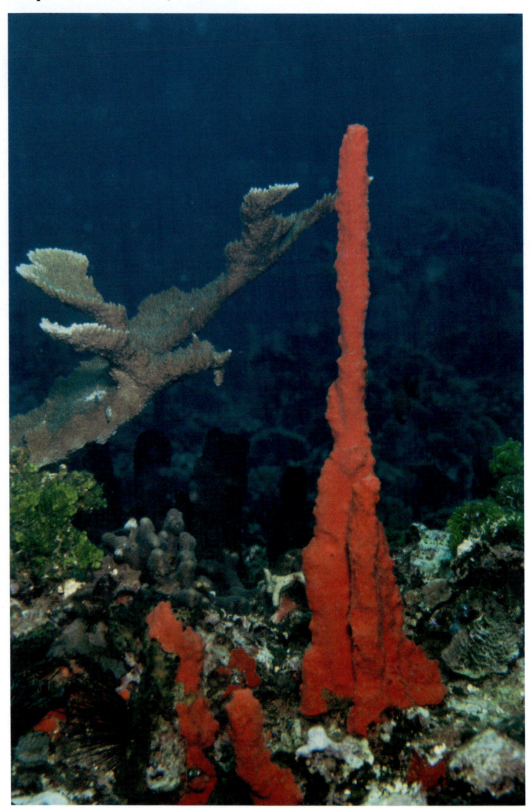

4.48 *Amphimedon compressa* is probably the easiest sponge to recognize because of its bright red color and upright stature. As is often the case in nature, the red color is a warning that the sponge tissue contains toxic or at least irritating compounds. It is best not to touch any reef organisms, but sponges especially should be avoided. This and many other sponges contain halitoxin, which is toxic to fish and was first extracted from this species. This example stands about a meter tall.

Aplysina archeri (formerly *Verongia archeri*)

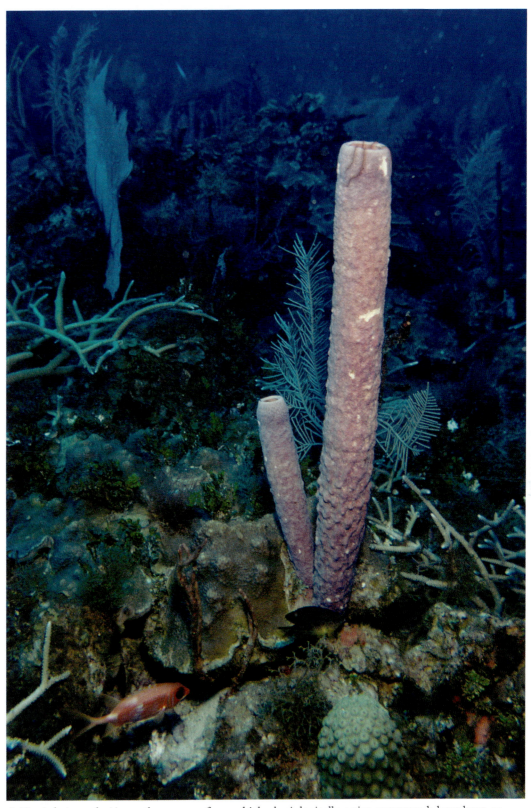

4.49 *Aplysina archeri* is another sponge from which physiologically active compounds have been extracted. The usual form is a group of tubes that can be over a meter tall; color may vary from a lavender to purple, and there are more or less pronounced bumps on the surface, often much more pronounced than in this example. A variant, possibly a different species, has a smoother outer surface and reddish-brown tubes, with distinctly yellower insides than outsides.

Xestospongia muta

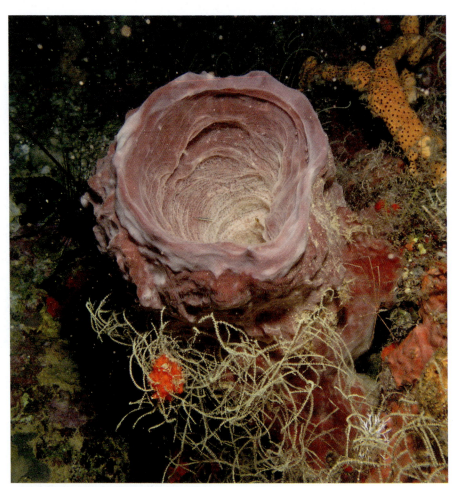

4.50 The barrel shape and large size of *Xestospongia muta* makes it fairly unmistakable. The color is brown to reddish purple. The outer surface is very irregular, and there are often rough projections on the surface. The yellow antipatharian in the bottom of the picture is probably *Antipathes robusiformis*. Also see fig. 7.8.

4.51 *Xestospongia muta* can be found on the reef top, but these examples live on the reef slope. This one is almost a meter high.

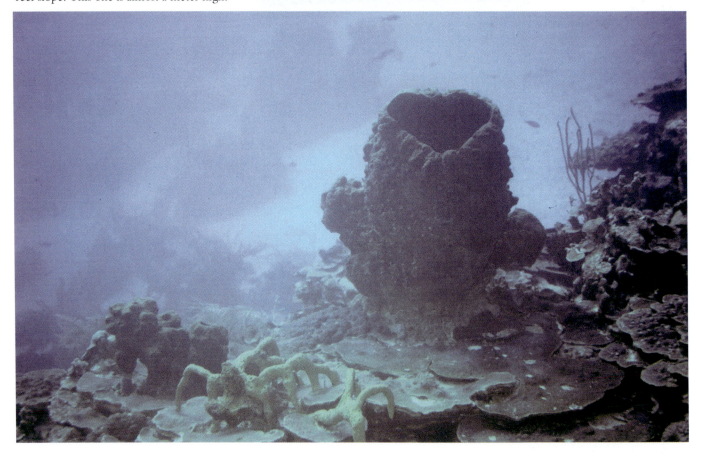

Niphates digitalis (formerly Gelliodes digitalis)

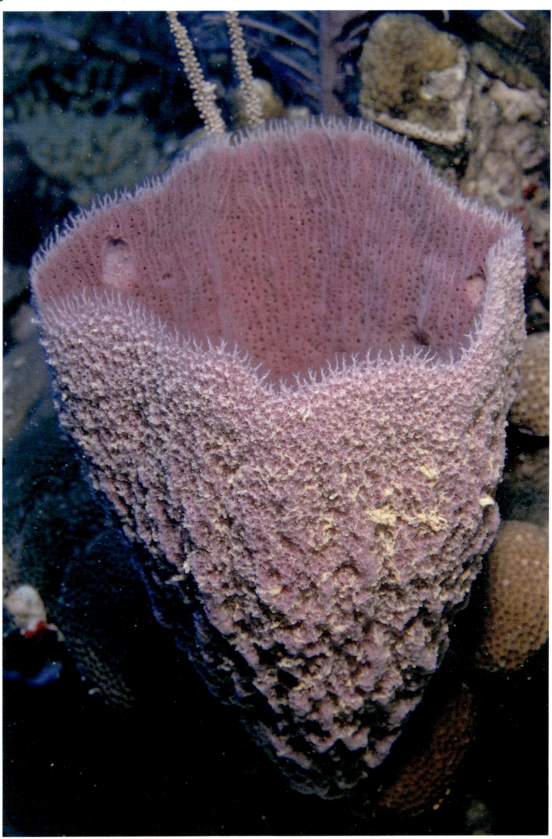

4.52 *Niphates digitalis* assumes a tube, or in this case, vase shape and grows to a third of a meter tall. The color ranges from gray to the lilac or light purple of this example. The diagnostic feature is the edge of the opening, which has thin projections supported by a transparent membrane. About actual size.

Ectyoplasia ferox

4.53 *Ectyoplasia ferox* may occur as an encrusting or massive sponge. It is typically dark orange or brown with brighter yellow or orange around the exhalant openings, or oscules, which may have transparent collars. The scale shown by the agariciid corals at the left and right indicates that the oscules are well under 1 cm in diameter.

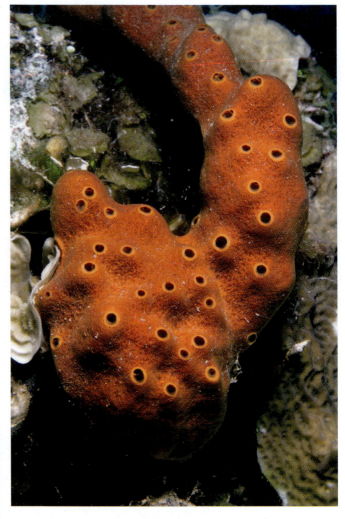

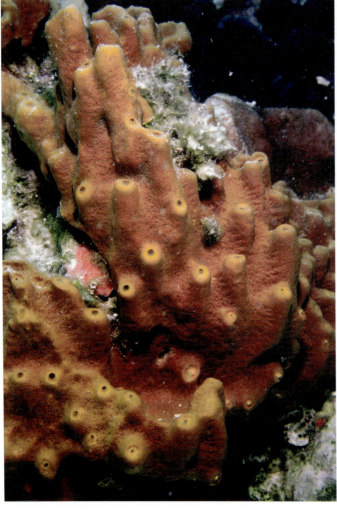

4.54 The oscules of *Ectyoplasia ferox* may terminate short cylindrical projections as in this example, or mere bumps as in fig. 4.53. They may be arranged in connected rows or randomly.

Chapter 4 Invertebrates 89

Callyspongia vaginalis

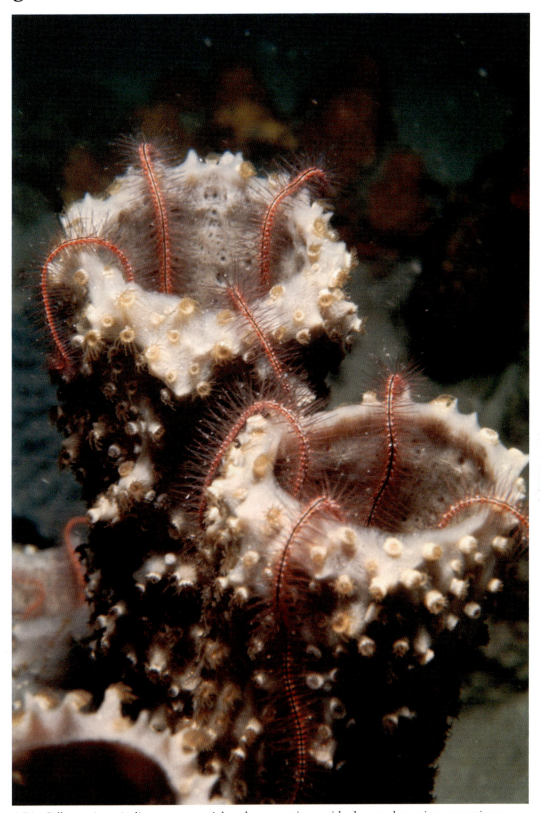

4.56 *Callyspongia vaginalis* occurs as upright tubes, sometimes with elongated openings, sometimes arranged as a fan. It is typically grey, but can also be pink, lavender, brown, tan, yellow, or green. The surface texture may consist of conules, or cone-shaped projections, though they are obscured in this example covered with *Umimayanthus parasiticus* zoanthids. Here, the tubes provide a daytime hiding place for two ophiuroids, or brittle stars, *Ophiothrix suensonii,* which are active at night.

Ircinia species

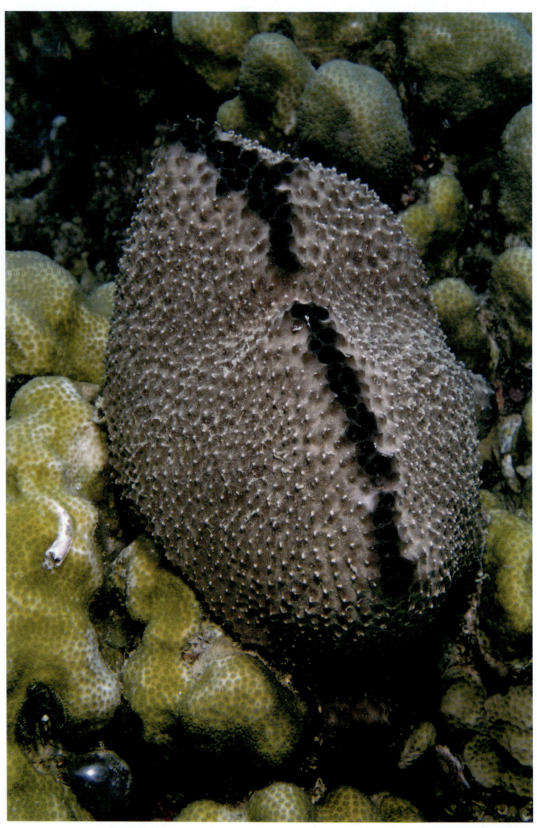

4.57 It is surprising that this rather distinctive sponge is one of several *Ircinia* species that still await formal descriptions and naming, but such is the field of taxonomy. This is referred to as *Ircinia species 1*. It assumes a massive form up to 30 cm or longer and has a surface made up of coarse conical bumps, or conules. The distinctive feature is the arrangement of oscules in one or more rows on the top surface.

Chapter 4	Invertebrates	91

Ircinia strobilina

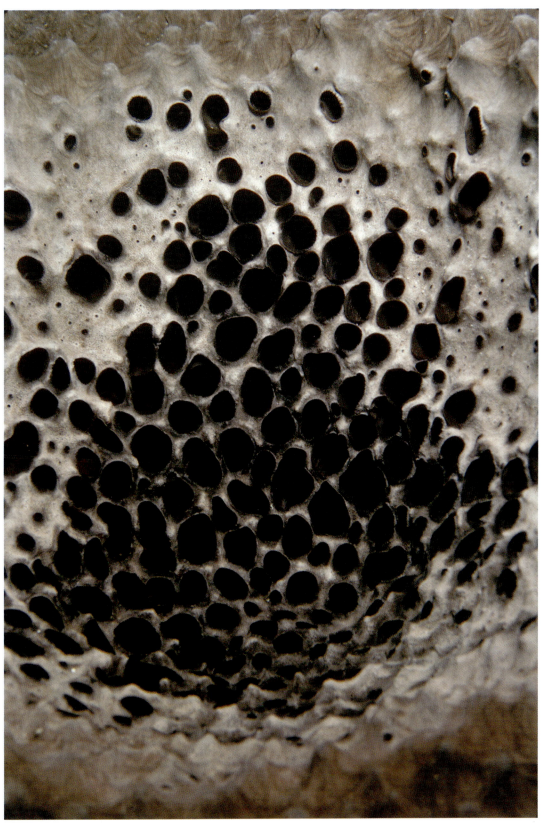

4.58 This close view of *Ircinia strobilina* shows its distinctive grouping of oscules in a depression on the upper surface. Like *Ircinia species 1*, its growth form is massive, and it grows to around 30 cm. It is also tan or grey to black in color. The large conules forming the surface are visible only at the top of this view. See fig. 4.60 for another example. *Ircinia sp. 1* was for a time considered a growth form of *Ircinia strobilina*.

Cliona delitrix

4.59 *Cliona delitrix* is an aggressive boring sponge that dissolves the calcium carbonate of corals on which its larvae settled. It creates galleries into which the sponge grows, and usually kills the coral it overgrows. It has prominent exhalant openings and is often dotted with *Umimayanthus parasiticus*. An *Anamobaea orstedii* sabellid worm (p. 104) also lives on the host coral.

Iotrochota birotulata

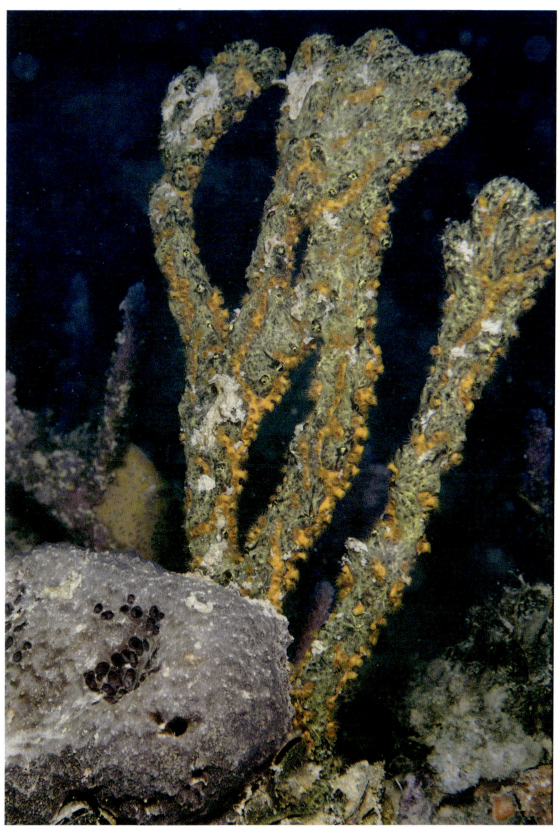

4.60 *Iotrochota birotulata* can be small and encrusting or upright and elongated, as is this example, with branches up to 5 cm thick. It is not tubular, and has oscules all over its irregular black and green surface. Winding rows of *Parazoanthus swiftii* are almost always present. An *Ircinia strobilina* is in the foreground.

Mycale laevis

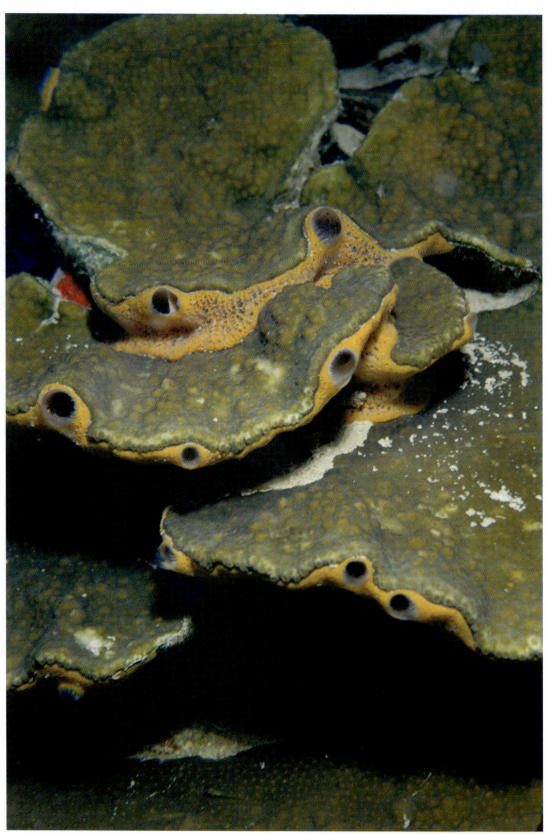

4.61 The undersides of these plates of *Orbicella franksi* are encrusted with *Mycale laevis*. The texture, yellow color, large exhalant openings with transparent white collars, and its location are diagnostic. The sponge affects the growth of the coral plate and also protects its underside from boring sponges.

Clathria curacaoensis

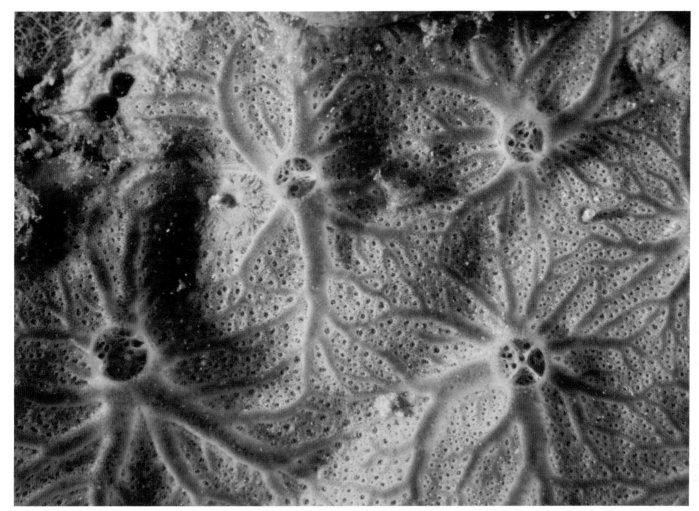

4.62 *Clathria curacaoensis* is an encrusting sponge found in protected places such as under coral overhangs. It is only known from Curaçao, where this was photographed, and nearby Bonaire. It can be yellow or grayish purple. In the Bahamas a similar species is found, *Clathria venosa,* which has a whitish transparent skin over red tissue. This view is about 2-3x life-size.

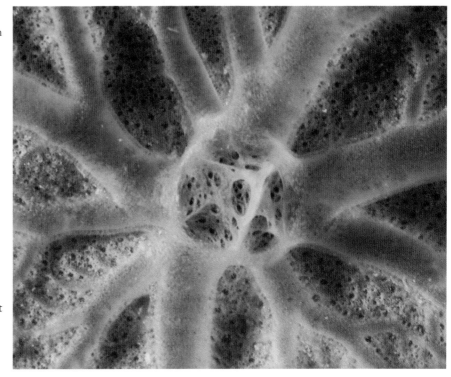

4.63 This view of *Clathria curacaoensis* at about 5x life-size shows the underlying structure and the details of the channels leading to the oscule.

Halisarca caerulea

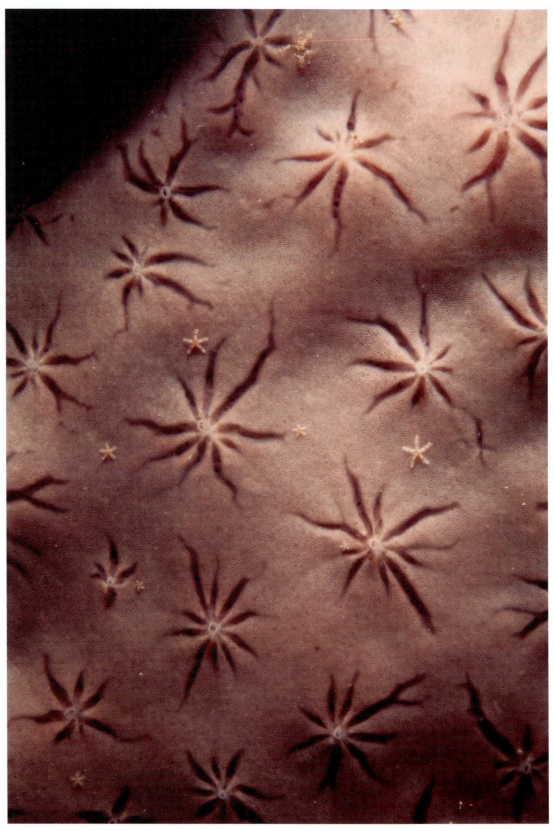

4.64 *Halisarca caerulea* encrusts in sheltered areas under coral projections. Water enters small openings on the smooth space between the oscules, to which it is carried by the radiating channels. The color and texture are diagnostic. Ophiuroids begin their association with sponges at an early age. About 2x life-size.

Monanchora arbuscula/barbadensis

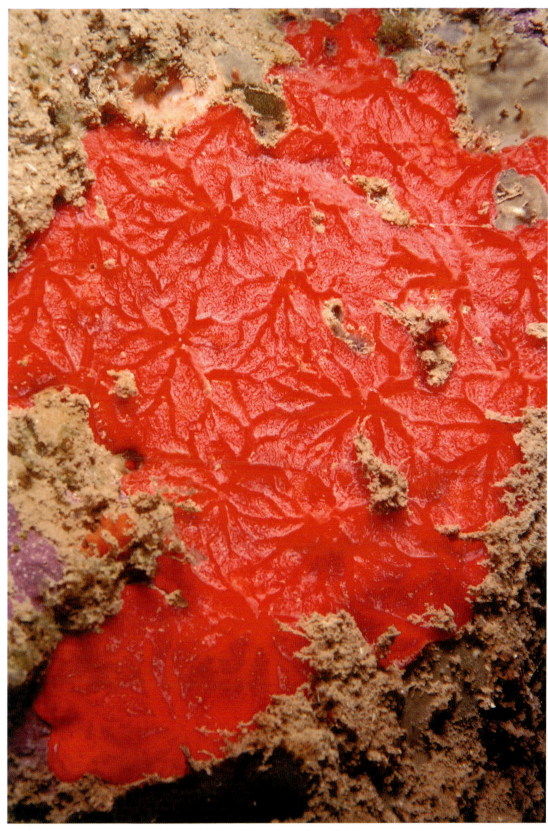

4.65 This red sponge with white mottled surface and radial canals leading to oscules encrusts surfaces under overhangs. Both this and a bushy form have been called *Monanchora arbuscula*. Some experts consider this a separate species, *Monanchora barbadensis,* others just a variant growth form. About life-size.

Diplastrella megastellata

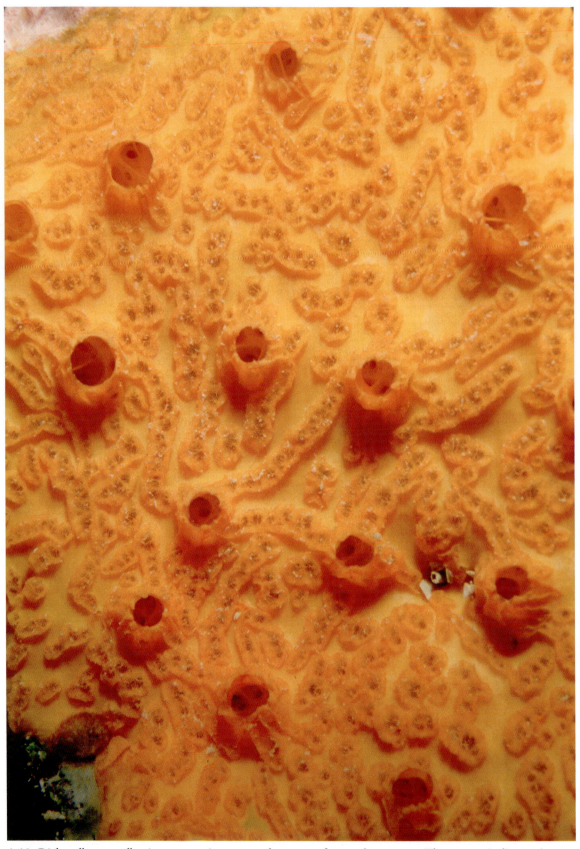

4.66 *Diplastrella megastellata* is an encrusting sponge that ranges from red to orange. The texture is diagnostic: larger oscules and raised canals protrude from a very smooth appearing surface. About 2x life-size.

Clathrina species

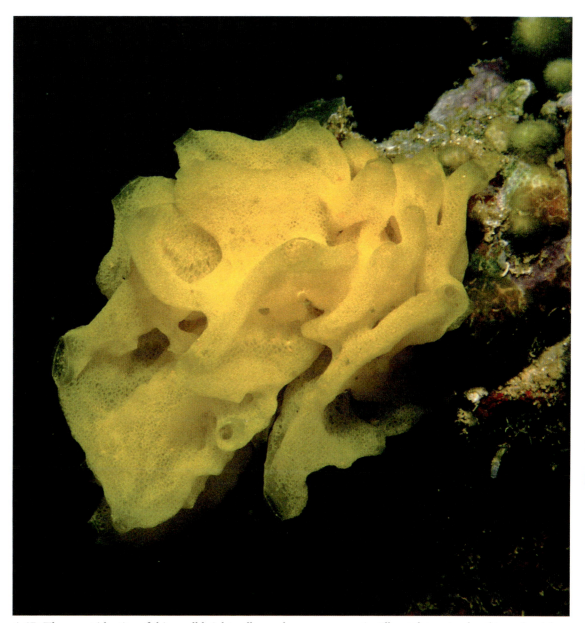

4.67 The exact identity of this small bright yellow calcareous sponge is still not determined and is under debate by experts. Some call it *Clathrina canariensis*, which is a species known from the Canary Islands and recorded from the Gulf of Mexico, but others assert that it is different and refer to it as *Clathrina species 2*.

Reminders: First, taxonomy is a continually evolving effort. The organisms studied do not change (not in our time scale), but the exact details of their relationships do as researchers use newer tools to study both recent specimens and old ones in museum collections. This often results in assignment to a different group or a change of its formal name. This is a formal business. Names like "pink vase sponge", in common use by enthusiasts, while not subject to formal change, are imprecise. In fact, the pink vase sponge is often grey. Using the scientific name forces us to look at the actual characteristics of the organism that make it unique.

Second, this catalogue of reef life is far from complete. If you encounter something you don't find here (and you will), but you haven't got an expert in the field handy to ask about it, consult several of the available internet resources. They will not all agree, partly because of the fluidity of taxonomy, and partly because some of them are maintained by non-professionals, which is what I am (though this will have been vetted by as many experts as I can find). Also keep in mind that classification of many of these organisms is not generally based on easily seen visual aspects but on microscopic or genetic differences.

Hermodice carunculata

Polychaete Worms

The worms of the reef are very different from the cnidarians and sponges and add to its variety. The most visible are members of the class Polychaeta. They are characterized by having "many bristles" (the literal meaning of the name) and are a mostly marine class of the phylum Annelida, whose other two classes include the earthworms and the leeches.

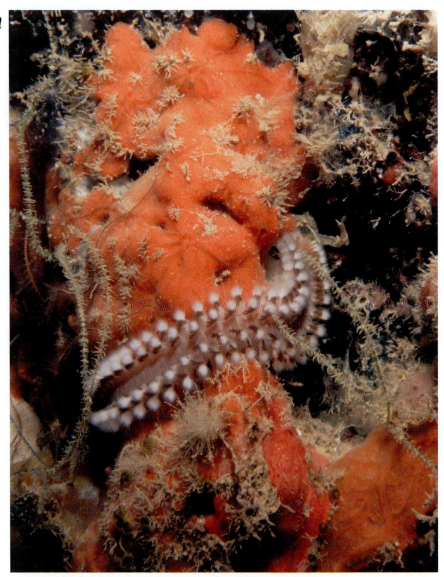

4.68 *Hermodice carunculata* is commonly called the fireworm (as in fire coral) because of the painful burning sensation that results from contact with the prominent bristles along the sides. These are the characteristic feature of this species, which can be 15-25 cm long, though 6 to 10 cm is more typical.

4.69 The corallites of *Orbicella annularis* give scale to this small example of *Hermodice carunculata*. While the individual in fig 4.68 above has a distinct double row of bristles on each side, the bristles on this one appear to be in a single row, though on close examination the two rows are very close together and pointed to the side rather than up. This may be due to the small size of this individual, or within the normal variability for this species, as are body colors from green to red-brown.

Chapter 4 Invertebrates 101

Spirobranchus gigantea

Unlike *Hermodice*, which is free-living and moves about foraging for food, the rest of the polychaetes here are sedentary tube worms. These are divided into two groups, the serpulids, which form and live in a calcareous tube that is overgrown by coral, and sabellids, which make a parchment-like tube that often stands free of the substrate. The bodies of both groups remain hidden, while feathery structures called radioles attached to the head segment extend into the water to trap plankton and also serve as gills to absorb oxygen. See fig. 3.20 for more examples.

4.70 The most visible of the tube worms is *Spirobranchus gigantea*, a serpulid, whose calcareous tubes are seen here overgrown with *Porites astreoides*. Each individual has a pair of spiral tree-shaped radioles. Normally extended, as at the top of this view, they are withdrawn to the safety of the tube at the slightest provocation. The worm is protected by a hard door, or operculum, that closes the opening. The operculum has two spines, also visible in the upper individual, and the tube itself also has a pointed thorn, visible in the middle of the picture, where another worm is fully withdrawn. At the bottom, a third worm is slowly extending its radioles again. They are commonly called Christmas tree worms. These are slightly larger than life-size.

4.71a (left), **4.71b** (center), and **4.71c** (right) The color of *Spirobranchus gigantea* is highly variable. The coral gives scale: about life-size.

 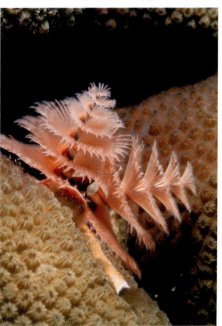 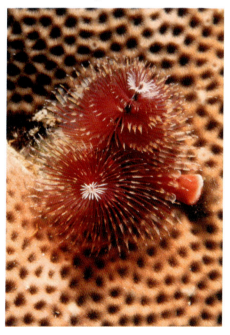

Pomatostegus stellatus

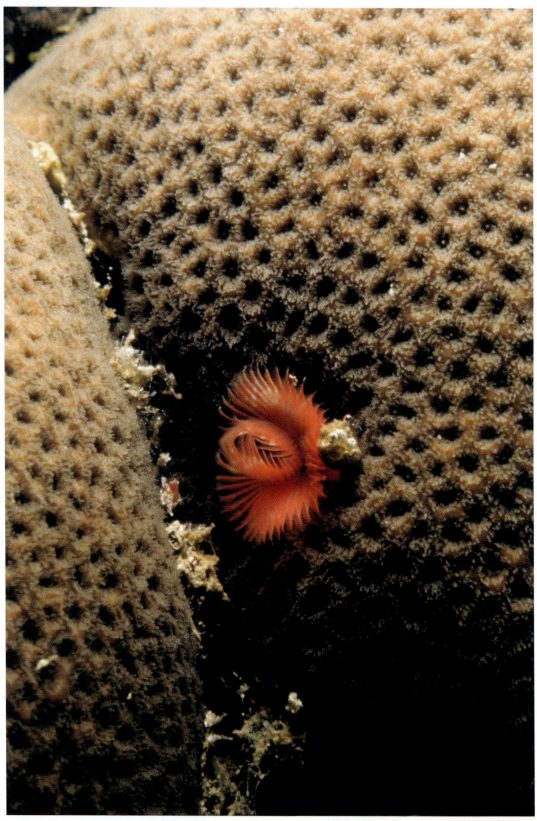

4.72 *Pomatostegus stellatus* is a serpulid whose feathery crown of radioles appears to be folded into a U-shape (the top of the U is on the far side here), giving it the appearance of a double row. The red, orange, yellow, or white color can be solid or banded. This is a small example; the crown can be up to about 4 cm. The host coral is a *Siderastrea*. About 2x life-size.

Chapter 4 Invertebrates 103

Bispira brunnea and *Bispira variegata*

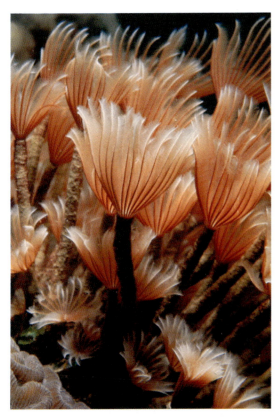

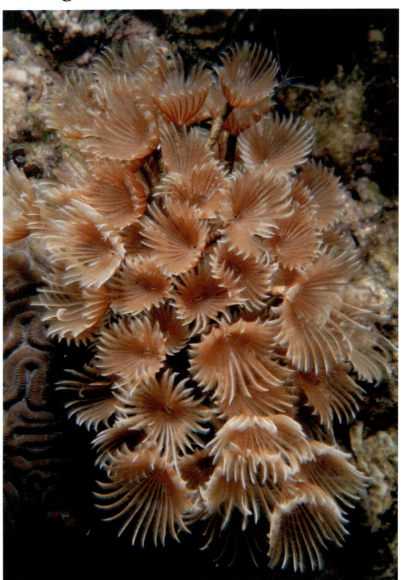

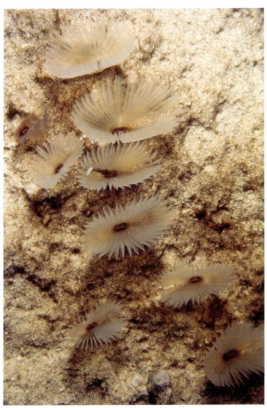

4.73 (above left) The parchment-like tubes of the sabellid *Bispira brunnea* and the feather-duster shape of the crown of radioles are visible in this side view.

4.74 (above right) *Bispira brunnea*, which reproduces asexually as well as sexually, occurs as clusters of identical individuals with circular crowns up to 3-4 cm across that wave in the moving water of the shallow reef. About life-size.

4.75 *Bispira variegata* is similar to *B. brunnea*, but its parchment-like tube is usually hidden within the sandy substrate it lives on. The color varies from nearly white through nearly black, but is usually drab. About life-size.

Anamobaea orstedii

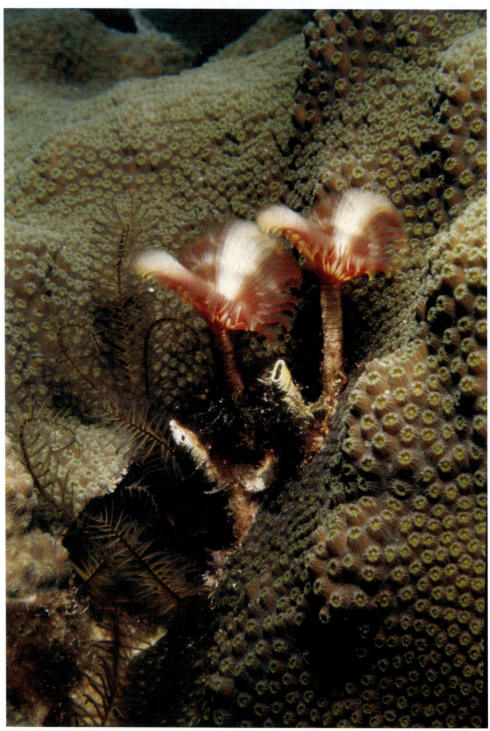

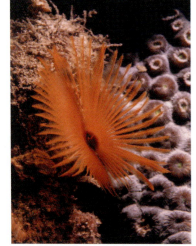

4.76 *Anamobaea orstedii* is a sabellid with two separate semicircular radiole crowns that together make a circular crown up to 5 cm with two halves separated by a small gap. The tube stands above the substrate. These share a gap in *Orbicella faveolata* with a crinoid and are about life-size.

4.77 *Anamobaea orstedii* may closely resemble *Bispira variegata* but is often patterned as in fig. 4.76 or more brightly colored if solid in color. About life-size.

Sabellastarte magnifica

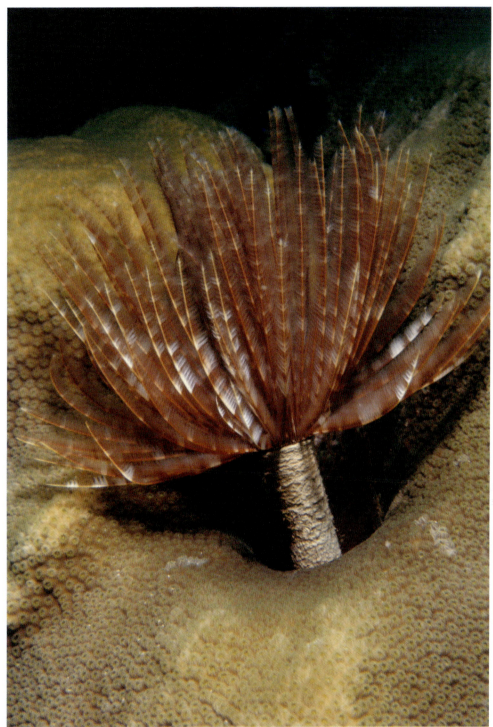

4.78 *Sabellastarte magnifica* is a large solitary sabellid with a variegated crown made up of a large number of feathery radioles. The crown on this individual is about 15 cm across. The coral surrounding it is *Orbicella annularis*.

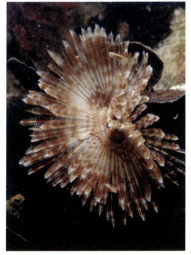

4.79 *Sabellastarte magnifica* is typically tan or brown with light bands or spots on the radioles.

Cyphoma gibbosum

Molluscs

The mostly marine phylum Mollusca is represented on the reef by the classes:

Gastropoda (snails)
Bivalvia (clams, scallops)
Cephalopoda (squids, octopi)

Most have shells, though some have a reduced internal shell or none at all. They are an enormous group with a wide variety of lifestyles. The few seen here are often very visible on the reef.

4.80 *Cyphoma gibbosum* may be the first mollusc a diver or snorkeler will notice, because of its bright coloration and prominent location on sea fans and other alcyonaceans, upon which it feeds. This one has stripped the flesh from part of a *Gorgonia*, revealing the hard black skeleton below. The shell is white; the color and spots are on a part of the gastropod's mantle that extends to cover the outside of the shell. The common name of this gastropod is the flamingo tongue cowrie. About 2x life-size.

Macrostrombus costatus (formerly *Strombus costatus*)

4.81 The large gastropod *Macrostrombus costatus* (common name: milk conch) is seen on sandy patches, covered with algae and reef debris. The edge of its shell curves up around the pair of eye stalks at the lower right. Seen here about 3/4 life-size, it is shorter in proportion and has rounder spines than the larger *Aliger* (formerly *Strombus*) *gigas*.

Lima scabra

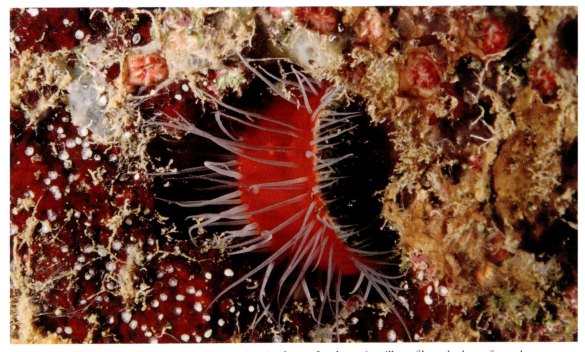

4.82 *Lima scabra* is a bivalve that occupies crevices in the reef and uses its gills to filter plankton from the water. The tentacles can range from red to white, and the mantle, the tissue that secretes the shell, is bright red. If threatened, it can escape in a rudimentary swimming motion by snapping its shells shut. About 1.5x life-size.

Elysia crispata (formerly *Tridachia crispata*)

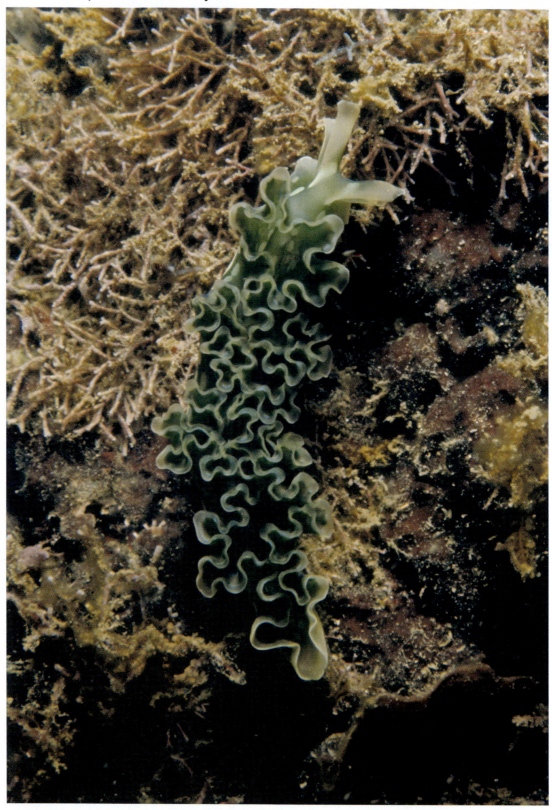

4.83 *Elysia crispata* is an opisthobranch gastropod: it has no shell. It also has no gills, and uses frilly structures called parapodia on its back for respiration. It is found on parts of the shallow reef rich in algae, on which it feeds. Some of the chloroplasts from the algae are passed to the parapodia, where they can live for several months, turning sunlight into nutrients for the animal. It is typically green as a result, but can also have blue coloration. This view is from above, with the head end at the top. About 2-3x life-size.

Sepioteuthis sepioidea

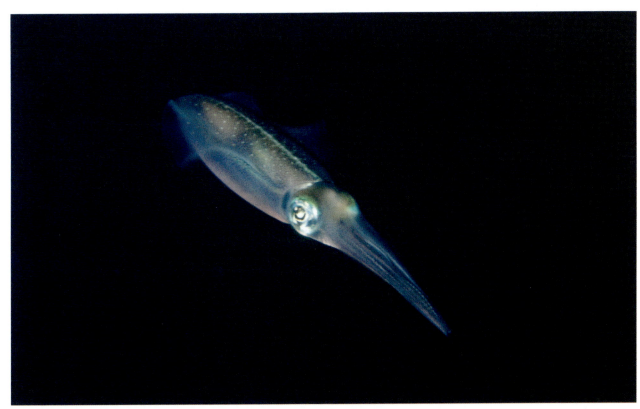

4.84 The squid *Sepioteuthis sepioidea* holds its tentacles together for streamlined swimming propelled by the motion of the fins on either side. Cephalopods can alter their color, so the appearance is variable. The length is about 20-25 cm.

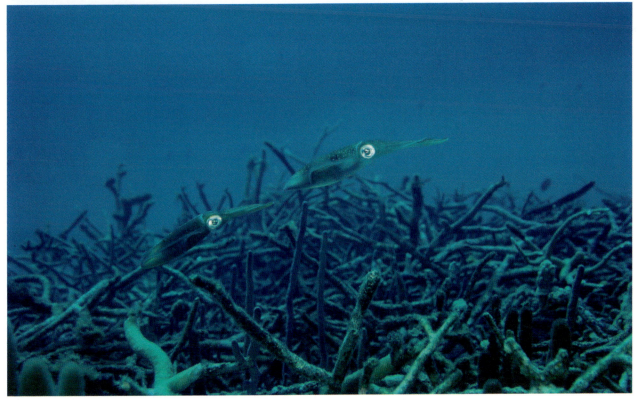

4.85 *Sepioteuthis sepioidea* inhabits the shallow water above the reef. The eyes (here reflecting flash light) are large, and this intelligent mollusc is wary of being approached. It swims forward using its fins, but can jet backward quickly if necessary.

Panulirus guttatus

Crustaceans

The phylum Arthropoda, which also includes insects and other groups, are segmented animals with heads, jointed appendages, and a chitinous exoskeleton. Members of the subphylum Crustacea are mainly aquatic, breathe with gills, and have a head, body, and abdomen. The crustaceans of the reef are the decapods: lobsters, crabs, and shrimp.

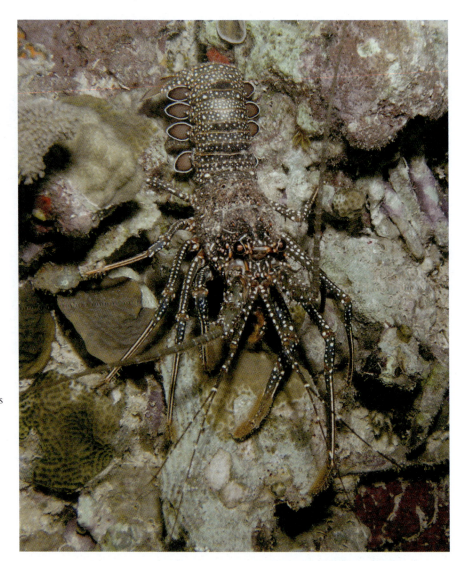

4.86 The smaller of the two *Panulirus* species in the Caribbean is *Panulirus guttatus*, the spotted spiny lobster. As the common name indicates, it has conspicuous white spots on its body and the upper segments of its appendages. Active at night, it spends the day in a crevice between or under coral masses. Commonly about 15-20 cm long.

Panulirus argus

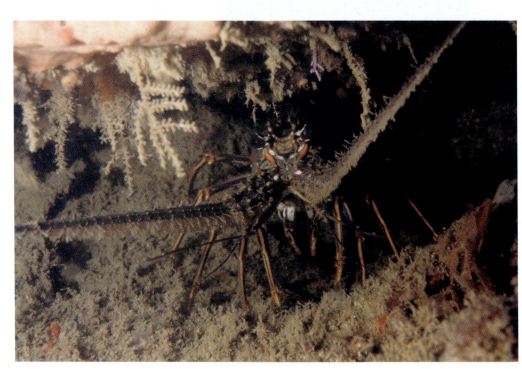

4.87 *Panulirus argus*, the Caribbean spiny lobster, is twice the size of *Panulirus guttatus*, reaching up to 40 cm in length. It is reddish-brown to dark green and lacks spots, and its long antennae are thicker in proportion than those of *P. guttatus*.

Chapter 4 Invertebrates 111

Stenopus hispidus

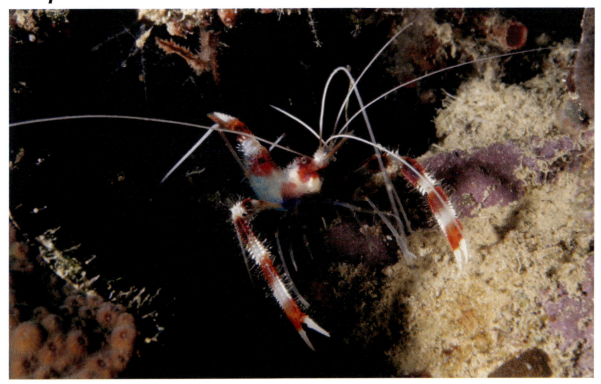

4.88 The red and white bands on the body and claws of *Stenopus hispidus* and the long white antennae advertise to fish the availability of cleaning services the shrimp provides. Up to 5 cm, it is larger than the *Periclimenes* cleaners.

Stenorhynchus seticornis

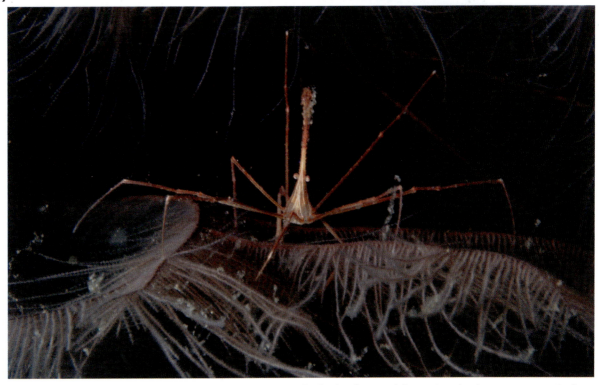

4.89 *Stenorhynchus seticornis,* the arrow crab, with its triangular body, elongated forward projection, or rostrum, in front of its eyes, and its long spidery legs is another unmistakable reef crustacean. Overall size is around 8 cm.

Mithrax spinosissimus

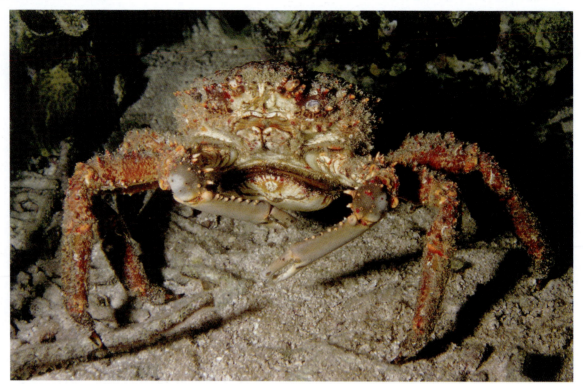

4.90 The large nocturnal *Mithrax spinosissimus* crab has a round carapace, and spines and tubercles on the red-brown carapace and legs. The claws are plain tan to grey with a single row of tubercles. About 30-40 cm across.

Calcinus tibicen

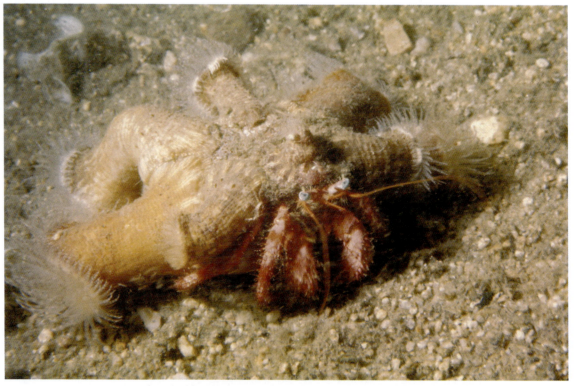

4.91 Lacking a strong shell, the *Calcinus tibicen* hermit crab uses an empty snail shell for shelter. For additional defense it puts small anemones on its shell, which then grow larger. When the shell is outgrown by one crab, it is left to a smaller one. The antennae and eyestalks are orange, the rest orange to red. About 1.5x life-size.

Parribacus antarcticus

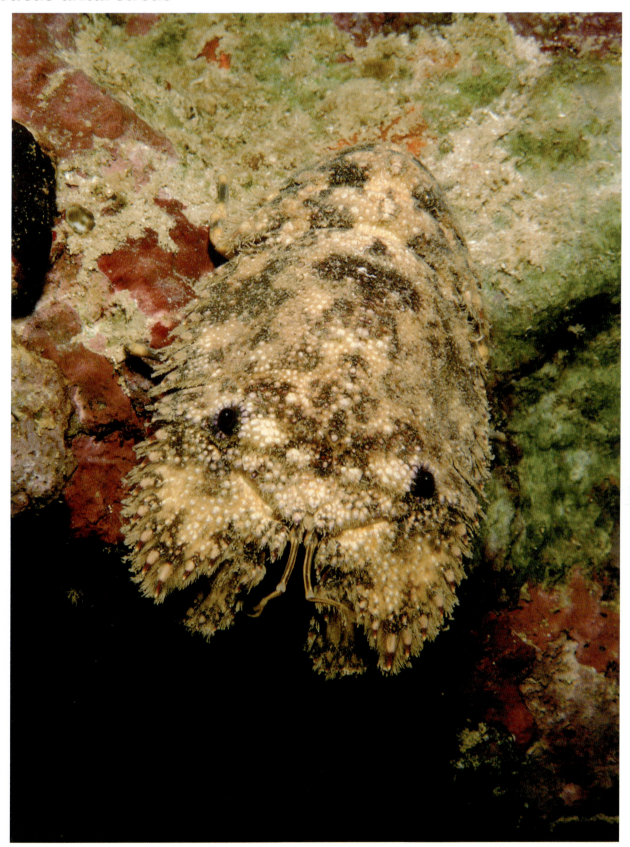

4.92 The slipper lobster, *Parribacus antarcticus,* is related to clawed and spiny lobsters. One pair of antennae are small and used to sense the environment. Another is enlarged into flat plates that project from the front of the head. Though found on Caribbean reefs, the same species occurs in the tropical Pacific and Indian oceans. About life-size, up to 20 cm.

Linckia guildingii

Echinoderms

Echinoderms are a phylum-level group. Some echinoderms are familiar, such as sea stars, but many of the classes are not. Classes of Phylum Echinodermata:

Asteroidea (sea stars)
Ophiuroidea (brittle stars)
Crinoidea (feather stars)
Echinoidea (sea urchins)
Holothuroidea
 (sea cucumbers)

Echinoderms are known for their five-fold radial symmetry, though they have bilateral larval stages that resemble embryonic chordates, suggesting that they evolved from bilateral organisms and are more closely related to vertebrates than other invertebrates are. The skeletons are made up of calcified plates, and a network of fluid filled canals, which terminate in tube feet, provide gas exchange, feeding, and locomotion.

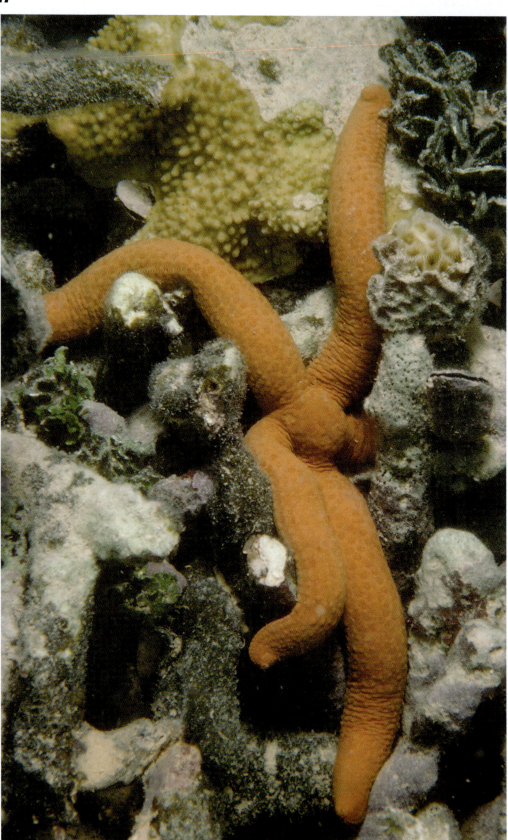

4.93 The asteroid *Linckia guildingii* grazes on the film of algae and bacteria that grows on coral rubble. Here, in this disturbed part of the shallow reef, an *Acropora* seems to be overgrowing bare coral rock but an *Agaricia* appears to be losing the struggle to grow and thrive. About 1.5x life-size.

Chapter 4 Invertebrates 115

Astrophyton muricatum

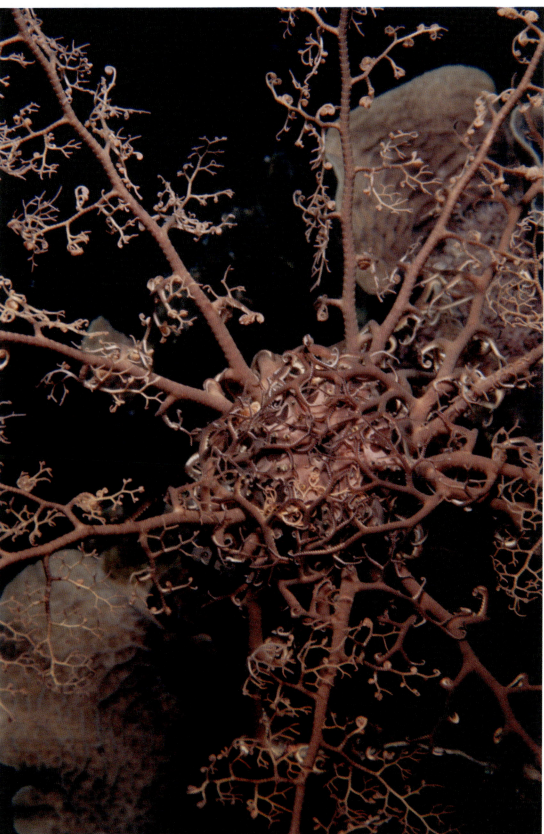

4.94 Ophiuroids have a distinct central disk and arms, unlike asteroids, whose arms blend with the body. The ophiuroid *Astrophyton muricatum*, a basket star, is a nocturnal filter feeder with many branching arms. Here, the central disk is obscured by inner branches. Also see figs. 8.15 and 8.16. About 2x life-size.

Ophioderma appressum

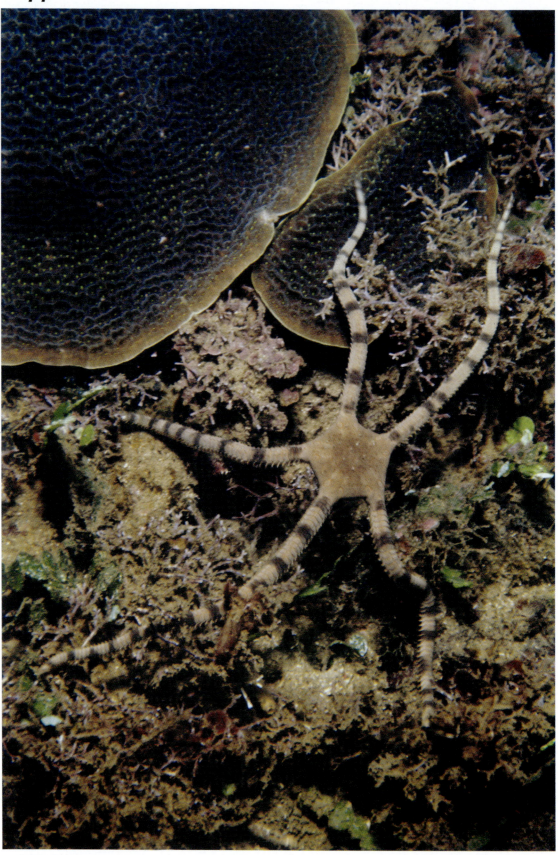

4.95 *Ophioderma appressum* has arms that are scaly rather than spiny. The tan color and banded arms are diagnostic. These ophiuroids forage on the abundant organic debris of the reef. About life-size.

Chapter 4 Invertebrates 117

Ophiothrix suensonii

4.96 *Ophiothrix suensonii* is almost always seen in association with sponges. The long, thin spines and black stripe on the arm are characteristic features. Note the *Umimayanthus parasiticus* zoanthids. About life-size.

Davidaster rubiginosa (formerly *Nemaster rubiginosa*)

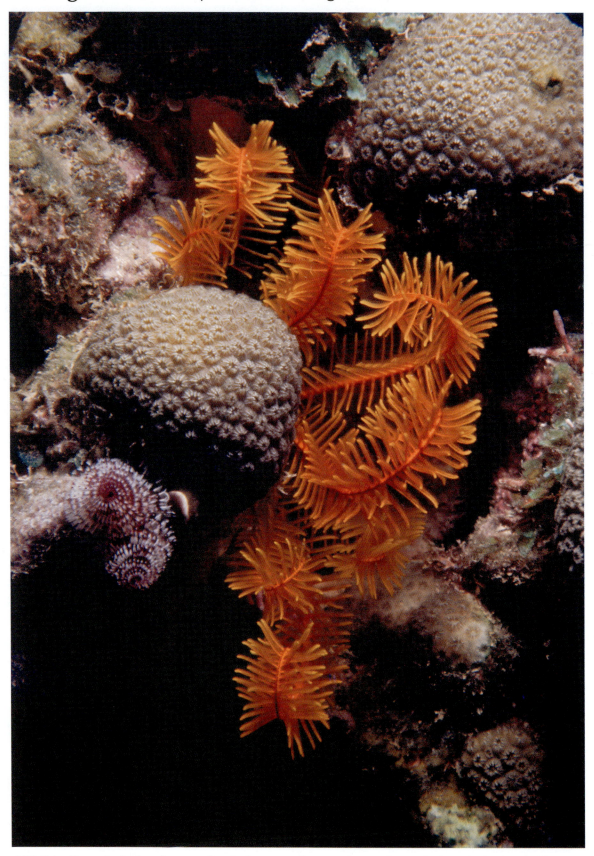

4.97 Crinoids catch plankton by extending feathery arms from crevices in the coral where the body is hidden. *Davidaster rubiginosa* ranges from orange to solid black. Note *Orbicella annularis*. About 1.5x life-size.

Davidaster discoidea (formerly *Nemaster discoidea*)

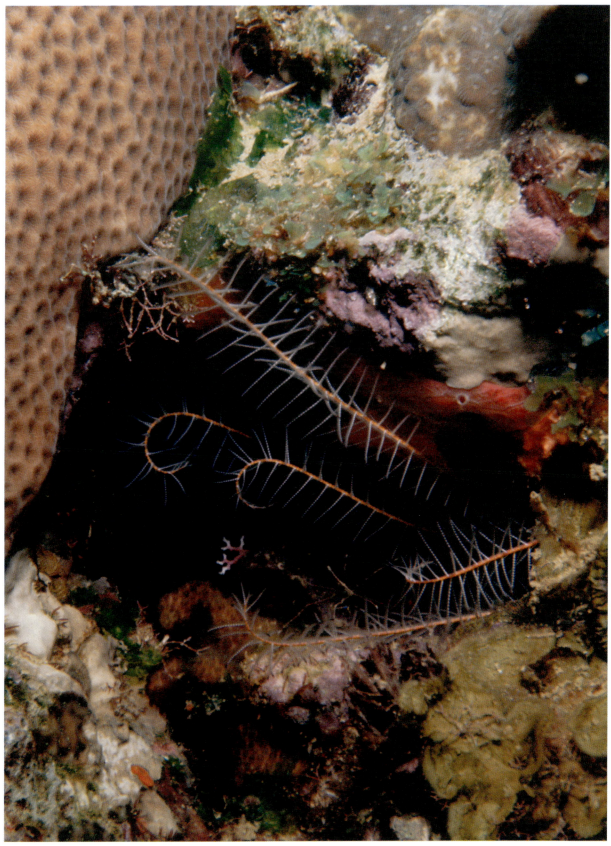

4.98 *Davidaster discoidea* is smaller and more delicate than *D. rubiginosa* but follows a similar lifestyle. Note that the pinnules, or ultimate branches, on the arms are arranged into four rows on both species. About 2x life-size.

Nemaster grandis

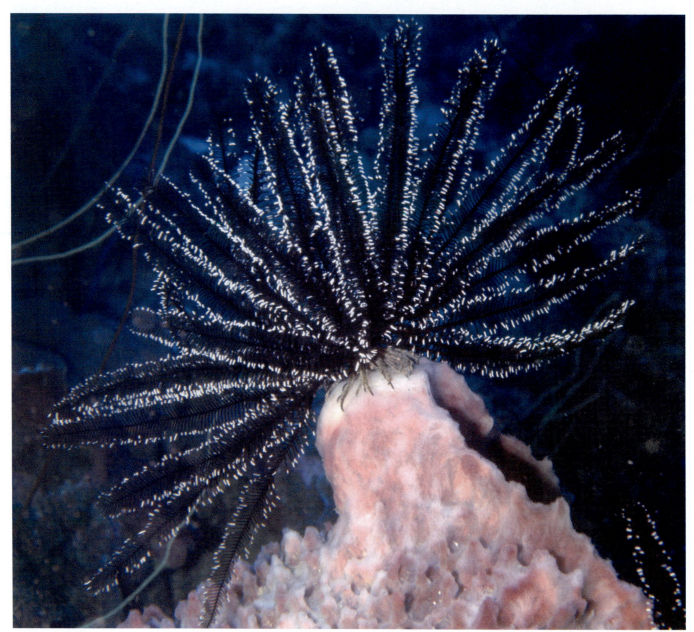

4.99 *Nemaster grandis* is a large crinoid that can be found in areas where there is a prevailing water current along the reef, distinct from the typical back and forth shallow-water wave surge. Crinoids can move, albeit slowly, using their arms, whose pinnules grip like Velcro®, pulling on one side of the central body and pushing on the other. Once they have climbed to a position from which they can extend their arms into the current, as on this *Xestospongia muta* sponge, they use the hooked cirri visible here to hold on. The two *Davidaster* species hold their pinnules in four rows, to catch plankton from the eddies swirling around the coral heads from many directions. Preferring the uniform flow of a prevailing current, *Nemaster grandis* holds its arms in the shape of a fan, and the pinnules are held in two opposite rows (like a feather, hence the common name feather star) to maximize the amount of passing water from which food can be collected. The pinnules use small but typical echinoderm tube feet to snare plankton, which is passed via a groove in the arm to the mouth, which is on the top of the central disk, or calyx. This is in contrast to asteroids and most ophiuroids, which have the mouth on the bottom for grazing the substrate. The nocturnal basket star *Astrophyton muricatum*, an ophiuroid seen earlier in the chapter, and to be seen again in Chapter 8, feeds in a very similar manner. The fan formed here is about 45 cm across.

Analcidometra armata

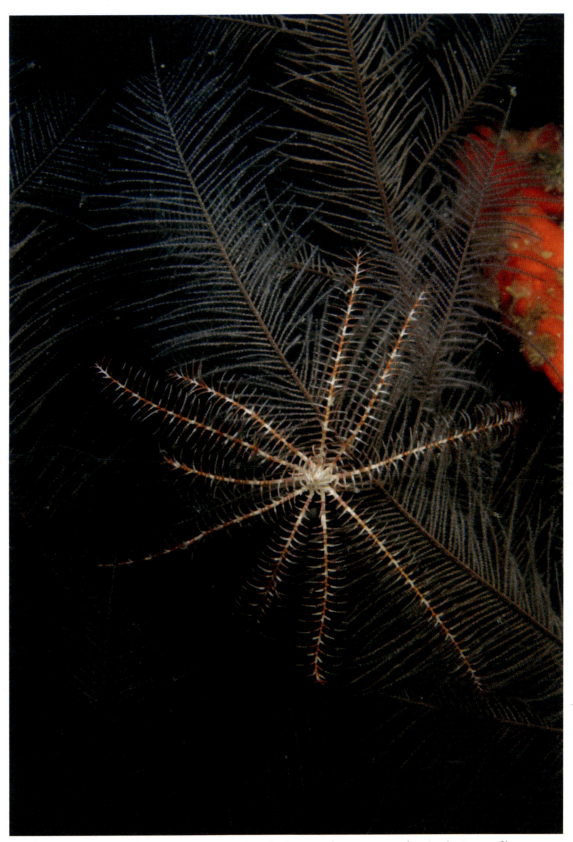

4.100 The nocturnal crinoid *Analcidometra armata* climbs onto alcyonaceans and antipatharians to filter plankton, abundant at night, from the water. It has ten banded red-and-white arms. The antipatharian is *Plumapathes pennacea*. About life-size. See also figs. 7.11, 8.19, and 8.20.

Diadema antillarum

Echinoids

Spiny urchins and the flattened sand dollars comprise the echinoids. All the urchins here graze on the algae that grow on dead coral, creating clean surfaces on which coral and other larvae can settle.

4.101 The urchin *Diadema antillarum* is normally all black, but some individuals are found that have white spines. The spines are barbed, break off easily, and contain an irritant, making them a hazard to snorkelers or divers who enter the water from the shore. An unexpected mass die-off of *Diadema* occurred in the early 1980s, and they are now quite rare. The disappearance of these important grazers led to expanded algal growth, to the detriment of corals. This one was seen out foraging at night. In figs. 2.2 and 8.26, *Diademas* on a shallow sandy bottom show their more typical color and their former abundance. About 3/4 life-size.

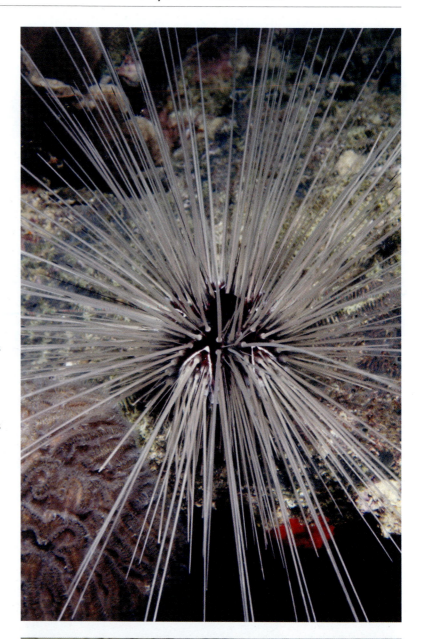

Tripneustes ventricosus

4.102 Another common urchin of shallow water is *Tripneustes ventricosus*, easily recognizable by its short white spines and dark body. It lives both on the reef and in backreef environments. It frequently puts bits of shell, sea grass, and other debris on itself for camouflage. About 3/4 life-size.

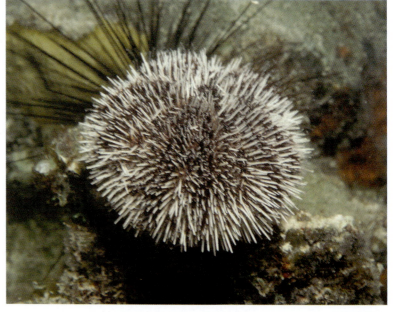

Echinometra viridis

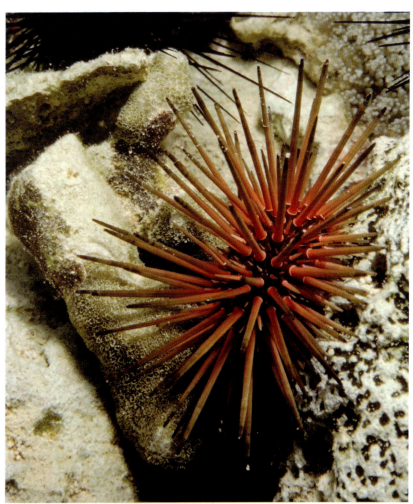

4.103 *Echinometra viridis* has a deep red body and stout spines, red at the base and green at the tip. It grazes on algae growing on coral rubble between 5 and 15 meters deep, i.e. on most of the shallow reef. *Echinometra lucunter* is a related species, uniformly dark and with spines that are shorter in proportion to the body size, so it looks less spiny. *Echinometra lucunter* (see fig. 6.13) lives in shallower water, from the low-water line down to about 5 meters. This *Echinometra viridis* is shown about actual size.

Eucidaris tribuloides

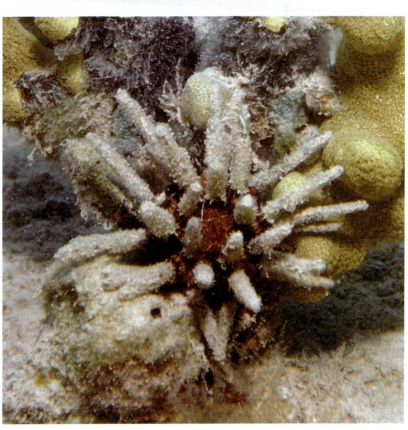

4.104 The only urchin here with spines this thick is *Eucidaris tribuloides*. The spines are often covered with algae, bryozoans, and even sponges. A similar Indo-Pacific species has been called the slate-pencil urchin, because the thick spines could be used like chalk to make marks on slate. In Hawaii missionaries taught the natives to write using flat stones and urchin spines. About life-size.

124 The Caribbean Coral Reef: A Record of an Ecosystem Under Threat

Holothuria thomasi

Holothurians

Holothurians are echinoderms with elongated bodies having a mouth at one end and an anus at the other. They ingest sand and extract whatever nutrients they can as it passes through their bodies.

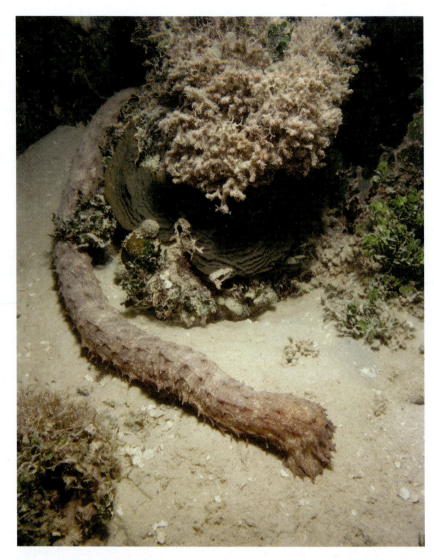

4.105 *Holothuria thomasi* can be up to 2 meters long, and never ventures out completely, instead keeping part of its body sheltered under the coral. There are short tentacles around the mouth. It is brown, sometimes mottled with white.

Euapta lappa

4.106 *Euapta lappa* has large tentacles around its mouth and has a wormlike, beaded appearance. It can be gray to brown and may be mottled in appearance. The length is 30 to 50 cm. This individual was photographed foraging at night.

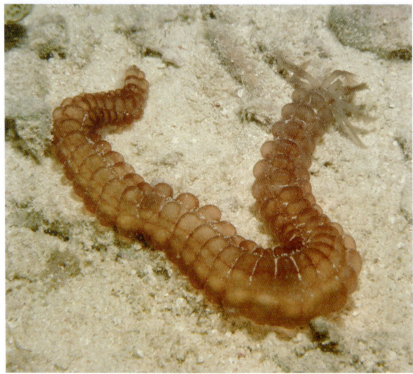

Holothuria mexicana

4.107 *Holothuria mexicana* has a gray to black body, which is relatively smooth but has creases around the circumference. It is around 40 to 50 cm long. The *Porites porites* and *Madracis auretenra* corals give scale.

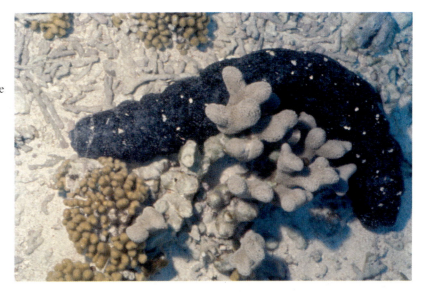

Isostichopus badionotus

4.108 *Isostichopus badionotus* lives on sandy patches on the reef and in thalassia grass, as here. It is orange-brown with prominent dark spots. The length is 30 to 40 cm.

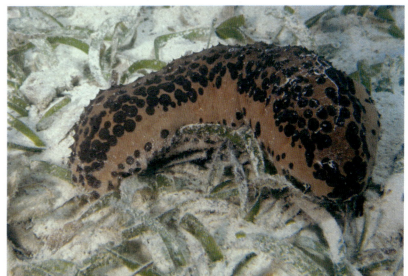

Astichopus multifidus

4.109 *Astichopus multifidus* can be brown, blotchy, or predominantly white as in this example. It is covered with what look like spines but are podia, or tube feet. The mouth faces down into the sediment and is not visible, and the animal has a skirted rather than cylindrical appearance. Its length is 30 to 40 cm.

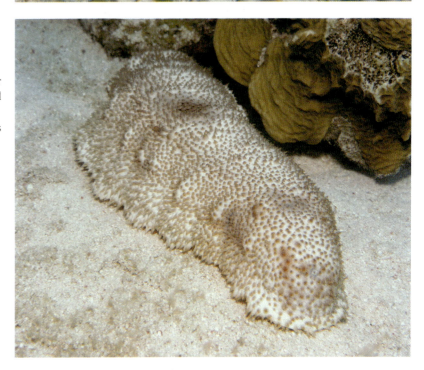

Clavelina puertosecensis

Tunicates

Tunicates are simple filter feeders, pumping water in through one opening and expelling it, along with wastes, out the other.

Tunicates belong to the phylum Chordata. Many tunicates have a free-swimming larval stage that has all the characteristics of chordates: a notochord, a dorsal nerve cord, pharyngeal slits, and a post-anal tail. It is likely that tunicates and chordates, including the vertebrates, shared a common ancestor in the distant past.

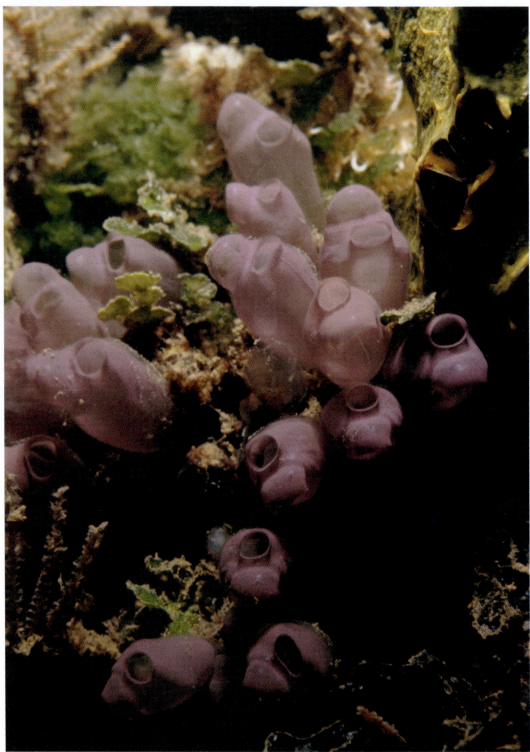

4.110 *Clavelina puertosecensis* is one of many colonial tunicates that can be seen on the reef. The pair of siphons are typical of tunicates, and the purple color and simple shape are characteristic of this species, though tunicates are very variable and identification is difficult. These are only about 3 cm tall.

5

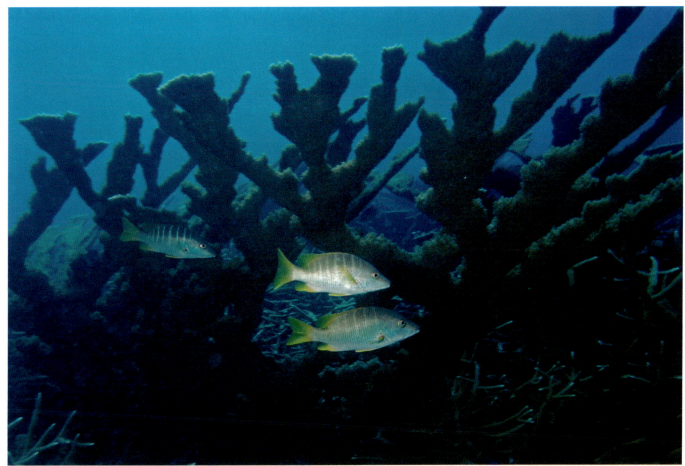

5.1 The eight vertical bars, yellow fins and tail, and slight concavity of the tail are characteristic of *Lutjanus apodus*, the Schoolmaster, one of the members of the family Lutjanidae, commonly known as snappers. Seen here in the shelter of an *Acropora palmata*, they have prominent canine teeth and feed on other fish, crustaceans, and mollusks, including cephalopods. The length can be 60 cm.

Fishes

Interactions between corals and between corals and other invertebrates in the constant struggle to grow and reproduce are complex, but above all, extremely slow. Many of the other invertebrates are unmoving filter feeders, and many of the more mobile invertebrates are active only under the cover of darkness. The fishes of the reef add color and motion to the otherwise tranquil scene. Some are herbivores, grazing on the algae that grows on dead coral. Some feed on small invertebrates among the corals or in the sediment of sandy patches. A few feed on the coral itself. There are also predators that use speed or stealth to catch other fish or crustaceans.

Most fishes of the reef have well-established common names, so it is appropriate to use them here along with the scientific names. Some groups, such as the parrotfish, have many similar species, and there are comprehensive references for reef fishes that will help to sort out their differences. This chapter presents a representative sample of commonly seen and easily recognized reef fish for the new visitor, plus a few less known but interesting species.

Microspathodon chrysurus
Jewelfish

Yellowtail Damselfish (juvenile)

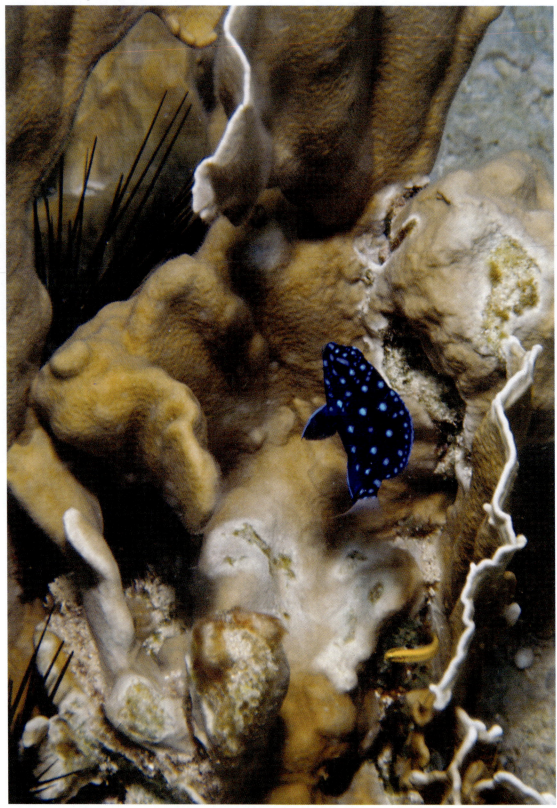

5.2 The most striking fish of the shallow reef is the jewelfish, the juvenile of the yellowtail damselfish, *Microspathodon chrysurus*. It is shy and hides among the corals, but the brilliant blue spots on an otherwise velvety dark blue-black body make it hard not to see, though it may resemble an unpalatable nudibranch to a predatory fish. As it matures the grey tail becomes yellow and the spots fade to a dull white or gray. This juvenile is about 6 cm long, and an adult will reach 15 cm. The yellow fish is a juvenile bluehead wrasse.

Abudefduf saxatilis
Sergeant Major

5.3 The five black stripes and yellow upper body of the sergeant major are unmistakable. It often swims above the shallow reef tops, sometimes in large groups. It eats algae, small crustaceans, invertebrate larvae, and small fish. It reaches over 20 cm in length.

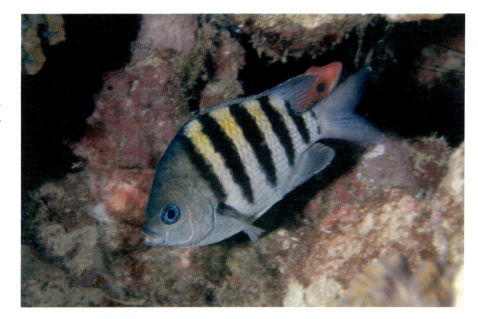

Stegastes planifrons
Threespot Damselfish

5.4 The yellow-gold crescent above the eyes marks the threespot damselfish. It is fiercely territorial and chases other fish away from its patch of algae-encrusted dead coral. It also emits a popping noise as part of its aggressive display. Though it only reaches 10-12 cm long, it will swim out and challenge a diver who gets too close as well, even attempting to nip the intruder. It eats small invertebrates in addition to the algae in its territory.

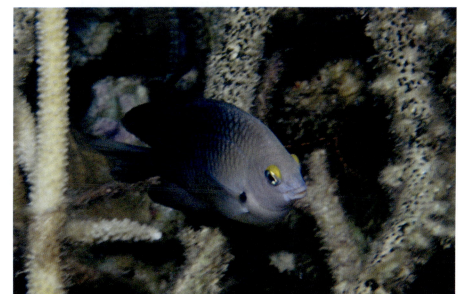

Holacanthus tricolor
Rock Beauty

5.5 Juvenile rock beauties shelter between corals in shallow water. They are entirely yellow except for a small black spot on the upper body which expands into a large black area as the fish grows. Large adults can be up to 35 cm, though this individual is about half that size.

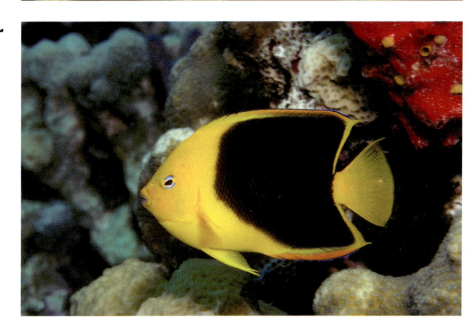

Holacanthus ciliaris
Queen Angelfish

5.6 The bright yellow and blue markings and the large size (up to 45 cm) of the adult queen angelfish make it a spectacular sight on the reef. They occur singly or in pairs, and feed on sponges. Juveniles are dark blue with blue to white bars and are cleaners, feeding on parasites of other fish.

A related species, the blue angelfish, *Holacanthus bermudensis*, sometimes interbreeds with the queen angelfish, producing a hybrid with intermediate markings that was originally thought to be a third species, *Holacanthus townsendi*. The blue angelfish is purplish to blue-green, with yellow only on the edges of the tail and pectoral fins.

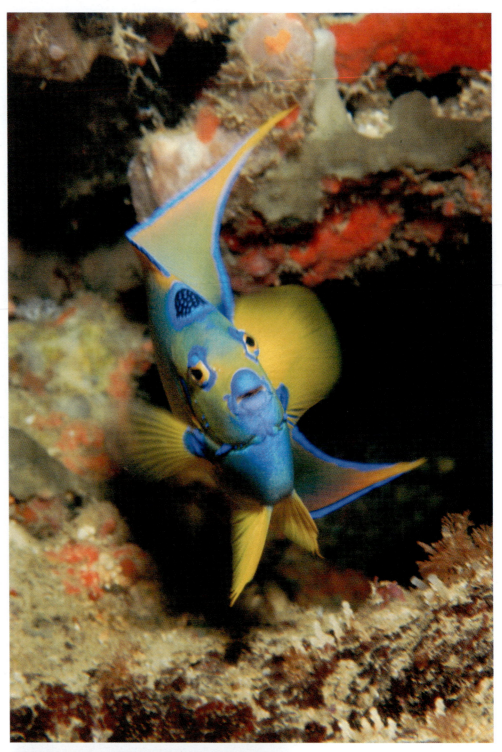

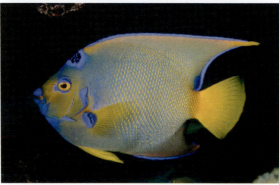

5.7 This side view shows the distribution of color on the queen angelfish. The scales on the side are blue with yellow edges. These two views together show the oval profile, laterally flattened body shape.

Chapter 5 Fishes 131

Pomacanthus paru
French Angelfish

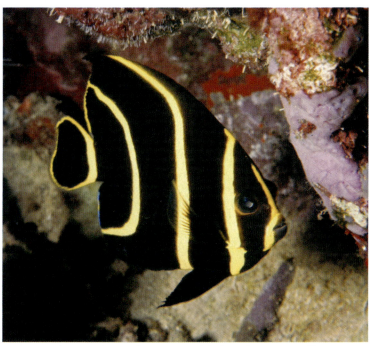

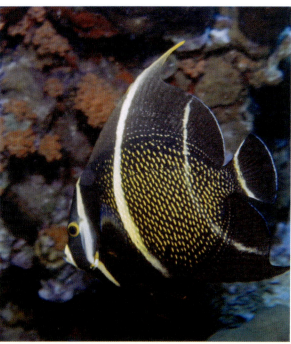

5.8 Juvenile French angelfish are deep black with distinct yellow stripes. This individual is 10-12 cm; an adult can be 40 cm. Juveniles clean parasites from larger fish. Adults eat sponges and other sessile invertebrates.

5.9 A sub-adult shows the transition to adult markings. The stripes will eventually disappear completely and the scale edges on the side of the body become yellow.

Pomacanthus arcuatus
Gray Angelfish

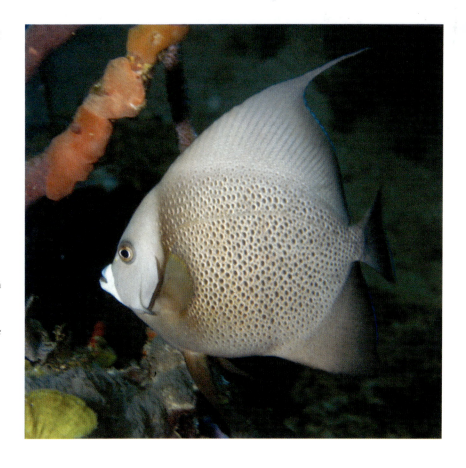

5.10 The gray angelfish grows to 60 cm long. Like the French angelfish, it has a flattened body more oval and less elongated than the damselfish and angelfish on previous pages. Juveniles resemble the French angelfish but have pale yellow to white stripes, including one on the tail, and blue tips on the pectoral fins. As they mature, the stripes fade. the head turns light gray, and the body lightens.

The damselfish, including the sergeant major, and the angelfish, including the rock beauty, are members of the family Pomacanthidae.

Chromis cyanea
Blue Chromis

5.11 Groups of the brilliant blue chromis are frequently seen feeding on small zooplankton in the open water just above patch reefs. It has black along the top and on the edges of the deeply forked tail. The length reaches 12-15 cm; this individual is shown here approximately actual size. There is also a very similar brown chromis, *Chromis multilineata*, which lacks the black upper body color but has a prominent black spot at the base of the pectoral fin and a white spot on the body behind the dorsal fin.

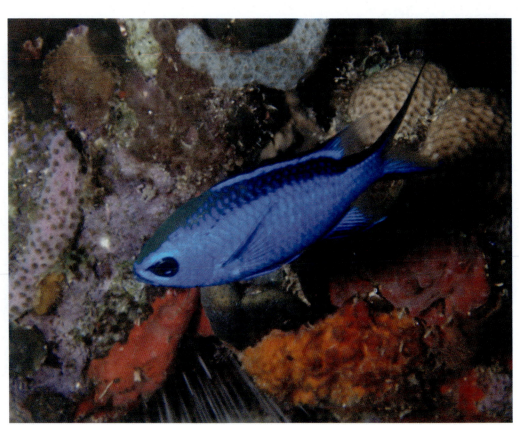

Chromis insolata
Sunshinefish

Olive Chromis (juvenile)

5.12 The juvenile olive chromis may call to mind for some the sun rising from (or sinking into) the horizon. As this omnivore matures to its full size of 12-15 cm the blue color fades and the yellow darkens until the fish is olive green with a light underside.

The chromises are members of the family Pomacentridae.

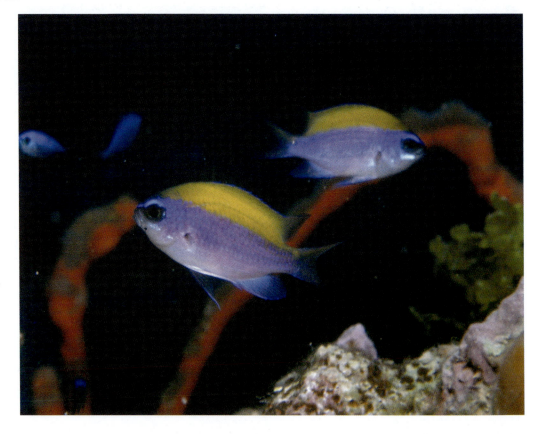

Chaetodon capistratus
Foureye Butterflyfish

5.13 *Chaetodon capistratus*, as the common name suggests, has a large spot just in front of its tail that may fool predators by resembling a big eye, making this small, thin fish look bigger. It has a more pronounced snout than the damsels, angelfish, and chromises, and feeds on polychaete worms, zoantharians, gorgonians, and tunicates. The length reaches 12 cm, but this 7-8 cm individual is shown here approximately actual size.

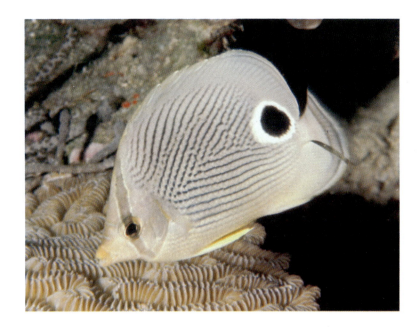

Chaetodon striatus
Banded Butterflyfish

5.14 *Chaetodon striatus* grows to 15 cm long, though this individual is similar in size to the *capistratus* above. Juveniles have a false eye at the base of the tail, but it fades with maturity. The eye is hidden by a black stripe, and there are two more prominent ones on the body and another at the tail. It feeds on polychaetes, small crustaceans, and coral polyps.

Another species, *Chaetodon ocellatus,* the spotfin butterflyfish, is similar in size but has only the eye stripe on a silvery body, with yellow fins and tail.

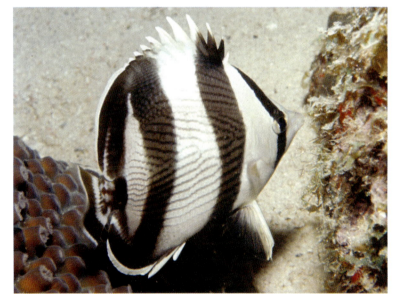

Prognathodes aculeatus
Longsnout Butterflyfish

5.15 *Prognathodes aculeatus* has a longer snout than the other butterflyfish and also is found deeper on the reef. There is a faint stripe on the forehead reaching toward the eye, but it doesn't extend below the eye. The color on the side grades upward from white through yellow and orange to a black dorsal fin. The longsnout forages in crevices for small invertebrates and has been reported to use its snout to reach between the spines of urchins to feed on their tube feet. It grows to only 8-9 cm in length.

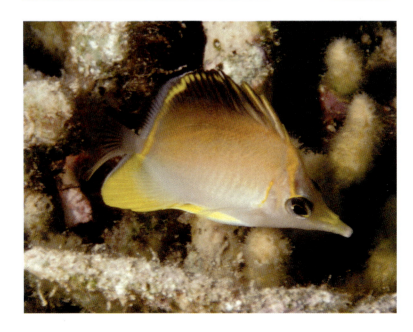

Hypoplectrus indigo
Indigo Hamlet

5.16 The indigo hamlet has six black bars on the body. The head and light bars are light blue to white. The length is 12-15 cm.

These are five of the eleven species of *Hypoplectrus* recognized in the Caribbean. They are hermaphrodites, producing both sperm and eggs, though they do not self-fertilize. Rather, each mating pair alternates providing eggs or sperm through multiple matings. Hamlets occur singly or in pairs foraging on the reef. They are members of the family Serranidae.

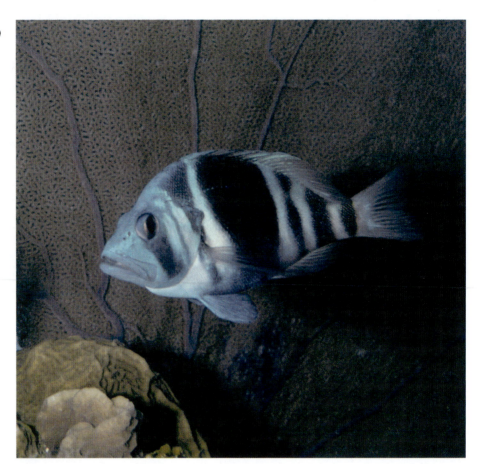

Hypoplectrus puella
Barred Hamlet

5.17 The barred hamlet has markings similar to those of the indigo, but brown to black in color. There are bright blue spots on the nose and bright blue stripes on the head. Length is up to 15 cm.

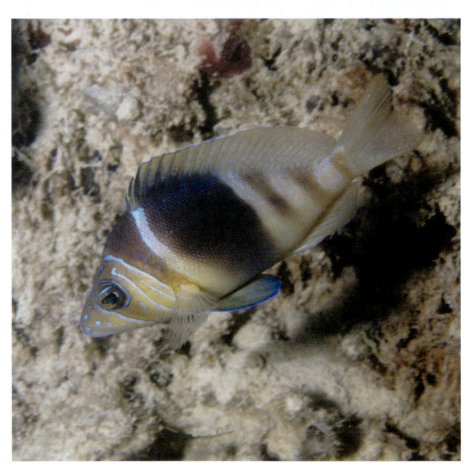

Chapter 5 Fishes 135

Hypoplectrus gummigutta
Golden Hamlet

5.18 The golden hamlet is mostly solid yellow with black and iridescent blue from the eye to the mouth. The length is 11-13 cm.

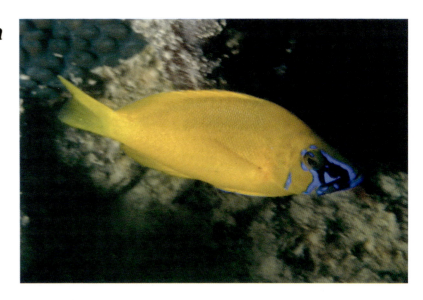

Hypoplectrus unicolor
Butter Hamlet

5.19 The butter hamlet is grayish to yellow in color. There is a prominent black spot at the base of the tail and another on the side of the snout. A bright blue line surrounds the eye, and there are similar lines on the head. The length is 10-12 cm.

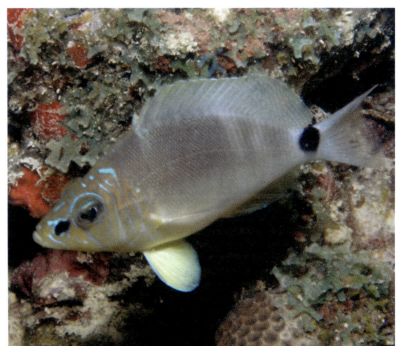

Hypoplectrus guttavarius
Shy Hamlet

5.20 The shy hamlet is bright yellow with a large solid black or dark blue area between the pectoral fin and tail. It has a black spot surrounded by iridescent blue on each side of the snout. Its length is 12-14 cm.

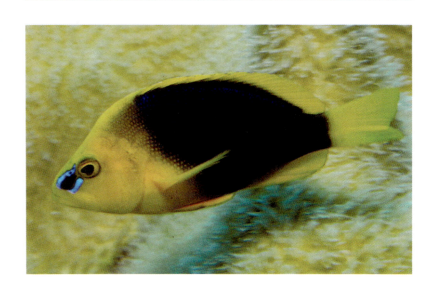

Serranus tigrinus
Harlequin Bass

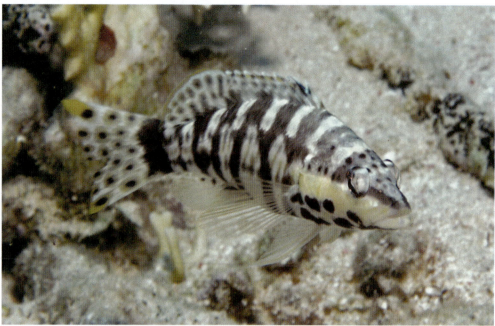

5.21 The harlequin bass is also a member of the Serranidae family and, like the hamlets, is synchronously hermaphroditic, with mated pairs alternating between producing sperm and eggs. The ground color of the body is white above, pale yellow below, with distinctive black markings on the body and gray-ringed black spots on the dorsal fin and tail. It frequents areas with coral rubble and sand and eats mostly crustaceans. Length is up to 25 cm; this example is about 15 cm.

Myripristis jacobus
Blackbar Soldierfish

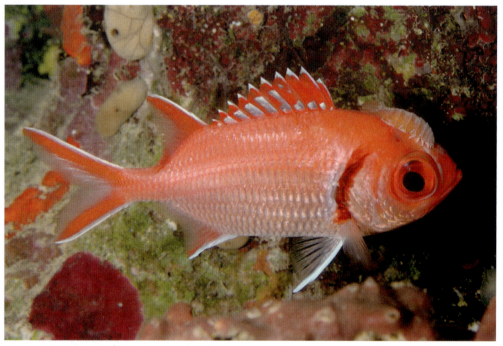

5.22 *Myripristis jacobus*, the blackbar soldierfish, spends the daytime in small caves under coral and forages at night. An isopod crustacean, *Anilocra laticaudata*, is attached to its head. This parasite attaches itself to the head or gill covers of many species, but *Myripristis jacobus* is so commonly infected that the hitchhiker is commonly called the soldierfish isopod. Length up to 25 cm.

Holocentrus rufus
Longspine Squirrelfish

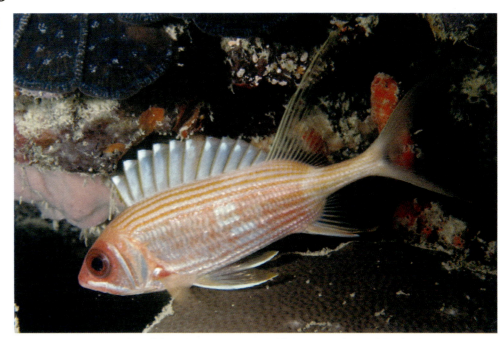

5.23 The blackbar soldierfish and these two squirrelfish are members of the family Holocentridae. The longspine squirrelfish has white at the tips of its front dorsal fin. Its rear dorsal fin is very long, as is the upper lobe of the tail. There is a faint white bar on the side. Both these squirrelfish frequent deeper parts of the reef than the blackbar soldierfish. They are seen here in their daytime shelter under and among the coral. Length up to 30 cm.

Neoniphon marianus
Longjaw Squirrelfish

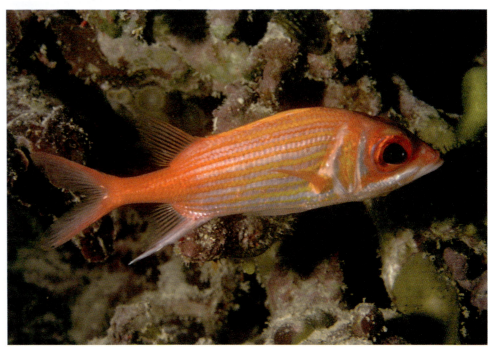

5.24 The longjaw squirrelfish has a more pointed snout than the longspine, and its lower jaw protrudes beyond the upper. Its anal fin is long, reaching to the base of the tail. The lateral stripes are yellow and more defined than on the longspine. Though not extended here, the dorsal fin is gold with white tips and a row of white spots. This is about 25 cm, maximum 40 cm.

Priacanthus cruentatus
Glasseye Snapper

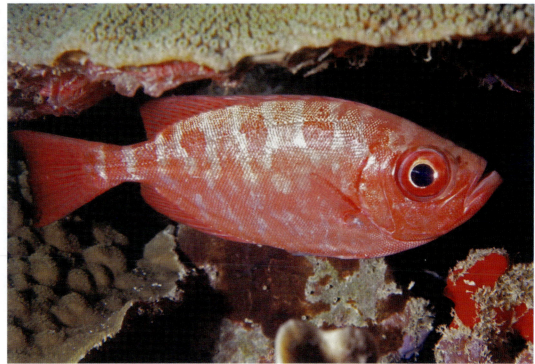

5.25 The glasseye snapper, *Priacanthus cruentatus*, can be distinguished from the very similar but slightly larger bigeye, *Priacanthus arenatus,* by the mottled pattern (versus solid) and the absence of dark margins on the tail and lower fins. Like the other red fish here, it is nocturnal. Length is about 30 cm.

Anisotremus virginicus
Porkfish

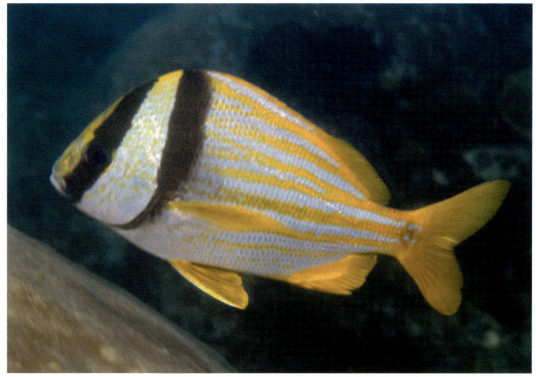

5.26 The porkfish is a member of a large family, Haemulidae, commonly known as grunts from the sound they can make. It is common in groups. The porkfish is the only one with the two black bars. Though the juvenile is striped differently, it also has the distinctive black bars. The length is 30-35 cm.

Chapter 5 Fishes 139

Equetus punctatus
Spotted Drum (adult)

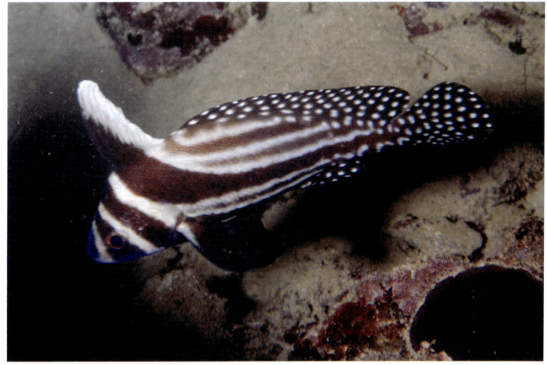

5.27 The spotted drum is in the family Scianidae, called drums or croakers from the sound they make using muscles and their air bladder. The black nose, two black bars on the head, black bar extending up the front dorsal fin, and the white spots on the rear fins and tail are characteristic. Length up to 20-25 cm.

Spotted Drum (juvenile)

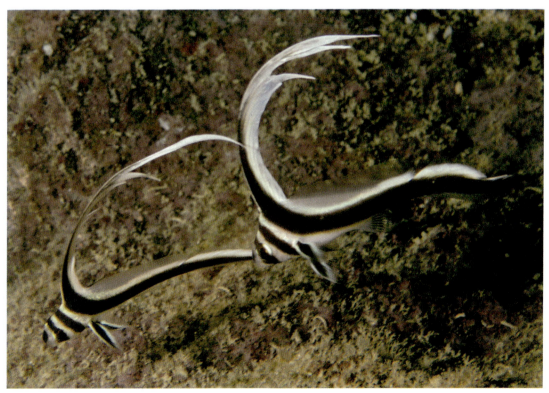

5.28 Juveniles lack spots and have a long front dorsal fin. The spotted drum is nocturnal and shelters under coral by day. A similar species of drum. *E. lanceolatus*, the jackknife fish, lacks the nose spot and fin spots of *E. punctatus*. Another, *Pareques acuminatus,* the high-hat, is striped differently. About actual size.

Thalassoma bifasciatum
Bluehead Wrasse

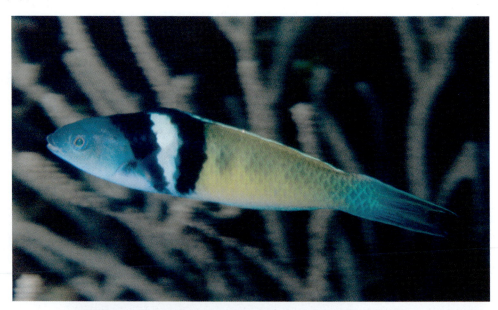

5.29 The bluehead wrasse terminal phase male, or supermale, is common swimming about on the shallow reef and does not flee when approached by divers. It swims with its pectoral fins and appears to drag its tail behind. Though the most noticeable, terminal phase males make up only 4% of the population. Length is about 15-20 cm.

5.30 (right) Blueheads have complicated coloration and sexual physiology. Juveniles and what are known as initial phase males and females can all exhibit three different color patterns, and they can change from one to another quickly. The most commonly seen pattern is shown here: yellow above, white below, with a black spot on the dorsal fin. There may also be black lateral stripes or vertical bars.

Initial phase males mate with females in daily group spawnings, releasing eggs and sperm into the water for fertilization. Supermales form harems and mate with one female at a time.

Both large females and initial phase males can change into terminal phase males.

5.31 (below) Though they would seem to be perfect prey for *Condylactis gigantea*, juvenile blueheads appear to be immune to anemone stings. About actual size.

A Reef Cleaning Station

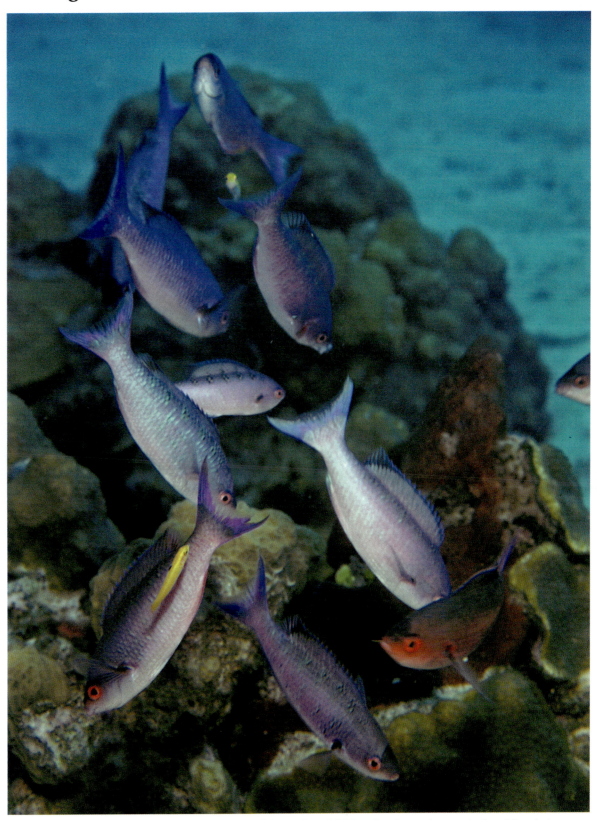

5.32 Small blueheads are the major cleaner fish of the reef, establishing cleaning stations and advertising their availability by doing a little 'dance' to attract clients. Fish wanting to be cleaned will assume a certain posture in the water to indicate that they want cleaning more than to eat the cleaner, and the little blueheads then nip off external parasites and dead tissue from the skin and scales. Here the client fish are creole wrasses, *Clepticus parrae*.

Clepticus parrae
Creole Wrasse

5.33 The creole wrasse is found in large schools on the fore-reef slope and the edge of drop-offs as well as on the reef top. It eats small zooplankton and has small teeth in a small mouth. They can reach 30 cm in length. There are a few brown chromises in this group.

Wrasses are members of the very large family Labridae. *Halichoeres garnoti*, the yellowtail wrasse, can be seen in fig. 2.8.

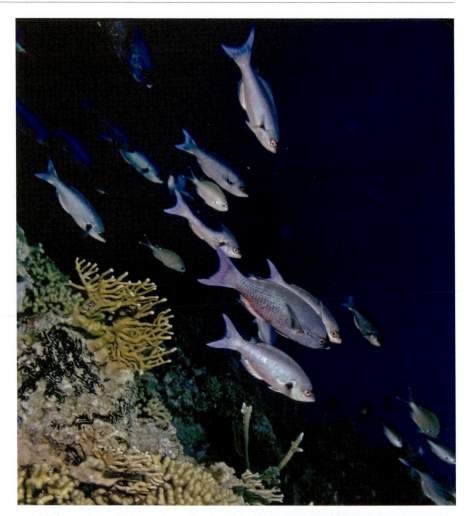

5.34 (below) The light of the underwater flash reveals other colors in the creole wrasse. Older individuals are more likely to have yellow or reddish areas on the underside (see previous page). The dark blue-black nose spot is characteristic.

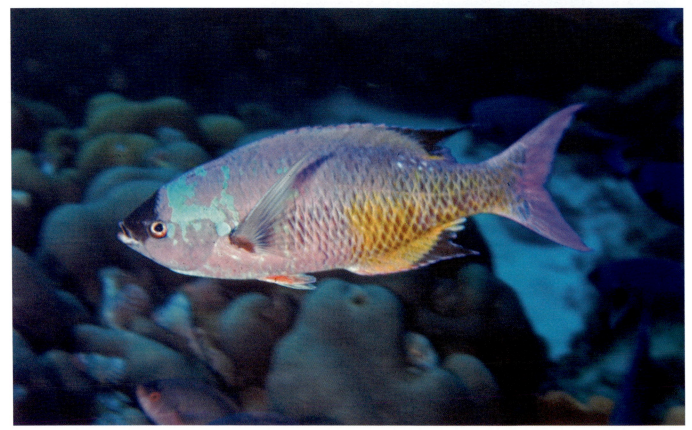

Chapter 5 Fishes 143

Aulostomus maculatus
Trumpetfish

5.35 The trumpetfish is a stealthy predator that feeds on small fish like the bluehead wrasse. It hides near sponges or this *Antillogorgia,* moving back and forth with the surge until its prey is close enough to catch. This individual is 60-70 cm long, though lengths up to 1 meter have been recorded.

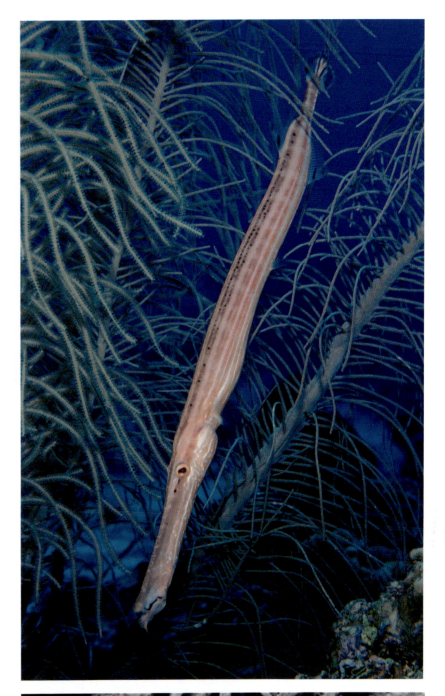

5.36 (right) The association between trumpetfish and alcyonaceans begins at an early age. This juvenile hiding in an *Antillogorgia* is shown here about actual size.

5.37 (below) The trumpetfish can change color rapidly. Brown is typical but blue, gray, yellow, and green are all possible.

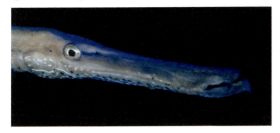

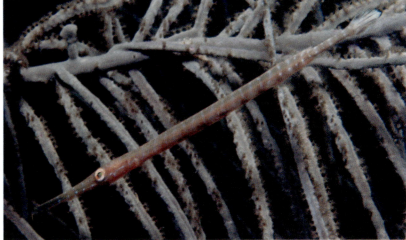

Epinephelus striatus
Nassau Grouper

5.38 The Nassau grouper feeds during the daytime by sucking small fish or crustaceans into its large mouth. Though it can grow to over a meter in length, it is a popular fish for eating and is overfished in most places, so that seeing a large one is very unlikely. The striped pattern is characteristic. Length of this example is about 30 cm.

Groupers are in the subfamily Epinephelinae of the family Serranidae, the same one that includes the hamlets. They begin life as females and change to males upon reaching a certain size.

Epinephelus guttatus
Red Hind

5.39 Both the red hind and graysby have red to brown spots on a light or darker background. The red hind can have faint banding on the sides. The tail and rear fins have dark margins edged in white, and there are no spots on the dorsal fin or tail. Length 25 cm, can grow to 70 cm.

Chapter 5 Fishes 145

Epinephelus fulvus
Coney

5.40 The coney is a smallish grouper with highly variable coloring. They can be red or brown above and white below, or solid brown or brilliant yellow-gold. All color phases have two black spots on the upper edge of the base of the tail and two black spots on the lower lip. Length 20 cm, can grow to 40 cm.

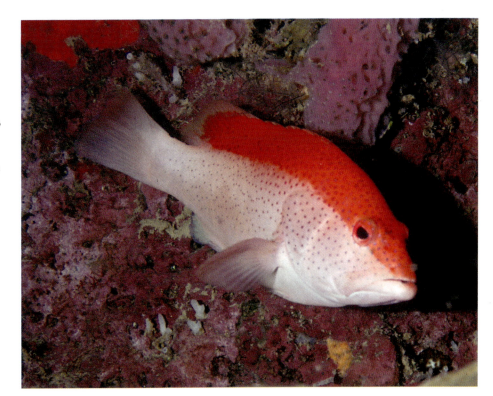

Epinephelus cruentatus
Graysby

5.41a (below) and **5.41b** (right) The graysby is smaller at maximum size than the red hind, though full size groupers are rarely seen. There are three to five dark or light spots just below the dorsal fin, and there are spots on the fins and tail. Length 20-30 cm long, can grow to 40 cm.

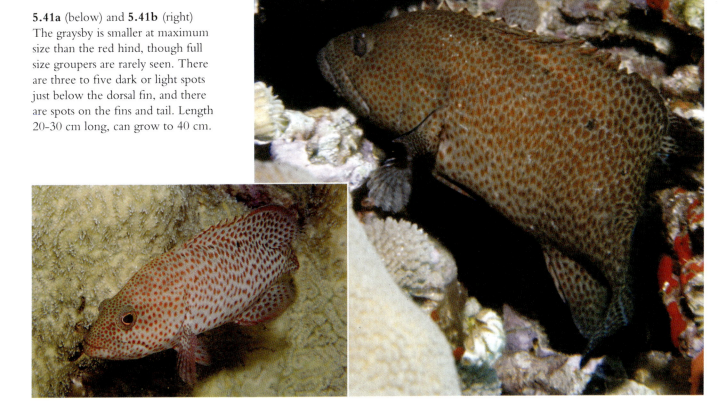

Gramma melacara
Blackcap Basslet

5.42 These two basslets are found in the shelter of coral overhangs and on walls. The blackcap basslet is found at greater depths. The length is 8-10 cm, or approximately actual size here.

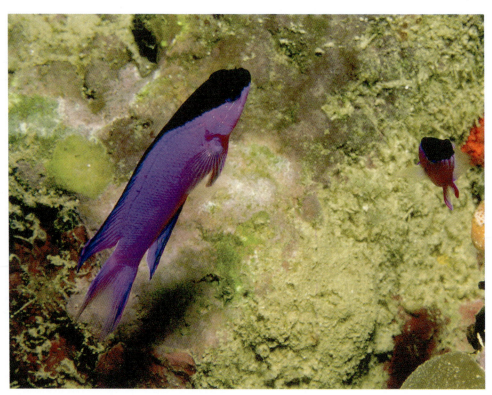

Gramma loreto
Fairy Basslet

5.43 (right) The photo is not upside down. The fairy basslet swims with its ventral surface toward whatever 'bottom' is nearby, no matter what the orientation. The length is 6-8 cm.

5.44 (below) The fairy basslet in a more conventional orientation.

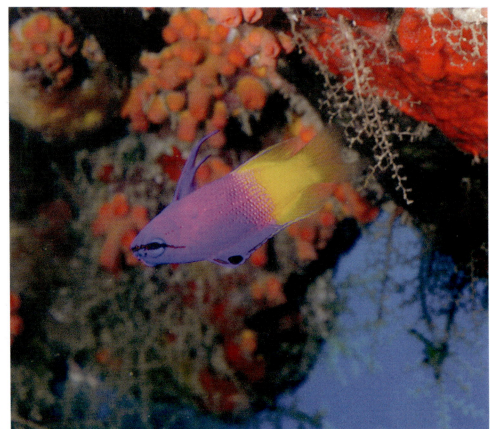

Chapter 5 — Fishes — 147

Synodus intermedius
Lizardfish

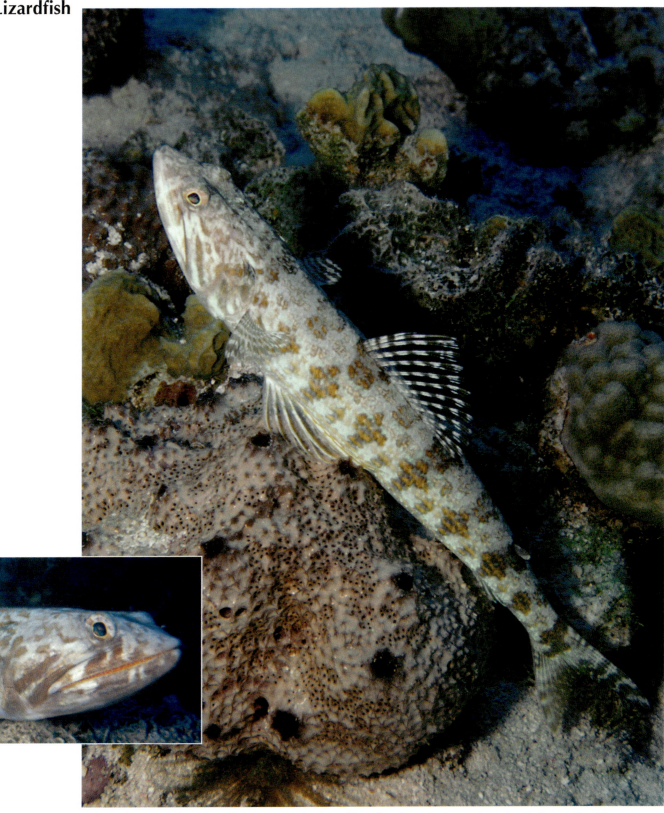

5.45a The 40-cm-long lizardfish is a torpedo-shaped bundle of muscle that waits patiently for smaller fish to pass. It has a large mouth full of sharp teeth and can dart forward very quickly to catch its prey. It is also called the sand diver because it may also burrow and wait half-hidden in the sand. The dark spots and interrupted golden stripes are characteristic. **5.45b** (inset) The very large mouth opening extends back beyond the eye.

Gymnothorax miliaris
Goldentail Moray

5.46 The goldentail moray has a brown body with yellow spots and has a yellow ring around the pupil of the eye. The tip of the tail is yellow or golden, though it is not likely to be seen in the daytime, nor is the full length of up to 40 cm. The *Diadema* spines and dead coral give scale. A row of sensory pits is visible on both the upper and lower jaw.

Moray eels are nocturnal hunters. By day they rest among corals with their bodies protected and only their heads visible. They continually open and close their mouths to pass water over their gills for respiration, revealing their sharp teeth and presenting an intimidating aspect to the passing diver. They can be approached and do not bite unless provoked. Their bodies are covered with a secreted mucous layer that protects against infection.

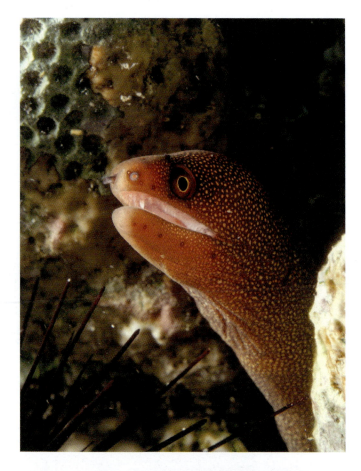

Gymnothorax moringa
Spotted Moray

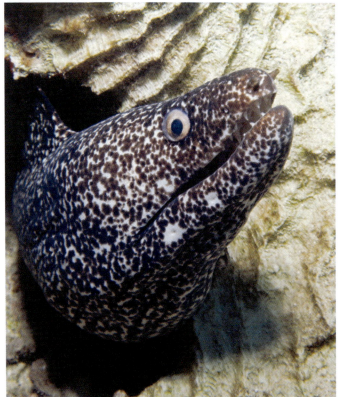

5.47 The spotted moray is common on the shallow reef, peeking out from under a coral shelter, in this case a dead brain coral, probably *Colpophyllia natans*. The length can be over 1 meter.

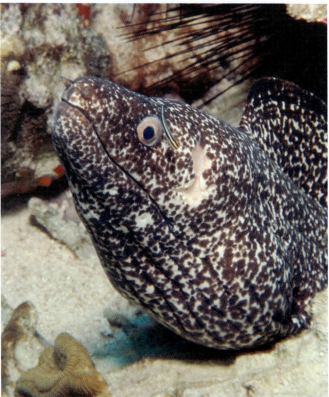

5.48 The other side of the same individual shows a wound that is being attended to by a striped cleaning goby, either *Elacatinus genie* or *Elacatinus evelynae*. (p. 155) The 4-cm cleaner gives scale.

Gymnothorax funebris
Green Moray

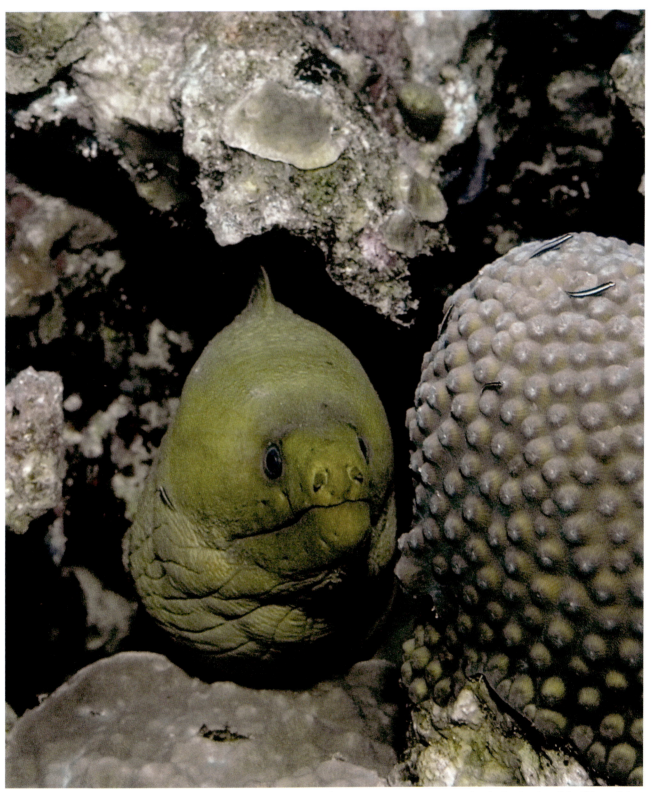

5.49 The *Montastraea cavernosa* and cleaning gobies give scale to this massive green moray resting in its daytime lair. The scaleless skin is actually blue, but the protective mucous layer is yellow, resulting in the green color. Like the other morays, it lacks pectoral fins, and the dorsal, tail and anal fin combine to form one fin that wraps around from just behind the head to the middle of the underside. Green morays can be over 2 meters long, and this one is probably all of that.

Scarus taeniopterus
Princess Parrotfish

5.50 There are many species of parrotfish, and juveniles, initial phase males and females, and terminal phase males (supermales) of the same species can all be different in appearance, making identification a challenge. Only two are shown here. This supermale princess parrotfish can be distinguished by the bright yellow area behind the gill cover, light stripes on the dorsal and anal fins and tail, and the stripes above and below the eye. Juveniles are striped in black and white and closely resemble the juvenile of the striped parrotfish, *Scarus croicensis*. The length is about 30 cm.

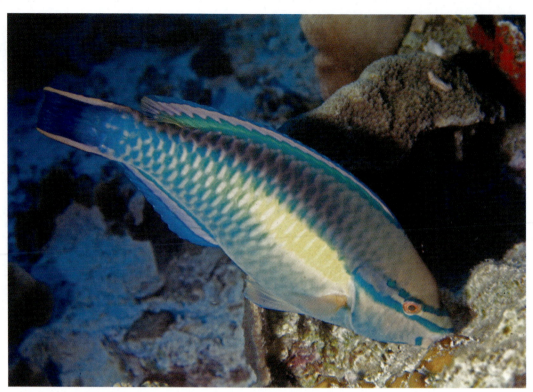

Sparisoma viride
Stoplight Parrotfish

5.51 Terminal phase male stoplight parrotfish are darker than this transitional individual, but the yellow spot on the gill cover, the multicolored tail, and the stripe running back from the mouth are characteristic. Juveniles are darker with white spots; initial phase are red below and have dark-rimmed white scales. Full size is 40-50 cm.

Parrotfish feed on algae and coral by nipping with teeth fused into beaks. The hard part of the coral passes through the fish and is eliminated as waste, contributing to the production of sand on the reef.

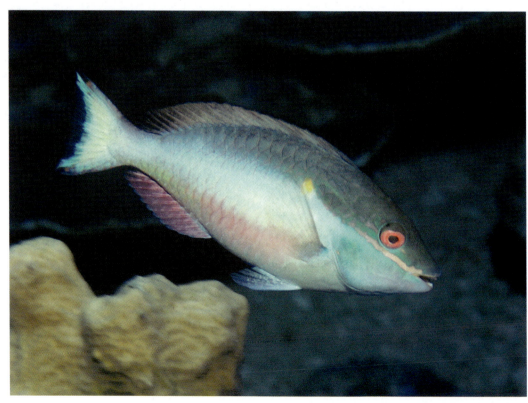

Scorpaena plumieri
Spotted Scorpionfish

5.52 (right) and **5.53** (below) The spotted scorpionfish uses camouflage to wait for prey to come close. It is brown to red and may have branched plumes resembling algae above the eyes. Poisonous dorsal, anal, and pelvic fin spines should be avoided. There are three dark bands on the tail. The length is about 30 cm, maximum 45 cm.

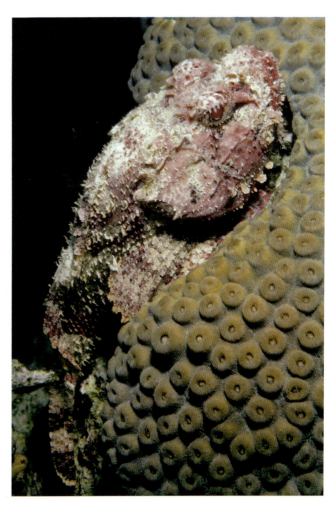

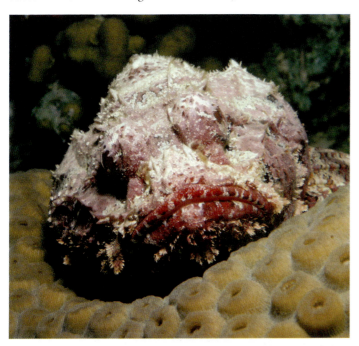

Aluterus scriptus
Scrawled Filefish

5.54 The overall shape of the body and the large tail of the scrawled filefish are characteristic, as are the bright blue and the black spots on an olive to gray background. It is an omnivore, feeding on algae, seagrass, hydroids, alcyonaceans, anemones, and tunicates, and can be found in shallow or deep water and from lagoons to the fore-reef, usually in the shelter of a coral such as this *Acropora palmata*. The common name comes from the abrasive texture of the skin, which is a result of very small spines on the scales. The length can reach 90 cm; this example is about 40 cm.

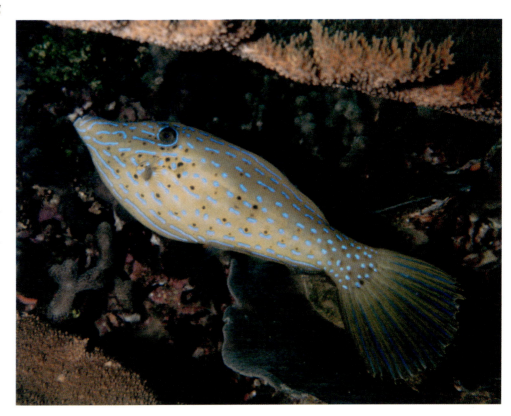

Acanthurus coeruleus
Blue Tang

5.55 The blue tang is in the family Acanthuridae, or surgeonfish, named from the scalpel-sharp spine at the base of the tail. It is more circular in shape than the other surgeonfish, and has long dorsal and anal fins edged in bright blue and a concave tail. It can change from light to dark blue quickly. The juvenile is bright yellow, and since some individuals make the color transition at a larger size than others, it is possible to see yellow tangs that are larger than blue ones, leading to the false impression that the yellow tang is a separate species. Length 15 cm, maximum 35 cm.

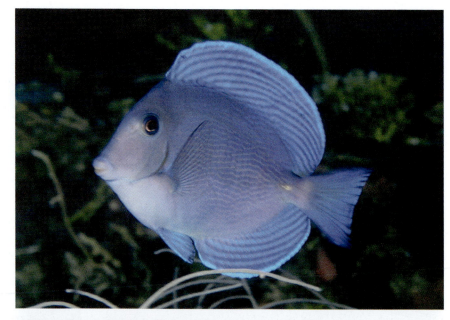

Sphoeroides spengleri
Bandtail Puffer

5.56 The row of spots on the lower part of the body and two dark bands on the tail mark the bandtail puffer, which can take in water to expand its body dramatically to deter predators. In addition, it has short spines that stand up when it inflates. It feeds on small crustaceans, echinoderms, molluscs, and polychaete worms. This example is about 15 cm in length, half the maximum size.

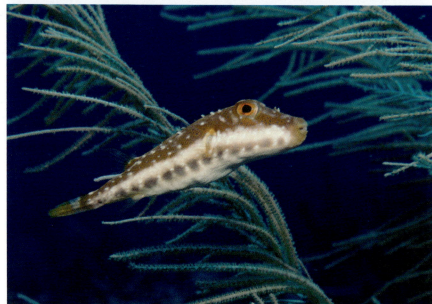

Rhinesomus triqueter
(formerly *Lactophrys triqueter*)
Smooth Trunkfish

5.57 The body of the smooth trunkfish is triangular in cross-section and made rigid by bony plates. There are hexagonal spots on the middle of the side, and large dark spots at the base of the pectoral and dorsal fins. It feeds on small invertebrates in the sand that it uncovers by squirting a jet of water from its mouth. Length of this example is about 12 cm, maximum 30 cm.

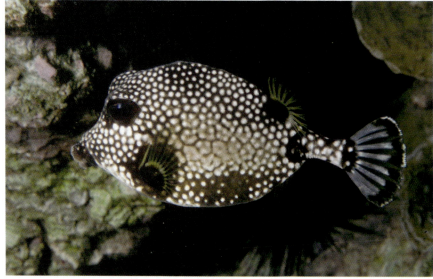

Chapter 5 — Fishes — 153

Diodon holocanthus
Balloonfish

5.58 The balloonfish has large eyes with yellow irises and iridescent green flecks in the pupils. There are long spines on the head and body. The body may be brown or tan, with a band of darker color across the head. Like the puffer opposite, it will inflate its body when it feels threatened, causing its long spines to stand erect, though it can raise its spines without inflating. The strong mouth easily crushes molluscs, urchins, and crabs that it hunts at night. This example is 30-40 cm in length; the maximum is 50 cm.

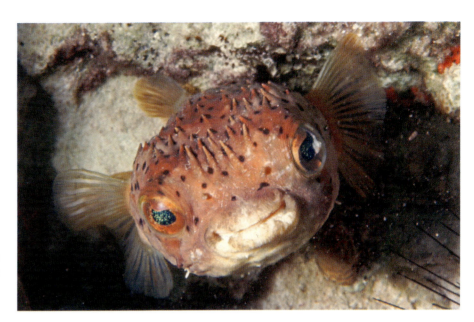

Chilomycterus antennatus
Bridled Burrfish

5.59 The bridled burrfish has dark spots on its body, and dark blotches, which may have light margins, above the pectoral fins and elsewhere. The irises are gold and also have spots like those on the body. The pupils have iridescent green flecks. The spines are always erect. Length of this example is 30-40 cm; the maximum is 50 cm.

The porcupinefish, *Diodon hystrix*, also inflates when threatened, but the spines are erect only when it is inflated. It also has small dark spots, but they can also be on the fins, and its pupils are clear black. It is also much larger than these, reaching 90 cm.

The thin leafy coral at the top of this view is *Agaricia lamarcki,* and the one at the bottom is *Helioseris cucullata.*

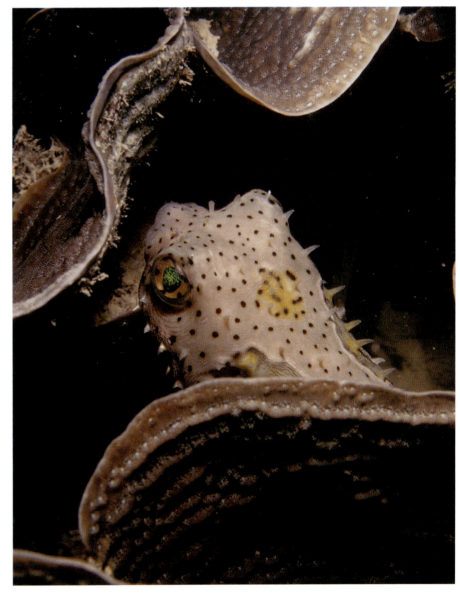

Acanthemblemaria rivasi
Spotjaw Blenny

5.60 A close look will reveal the small fish of the reef, mostly blennies and gobies. There are very many species of both. All those shown here have a maximum length of 3-5 cm. The spotjaw blenny was first described in 1970. Its red eyes, black spots below the eyes, and habit of dwelling in empty worm holes in coral or sponge are characteristic. Also see fig. 3.99.

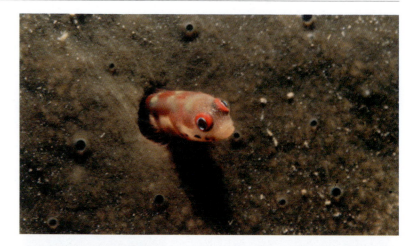

Acanthemblemaria maria
Secretary Blenny

5.61 Many blennies have fleshy appendages called cirri on their heads that resemble algal filaments or hydroids and provide camouflage. The white spot near the eye and cirri intermediate in shape to those of *A. aspera*, the roughhead blenny, and *A. spinosa*, the spinyhead blenny, indicate that this is a Secretary, though field identification would be difficult, especially with most of the body hidden. It was described in 1961.

Lucayablennius zingaro
Arrow Blenny

5.62 The long continuous dorsal fin of the arrow blenny is one of the characteristics shared by blennies that differentiates them from gobies, which have two dorsal fins. Described in 1957, the arrow blenny can be recognized by its long, pointed snout and habit of keeping its tail bent so it can dart forward and seize its prey. The length is about 4 cm.

Coryphopterus personatus
Masked Goby

5.63 The masked goby, 1.5-3 cm long, is largely transparent, has an interrupted white stripe on its side, occurs in groups, and is prey to the not-much-larger *Lucayablennius zingaro*. *Coryphopterus hyalinus*, the glass goby, is so similar that determination in the field is probably impossible, and side-by-side comparison is probably required even in the lab.

Elacatinus species
Small striped cleaning gobies

5.64 We have seen cleaning gobies in pictures of larger fish (figs. 5.48 and 4.59). There are a number of very similar species that probably would be difficult for an expert to distinguish from one another in the field. They are curious and not afraid if approached slowly, treating the diver's hand like just another part of the reef, perhaps in need of a cleaning. These were all described (by Böhlke & Robins) in 1968 in the genus *Gobiosoma*, though *Elacatinus* is now the accepted genus name.

Elacatinus evelynae
Sharknose Goby

5.65 Unlike the casual observer, scientific experts require specimens to definitively identify very similar species. The sharknose goby is described to have an 'underslung' mouth like a shark's, rather than a 'terminal' one at the forward end of the head. There are three color varieties. One has a white V on the nose and bluish-white stripes, as here, and these can probably reliably be called the sharknose. So can the variety with a yellow nose V continuing to yellow stripes.

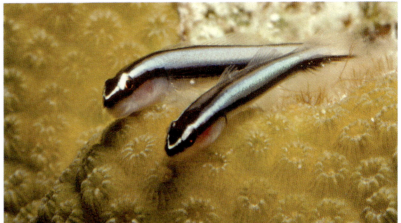

Elacatinus genie (?)
Cleaning Goby (?)

5.66 The cleaning goby is also described as having an underslung mouth. It always has a yellow V on the head and pale body stripes, but the third variety of the sharknose is similarly described, so this may be a cleaning goby or a variety of sharknose. Are these 'pale-blue' body stripes or only 'pale' stripes? It is probably best to describe a goby with yellow V and non-yellow color stripes as *Elacatinus* 'species'.

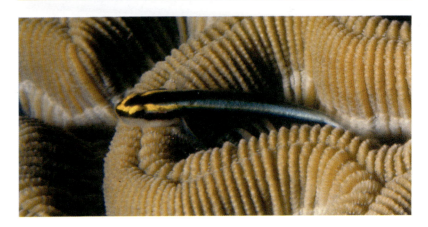

Elacatinus illecobrosus
Barsnout Goby

5.67 The barsnout goby, described in 1968, can be distinguished from the other cleaning gobies by the little white bar on the nose. In addition to these, there are several other little striped cleaning gobies with generally similar characteristics.

Opistognathus aurifrons
Yellowhead Jawfish

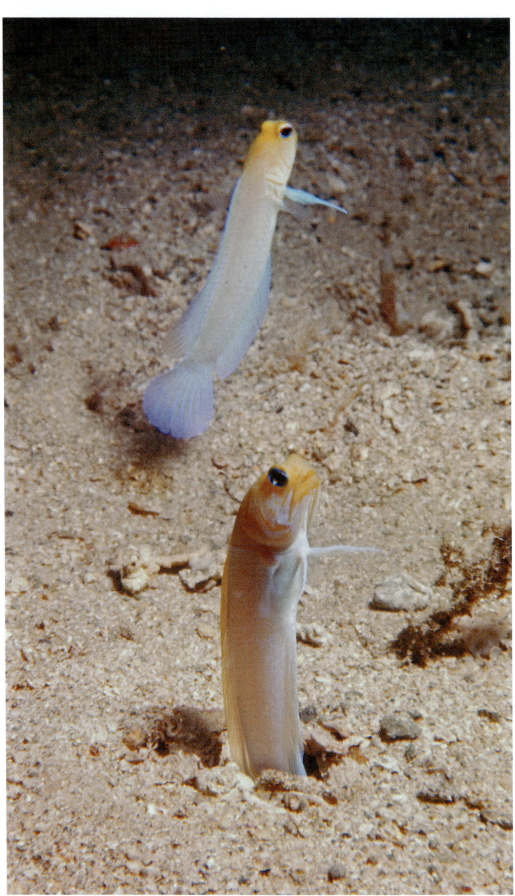

5.68 Sandy areas between coral-covered reef patches are populated by different fish than those of the reef proper. The yellowhead jawfish hovers above the bottom in a vertical orientation and retreats into its burrow tail first if approached too quickly. When it is not hovering above its burrow, it maintains it industriously, making repeated trips into it and emerging with a mouthful of sand or pebbles, which it deposits around the opening. The head is yellow, and the fins and tail are often tinged with blue. They reach 10 cm; these are about actual size.

Malacanthus plumieri
Sand Tilefish

5.69 Like the yellowhead jawfish, the larger sand tilefish swims close to its burrow, but it enters it head first when seeking its safety. It is white below and only slightly darker above, and has long undulating dorsal and anal fins. This individual is 16-20 cm, but the maximum can be 50-60 cm.

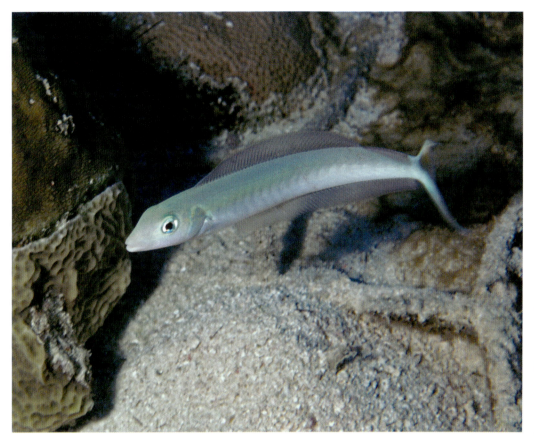

Coryphopterus glaucofraenum
Bridled Goby

5.70 A close look at a sandy or rubbly bottom may reveal any one of several very similar gobies resting on their pectoral fins. This is the bridled goby, named for the white stripe that runs back from the mouth to the gill cover. It can also have bright and brown spots on its translucent body. The length can be up to 7.5 cm. Note the *Elysia crispata* mollusc in the background (see fig. 4.83).

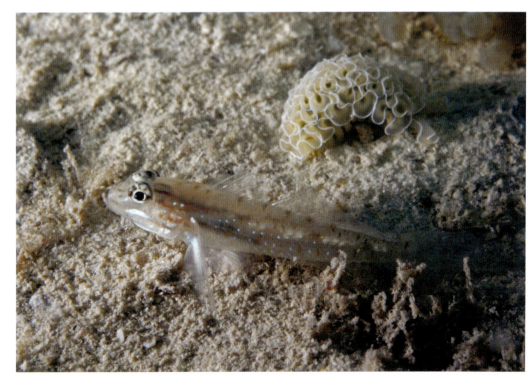

Mulloidichthys martinicus
Yellow Goatfish

5.71 The yellow goatfish is usually seen in small groups either swimming above the corals or feeding on small invertebrates in the sand. It has a distinctive yellow stripe down the side and a deeply forked yellow tail. Below the mouth there is a pair of barbels used for finding prey, which can be tucked away in a pair of grooves when not in use. The length here is about 25 cm, the maximum about 35 cm.

There is a similarly colored fish, the yellow snapper, *Ocyurus chrysurus,* which is larger, lacks barbels, does not feed in the sand, and is a generally sleeker, more powerful looking fish.

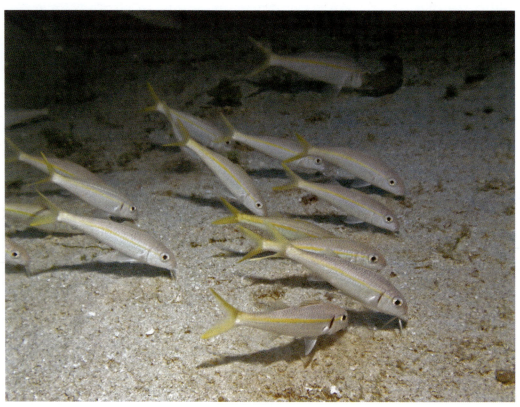

Pseudupeneus maculatus
Spotted Goatfish

5.72 The spotted goatfish also has barbels to search in sand and rubble for food. It has three dark spots on the side, but it can change its color and pattern to a blotchy red and white when it is inactive at night (see fig. 8.14). The length is 20-25 cm.

The fish in the background are juvenile striped parrotfish, *Scarus croicensis,* which are recognizable by the black and white stripes and the yellow nose.

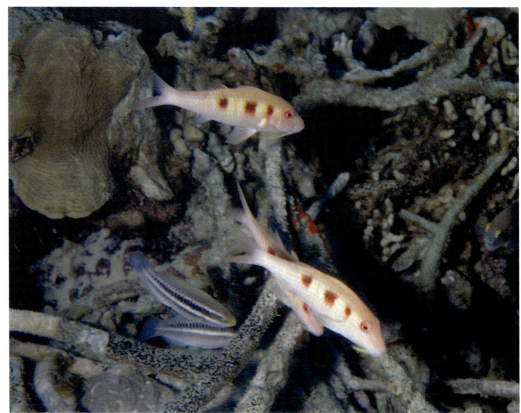

Fistularia tabacaria
Bluespotted Cornetfish

5.73 Typically more than a meter long, the bluespotted cornetfish can grow to two meters. It resembles the trumpetfish superficially but is thinner with a more pointed snout, and the tail has a long central extension. Unlike the trumpetfish, which hides and awaits its prey on the reef, the cornetfish swims in the open over sandy and grassy bottoms near the reef.

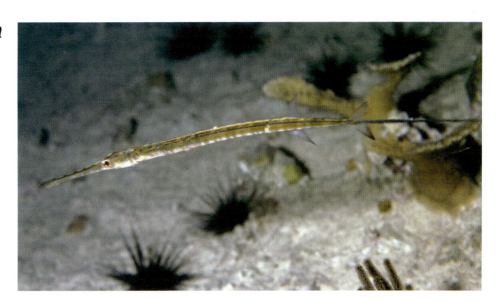

Dasyatis americana
Southern Stingray

5.74 The southern stingray has a flattened, angular body with a pointed snout and pointed tips of its greatly enlarged muscular pectoral fins, which it uses like wings to move through the water. It has a single straight row of spiny bumps down its back, and one or two venomous spines at the base of its long whiplike tail. It frequents sandy bottoms where it feeds on mollusks and crustaceans. Its mouth is on the underside. The body, excluding the tail, can be more than a meter long/across.

Dactylopterus volitans
Flying Gurnard

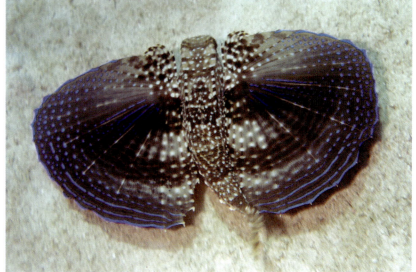

5.75 (left) The flying gurnard uses the separate front part of its pectoral fins, with the larger rear part folded back, to walk on the bottom and search for food.
5.76 (above) When startled, it expands its spectacular pectoral fins, making it look larger and hiding the body within the fins' pattern. Length is 30 cm or more.

Bothus lunatus
Peacock Flounder

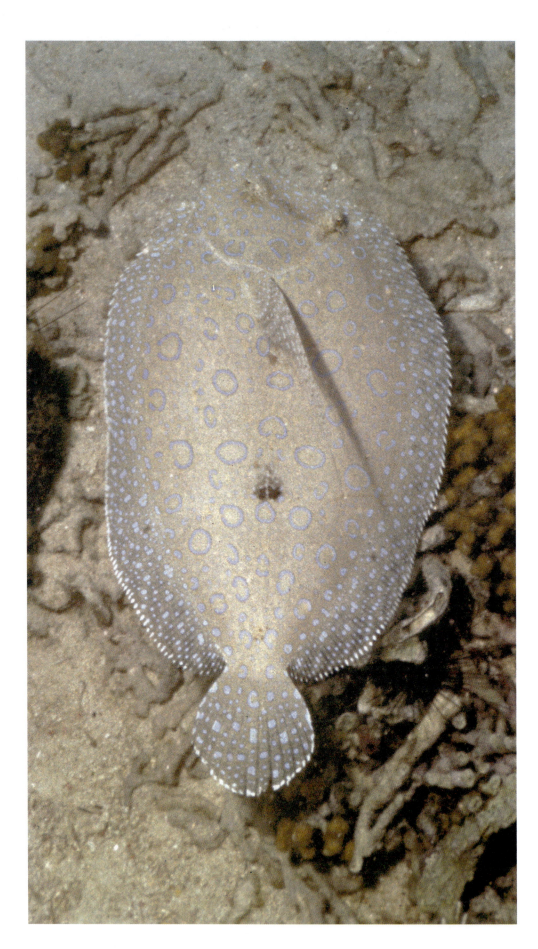

5.77 The peacock flounder has blue rings on the body and blue spots on the fins, tail, and head, though it can change color quickly, darkening when swimming over darker coral and turning pale to match the sand. The pectoral fin is long and often stands upright. It swims by undulating the dorsal and anal fins which encircle almost the whole body. The eyes protrude on bumps raised above the body. The length is 25-35 cm.

The peacock flounder and the yellow stingray opposite show both different and similar ways of adapting to life on a sandy bottom. The flounder begins life as a typical fish with an upright profile, but as it grows, one eye migrates to the other side of the body and it begins to swim on its side, with the eyes on the upper side. Since the fish is on its side, the mouth at the front end, which is difficult to see here, opens side to side rather than up and down, and the tail is horizontal rather than vertical.

Chapter 5　　　　　Fishes　　　　　161

Urolobatis jamaicensis
Yellow Stingray

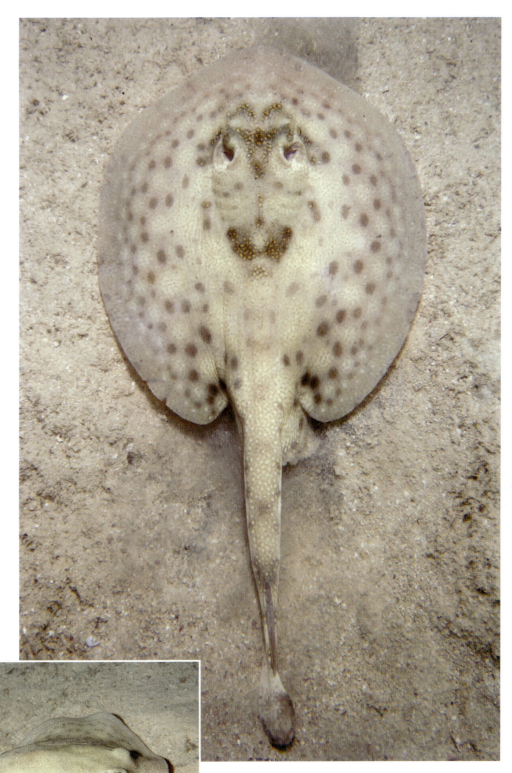

5.78 The yellow stingray is pale yellow with dark spots, though like the peacock flounder it can change its coloration to better match the substrate. The rounded snout and pectoral fins give an overall rounded shape to the flattened disk, which undulates to propel the ray forward. There is a venomous spike between the tapered rear end of the body and the tail fin. The disk can be over a meter, though these examples are 50-75 cm in total length.

Like the southern stingray and other rays, the yellow stingray is related to sharks. Both groups have skeletons made of cartilage rather than the hard bone of all the other fish seen here. The cartilaginous fish are in the class Chondrichthyes. The bony fish are in the class Osteichthyes.

5.79 Settling on the sand, this yellow stingray has faded its dark spots to match the sandy bottom. The undulations of the pectoral fins can be seen here. The ray often flutters them as it settles, stirring up sand that then partly covers it. The flounder does the same. Like the flounder, the ray also has eyes that are raised so it can see when partially buried.

Echeneis neucratoides
Whitefin Sharksucker

5.80 The light tips of the rear dorsal, anal, and tail fins, as well as the white stripes, are characteristic of this small whitefin sharksucker. Like other members of the Echeneidae, the remora family, it has a sucker disk on the top of its head, which it uses to attach to turtles, sharks, and other large fish. Here a small one is shadowing a diver. This individual is about 20 cm; the maximum length can be 70-75 cm.

Aetobatus narinari
Spotted Eagle Ray

5.81 The spotted eagle ray is large and swims gracefully but warily above the reef, slowly flapping its pectoral fins. It is black with white spots and circles on top and white underneath. The head is distinct and extends forward of the pectoral fins. The long tail has several venomous spines at the base. Though it feeds on molluscs in the sand it does not settle on the bottom. Overall length is 2 meters.

6

6.1 An underwater meadow of *Thalassia testudinum* grows in shallow water sheltered from strong wave action by the reef. Commonly called turtle grass, it provides shelter for juvenile reef fish. Those here are probably juvenile *Haemulon flavolineatum,* or French grunts.

The Back Reef

On a Pacific atoll, the shallow area behind the reef crest, usually ringed all around by the reef, is called a lagoon. In the Caribbean the analogous environment is usually the area between the fringing reef and the shoreline, especially where the shoreline forms a small bay. The water is relatively shallow, and the reef or shoreline configuration protects the environment from strong wave action. Some species seen on the reef are also found in the back reef, though others are limited to this calmer environment. The back reef provides a nursery for juveniles of many of the reef's fish.

This is primarily an environment of plants, unlike the reef itself, though it could be argued that the reef is part plant, because the nutrition and growth of the reef corals and alcyonaceans depends on the photosynthetic algal cells in their tissues. Since the previous chapters have focused on the animals of the reef, this one will also include some plants that can be found on the shallow reef as well as in the back reef environment.

163

Thalassia testudinum

6.2 The broad blades of *Thalassia testudinum* are grazed by turtles, parrotfish, and urchins. Other grazers feed on the community of bacterial films, diatoms, and algae that grow on the thalassia. It is a true grass, spreading by means of rhizomes, or horizontally growing roots, that are buried between 5-25 cm deep in the sediment. It also reproduces sexually, producing male and female flowers and, after pollination, seeds. There are several other seagrasses, including the narrow-bladed one mixed in with this *Thalassia*. Seagrasses are an important store of carbon, absorbing CO_2 and giving off oxygen. They also absorb excess polluting nitrogen and phosphorus from coastal waters, and have recently been discovered, by an as-yet unknown mechanism, to reduce the level of bacteria in the water, leading to healthier coral near beds of seagrass.

Acetabularia calyculus

6.3 *Acetabularia calyculus* is a very large single-cell organism with a single nucleus. It has a base, containing the nucleus, a thin stalk, and a cup-shaped cap. The stalk is up to 4 cm tall; the cap is under 1 cm across. Another species, *Acetabularia crenulata,* is twice as large. Important experiments in the mid-20th century using *Acetabularia* showed that the nucleus of a cell contains the genetic information that directs cell development.

Penicillus capitatus

6.4 This alga, commonly called the merman's shaving brush, or shaving brush alga, has a stalk up to 10 cm long topped by a "brush" of calcified filaments. It is common either mixed in with thalassia and other seagrasses or by itself in large groups. A related species, *Penicillus dumetosis,* is similar but with a shorter stalk and larger, looser head. Note also in this view, which is 1.5x to 2x actual size, the community of algae and other small organisms that live on the thalassia blades.

Epinephelus striatus — Nassau Grouper

6.5 This view in the thalassia backreef has species familiar on the reef: a Nassau grouper, *Epinephelus striatus*, and a *Condylactis gigantea* anemone.

Chilomycterus antennatus — Bridled Burrfish

6.6 The bridled burrfish (fig. 5.59) also frequents the sandy bottom of the backreef, hunting molluscs and crustaceans in the sand. The permanently erect spines and spotted irises are visible.

Myrichthys ocellatus — Goldspotted Eel

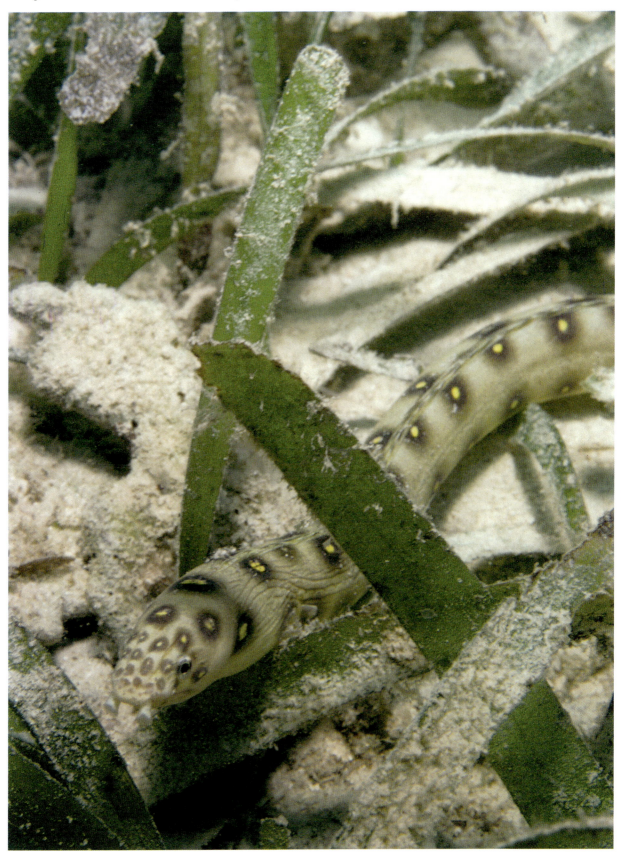

6.7 *Myrichthys ocellatus*, the goldspotted eel, is a snake eel. It has greatly reduced fins and resembles a snake. It hunts at night and can move through the sand. The yellow and black spots and tan body are characteristic. Length: up to 60 cm.

168 The Caribbean Coral Reef: A Record of an Ecosystem Under Threat

Pinna carnea

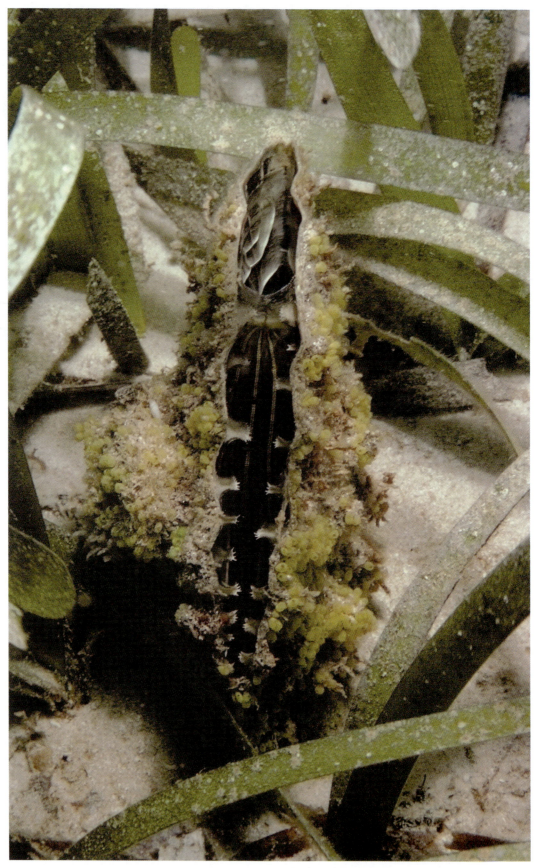

6.8 *Pinna carnea* is a bivalve mollusc with a fan-shaped shell whose narrow pointed end is buried in the sand. Its gills filter planktonic food from the water and pass it to the mouth. The outside of the shell is usually covered with other organisms, here little tunicates. Length of the shell can be 30 cm or more.

Chapter 6 — The Back Reef

Stenorhynchus seticornis

6.9 *Stenorhynchus seticornis*, the unmistakable spidery-legged arrow crab seen on the reef (fig. 4.89), can also be found on the backreef.

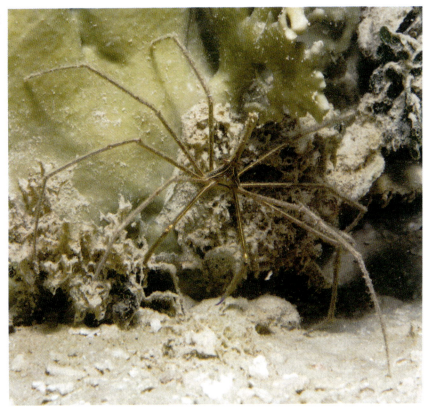

Oreaster reticulatus

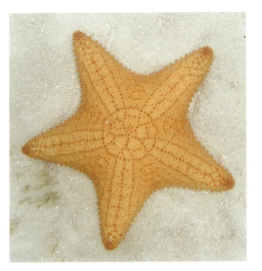

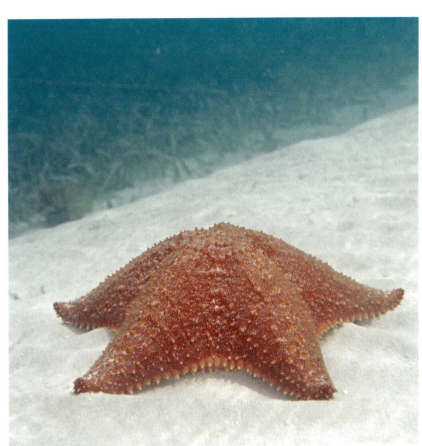

6.10 (above left) *Oreaster reticulatus* gets its name from the pattern of short spines visible on this individual viewed from directly above. Sometimes they stand out in a lighter or darker color, emphasizing the pattern. **6.11** (above right) This member of the class Asteroidea has a thick body and five tapered arms that blend with the body. These are 25-30 cm across; the maximum is about 45 cm.

Meoma ventricosa

6.12 *Meoma ventricosa* is a large urchin with hundreds of short reddish brown spines. In the daytime it may burrow in the sand or cover itself with bits of reef debris. It is somewhat flattened and heart-shaped rather than round. The length is 15-18 cm.

Echinometra lucunter

6.13 The urchin *Echinometra lucunter* can be found both on rocky cliffs in high-wave-action intertidal environments and also on coral rubble in low wave-energy calm-water thalassia areas. The color can be red, black, brown, or green as in this example. In rubble areas it will cover itself with bits of shell or other rubble to help it hide in the daytime. The blades of thalassia give scale in this view, which is approximately life-size. Also see *Echinomerta viridis* in fig. 4.103.

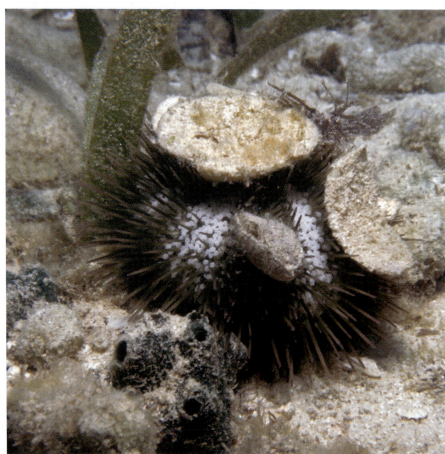

Astropyga magnifica

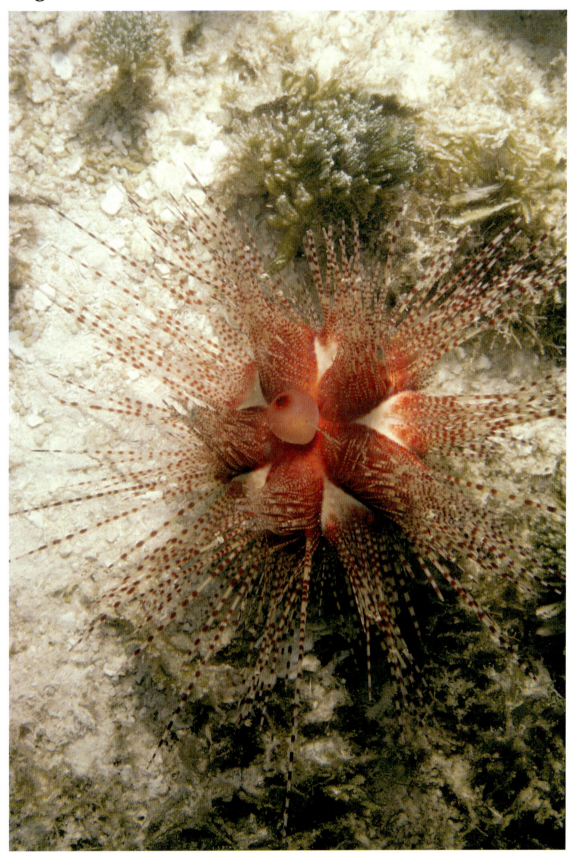

6.14 *Astropyga magnifica* closely resembles the long-spined *Diadema antillarum* except for its unmistakable red and white coloration. They are both members of the family Diadematidae. This one is approximately life-size.

Caulerpa racemosa

6.15 The spherical structures of the alga *Caulerpa racemosa* resemble bunches of small grapes up to .5 cm in diameter. It occurs in a wide variety of water clarity conditions and from shallow depths down to 100 meters. It is an enormous single cell with many nuclei, and organelles like chloroplasts are free to move about the organism. The non-spherical parts seen here are the growing parts that will sprout more grape-like spheres.

Halimeda copiosa

6.16 There are numerous species of *Halimeda* calcareous algae. They all have connected flat green segments which are highly calcified, and *Halimeda* flakes are a major component of the sandy sediment on the reef. Like *Caulerpa*, to which it is related at the order level, it is a multinucleate single-cell organism. *Halimeda copiosa* forms long chains of segments with a thin connection between them. The segments are about 1.5 cm wide.

Halimeda discoidea is similar, but forms branched chains of segments rather than elongated ones.

Halimeda opuntia is another species, which forms clumps of flakes, and is probably the species seen in the upper right of fig. 4.93.

7

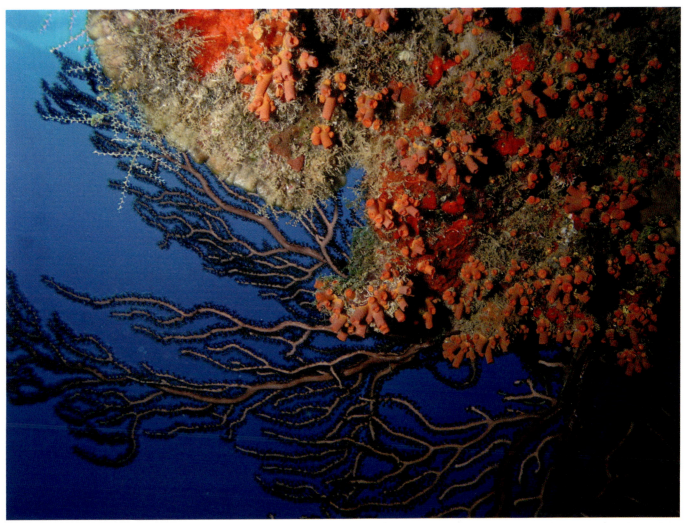

7.1 The orange coral with its polyps withdrawn, *Tubastrea coccinea*, an azooxanthellate ahermatype, inhabits the underside of a coral plate protruding from a wall. The alcyonacean, whose flat growth form filters plankton from passing current, is *Iciligorgia schrammi*.

The Hidden Reef

In some places the shallow reef drops off precipitously to greater depths in the form of a vertical wall rather than an angled slope. In such circumstances the coral at the top of the wall grows out into the light and forms overhangs, creating a shaded environment in which photosynthesizing zooxanthellate corals cannot prosper, allowing other organisms such as sponges, azooxanthellate corals, and tunicates to do so. Many of these are encrusting, while others extend out into the water to trap passing plankton.

Patch reefs growing toward the surface from moderate depth can form canyons, and corals growing faster at their tops can eventually roof over the spaces between them, turning canyons into caves. These dark, still places often contain organisms otherwise found only at greater depths on an open wall. These environments are not normally visited by the casual diver. Though largely hidden, they are still part of the variety of the coral reef. We have already seen some of the organisms found under overhangs and on walls. Here is a closer look at the hidden reef.

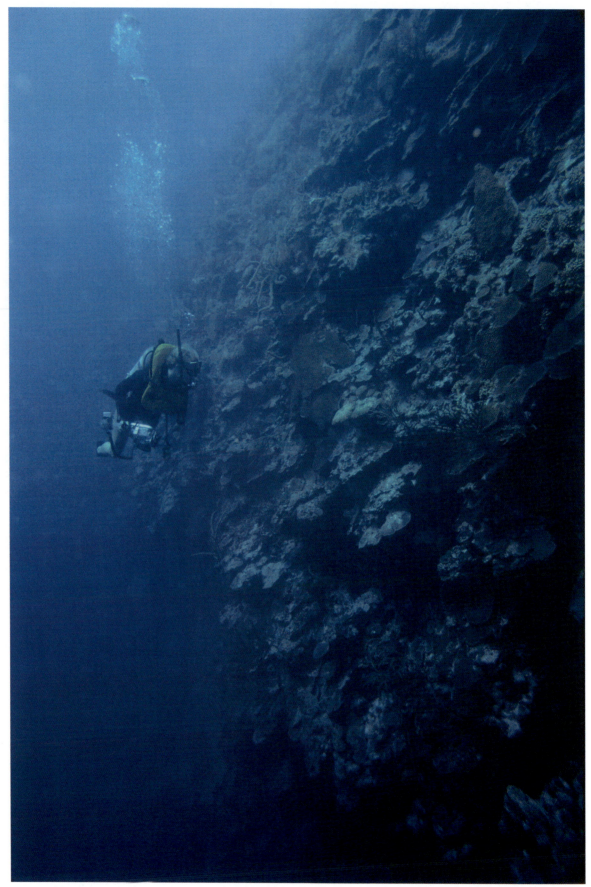

7.2 Flat coral plates project from a vertical wall. Their growth is a compromise between extending straight out to maximize the capture of sunlight and pointing downward to readily shed sediment from the reef above.

Chapter 7 — The Hidden Reef — 175

7.3 The yellowish green single stalk of the antipatharian *Stichopathes occidentalis* is common on the wall. It is straight at the base and spirals at the end. Length is 2 meters.

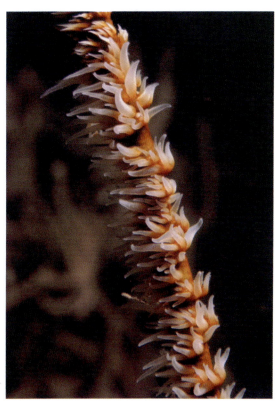

7.4 *Stichopathes lutkeni* is similar in form to *S. occidentalis* but orange or reddish brown with white-translucent tentacles. The polyps are very crowded.

7.5 Translucent tentacles suggest this is *S. lutkeni*, but even experts admit that these two species, similar in spiral shape and often occurring together, are hard to distinguish in the field. It may better to call it *Stichopathes* species.

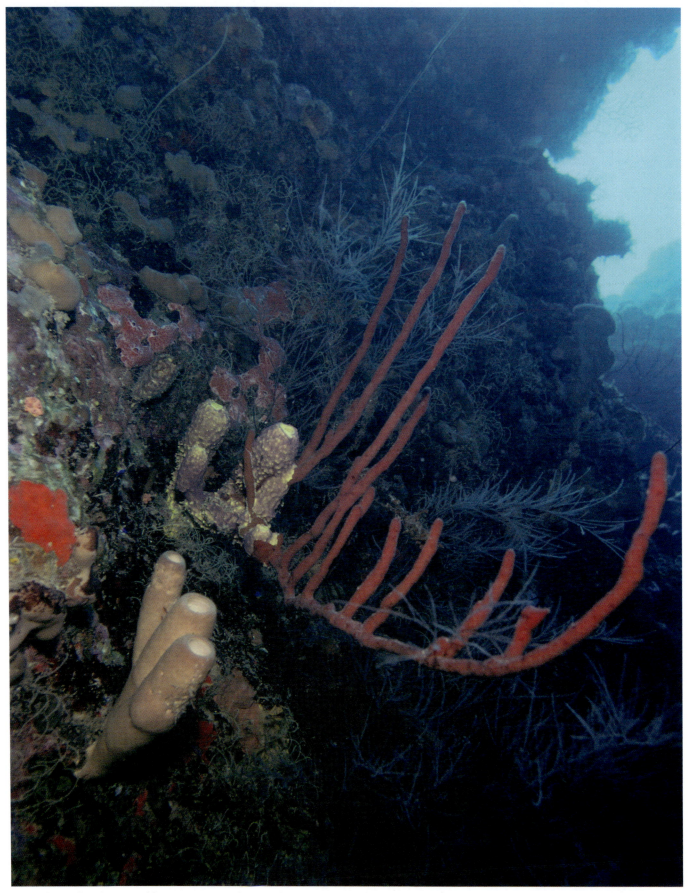

7.6 This wall is dominated by encrusting and upstanding sponges and feathery antipatharians, or black corals. The red sponge is probably *Amphimedon compressa*, the one at its base, *Aplysina archeri*, and the .5-meter one in the foreground, *Aplysina fistularis*.

Chapter 7 The Hidden Reef 177

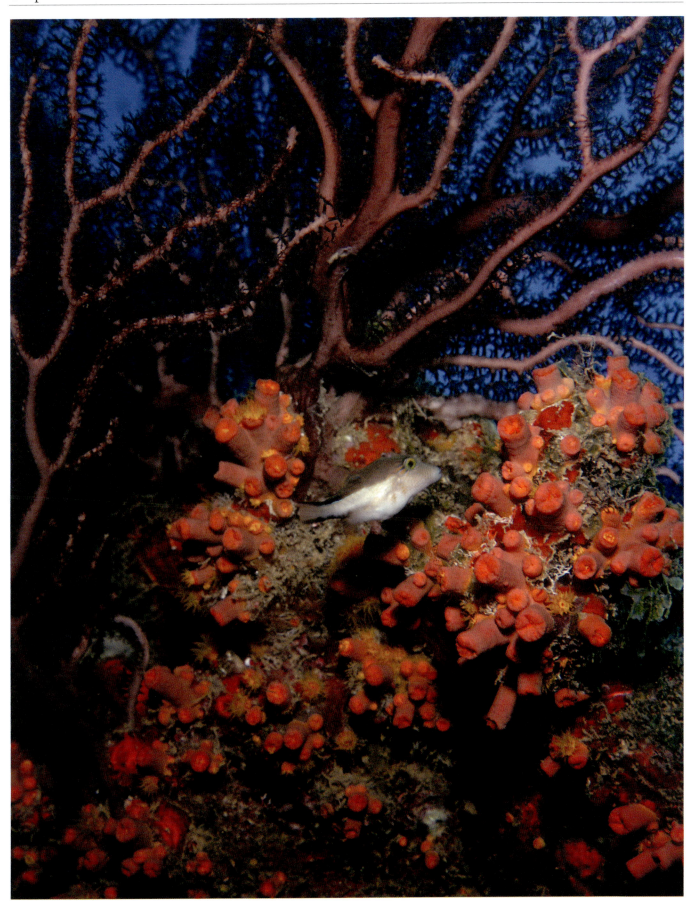

7.7 A small sharpnose puffer, *Canthigaster rostrata,* swims under a coral overhang. Orange *Tubastrea coccinea* cover the underside. The polyps will extend fully at night when plankton is more abundant. *Iciligorgia schrammi* is the branching alcyonacean. About life-size.

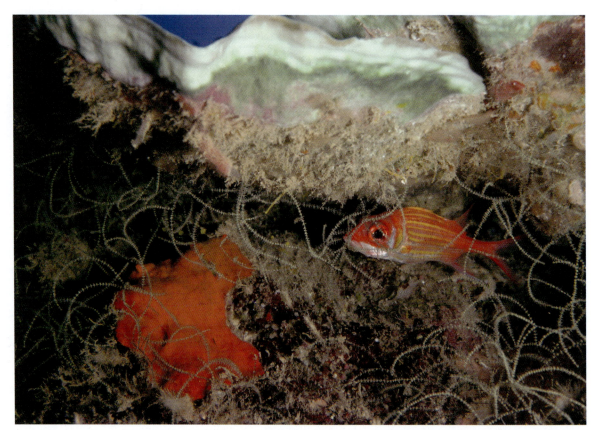

7.8 The underside of this coral plate is free of encrustation at its edge. A longjaw squirrelfish, *Neoniphon marianus*, swims among yellow antipatharians *Antipathes rubusiformis*, described in 2004, known only from Jamaica.

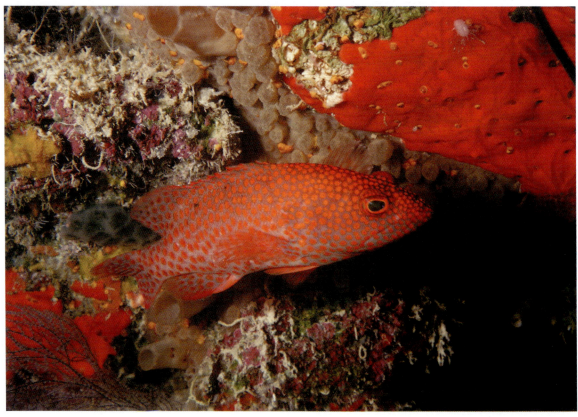

7.9 A graysby, *Epinephilus cruentatus*, with particularly red spots, swims under another coral overhang against a background of red encrusting sponge, brown colonial tunicates, and purple calcareous algae. See also fig. 5.39.

7.10 This surface under a coral overhang is dominated by a species of *Balanophyllia*, a small ahermatypic coral. The color ranges from this intense magenta to orange to light pink to white. The thick septa are characteristic.

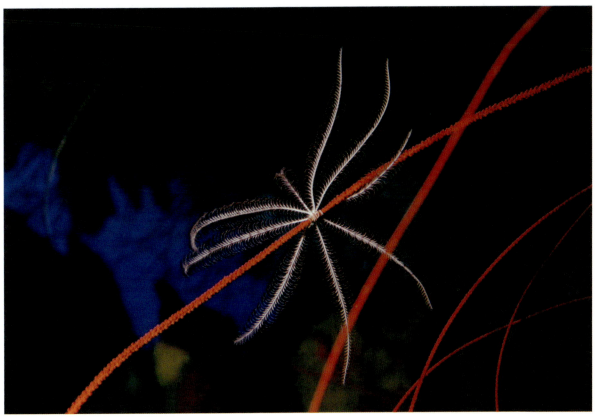

7.11 A crinoid, *Analcidometra armata*, sits on the alcyonacean *Ellisella barbadensis*, near the entrance to an overroofed cave. The blue of the open water is visible in the background. The gorgonian's white polyps are withdrawn.

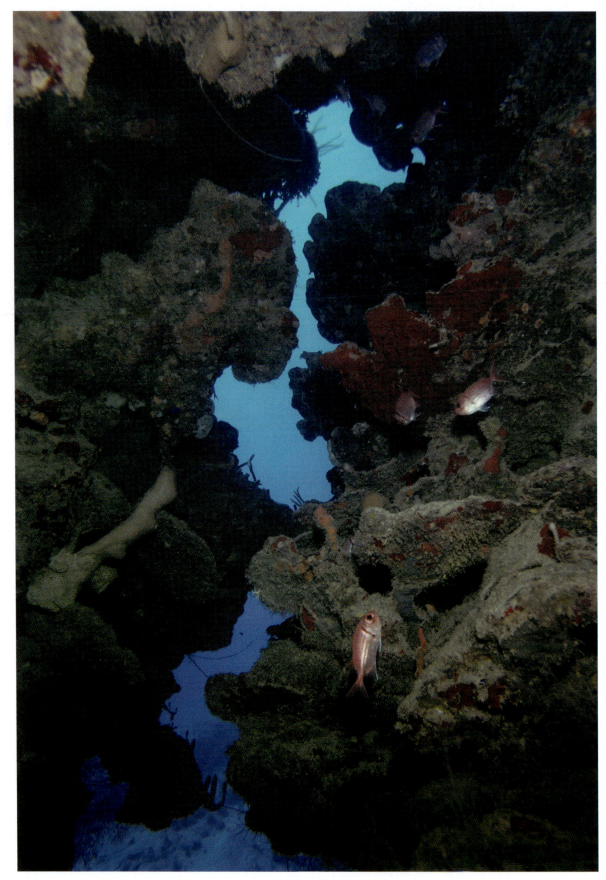

7.12 The initial stage of cave formation is the slow upward growth of adjacent patch reefs. The blue of the open water in the background is the source of the light that aids in the nourishment of corals growing into the gap. The faster coral growth nearer the surface closes the gap at the top and creates a roof over a cave.

Chapter 7 The Hidden Reef 181

7.13 This cave is not completely roofed over. A thin horizontal agariciid coral catches what light shines down into the cave through an opening at the top. Sediment from the reef above has accumulated on upward-facing surfaces, limiting the settling of most organisms to downward-facing ones.

7.14 The cave opening leads to passages that are ever narrower until it is not possible to enter them, but only to look into them. Here sediment from above covers upper surfaces, limiting the settling of organisms.

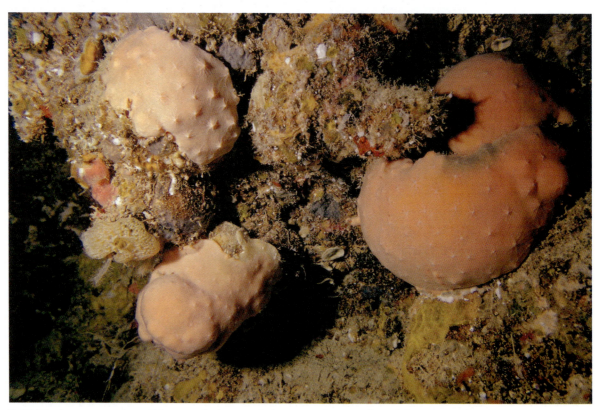

7.15 The largest organism of the caves is the rounded, orange *Ceratoporella nicholsoni,* a coralline sponge, a type of sponge with soft tissue covering a hard calcium carbonate skeleton, found on deep walls and in caves formed by reef growth in shallower water. Fossil coralline sponges are known from the Cambrian period. About 15-30 cm.

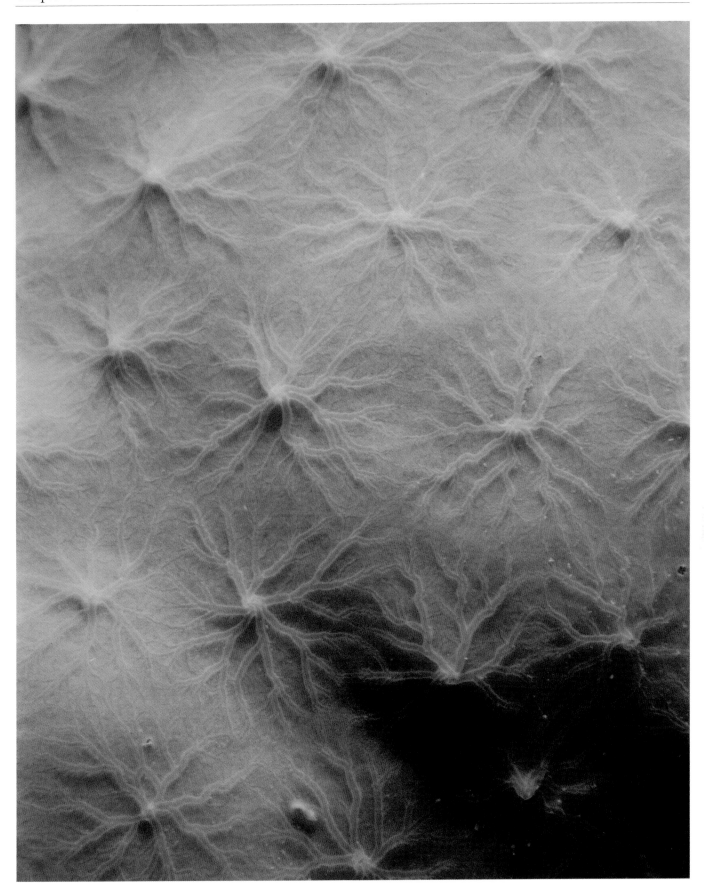

7.16 The surface of *Ceratoporella nicholsoni* exhibits the pattern of radial channels leading to a central exhalant oscule seen on encrusting sponges. In this case the living tissue is "encrusting" on a hard calcareous skeleton, which is deposited by the soft tissue at a very slow rate, adding about a millimeter of dense calcareous skeleton a year. This view is approximately twice actual size.

184　The Caribbean Coral Reef: A Record of an Ecosystem Under Threat

7.17 (above) Two additional species of coralline sponge inhabit the deeper recesses of the cave, slowly building the reef from the inside. A rounded, massive white *Stromatospongia norae* is at the top of this view, being overgrown by one of two *Goreauiella auriculata,* which grows in a thin, flattened form that is pedunculate rather than encrusting. These are approximately life-size.

7.18 *Goreauiella auriculata* can grow in significant densities on cave walls, slowly filling the cave cavities and helping to solidify the reef.

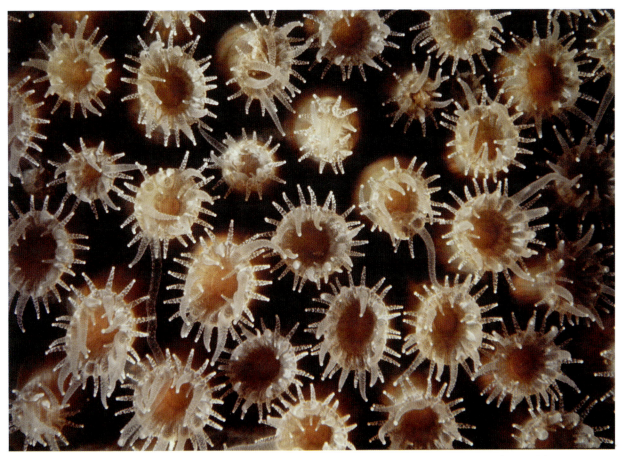

8.1 *Montastraea cavernosa* extends tentacles for feeding at night. The long "sweeper" tentacles are also used for aggression against other coral species at the colony's edge. The white spots are clusters of stinging cells. About twice life-size.

The Reef at Night

A fundamental change occurs on the reef each night. As the light dims at sunset, an upward migration of tiny animals, collectively called zooplankton, begins. Most of them avoid the light and predators by retreating to deep water during the day, but at night they rise to feed on the planktonic plants, or phytoplankton, that live only in the upper water where the sunlight they need for photosynthesis penetrates in abundance. The zooplankton are in turn eaten by corals and many other reef animals.

Though some corals also feed in the daytime, night is the primary feeding time because of the greater abundance of zooplankton in shallow water. Like their kin the anemones, corals have stinging tentacles surrounding the mouth. Though usually withdrawn and hidden in the daytime, at night the tentacles are extended out into the water to catch tiny prey passing in the current. White spots on the otherwise clear tentacles are clusters of cells bearing specialized structures called nematocysts. These react to contact extremely quickly and, depending on the type of structure, ensnare or adhere to the prey or penetrate and inject a paralyzing toxin.

Most of the familiar reef fish sleep hidden in crevices in the reef at night, while others like the moray eel hunt night-active prey. Similarly, some invertebrates such as the octopus and many echinoderms and crustaceans are active and can be seen only at night. As on land, the cycle of night and day allows more and different species to exploit the same environment and resources, increasing the diversity and richness of the reef community.

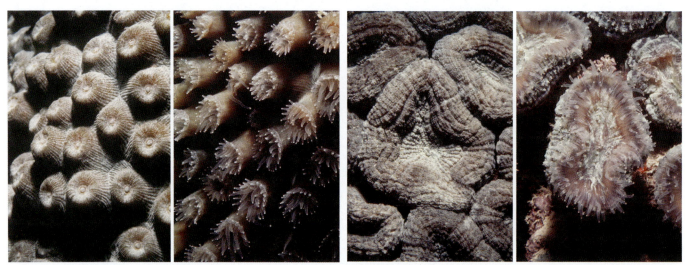

8.2a (left) *Montastraea cavernosa* with tentacles withdrawn in the daytime. **8.2b** (right) At night with tentacles extended to feed.

8.3a (left) *Mussa angulosa* with tentacles withdrawn in the daytime. **8.3b** (right) At night with tentacles extended for feeding.

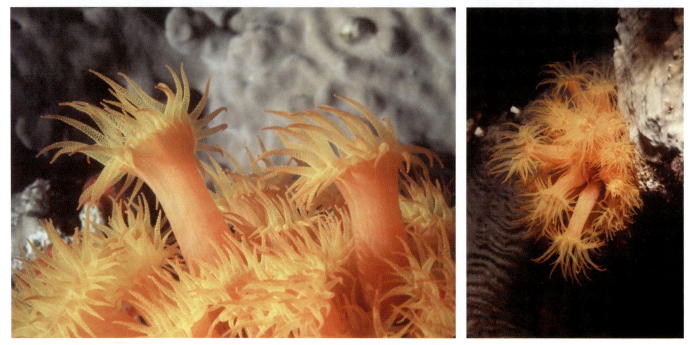

8.4 (left) and **8.5** (right) *Tubastrea coccinea* is an azooxanthellate coral. That is, it does not have symbiotic algae (zooxanthellae) in its soft tissue that can use light energy to produce food that the coral can use. As a consequence, it does not have the brown or green color of the zooxanthellate reef-building corals. Not needing light, it grows in the shade under other corals. It must meet all its nutritional needs by capturing plankton, which it does by extending its tentacles with stinging cells (nematocysts) at night. Also see figs. 3.102 - 3.104.

8.6 These *Tubastrea coccinea* on the underside of a relatively flat coral have their tentacles mostly withdrawn in the daytime. The bright red patches are encrusting sponges. The brown ones are colonial bryozoans, tiny filter feeders in a phylum of their own.

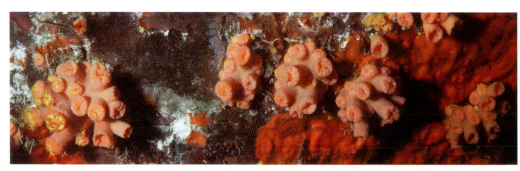

Chapter 8 — The Reef at Night

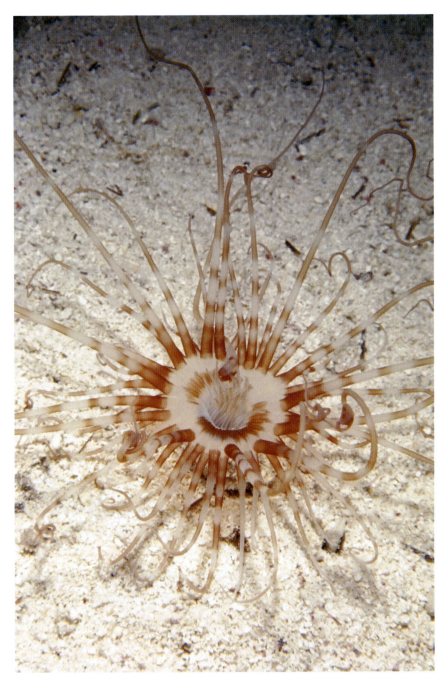

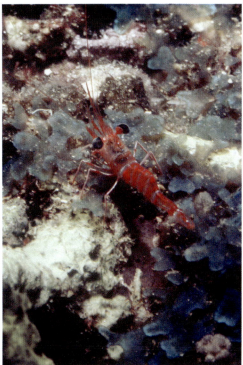

8.7 (left) This cerianthus, *Arachnanthus nocturnus,* is completely hidden in a tube in the sand in the daytime, but extends its body and tentacles out into the water at night to feed. It will quickly withdraw if approached too closely. This one is about 30 cm high. See also fig. 4.45.

8.8 When a dive light is aimed into the distance on the reef, many pairs of reflective red eyes are seen looking back. They belong to this 5 cm long shrimp, *Rhyncocinetes rigens*.

8.10 (below) *Eusmilia fastigiata's* nighttime appearance. About life-size.

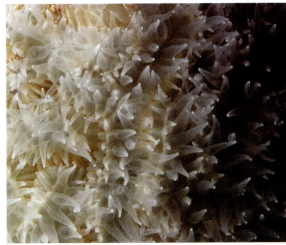

8.9 (right) It is difficult to identify this species in this close view, in which the overall form is not seen and the extended tentacles obscure the skeleton's details. It is probably *Meandrina meandrites*.

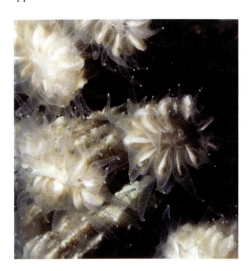

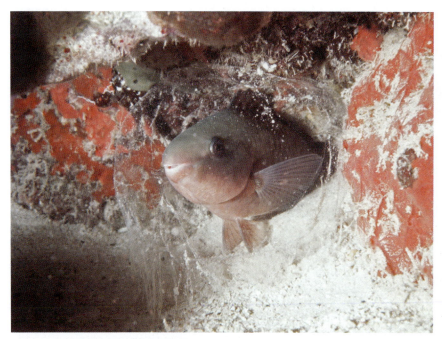

8.11 An unidentified parrotfish beds down for the night in a nook under an overhanging coral. It secretes a mucous bag around itself to discourage any predators.

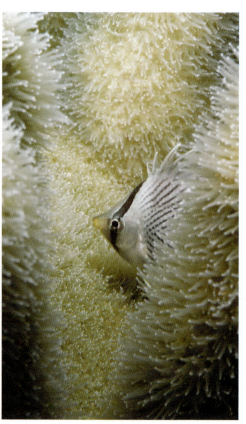

8.12 A fourspot butterflyfish, *Chaetodon capistratus*, finds nighttime shelter in the upright columns of *Dendrogyra cylindrus*, which, unlike most corals, also extends its tentacles in the daytime.

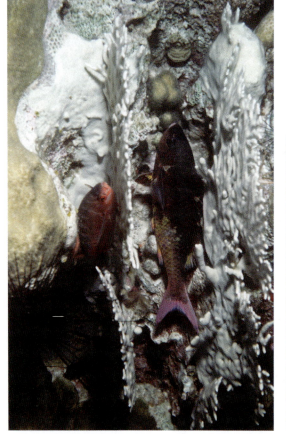

8.13 A parrotfish and a creole wrasse sleep between thin upright blades of the hydrozoan fire coral *Millepora alcicornis*, apparently impervious to its sting.

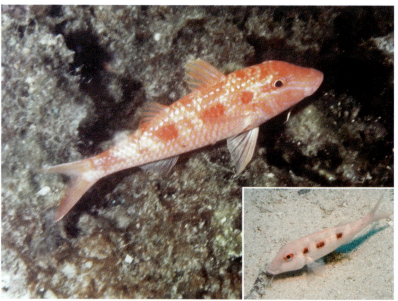

8.14a and **8.14b** (inset) The spotted goatfish, *Pseudupeneus maculatus*, undergoes a dramatic color change at night. By day (inset) it forages for invertebrates hidden in the sand with barbels below its mouth. Also see fig. 5.72.

Chapter 8 The Reef at Night 189

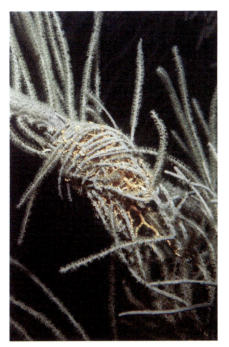
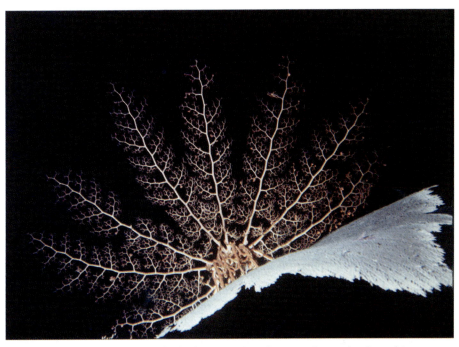

8.15 (left) Ophiuroids, or brittle stars, are mostly nocturnal echinoderms. This basket star, *Astrophyton muricatum,* has branching arms and resembles a tangle of string if seen at all in the daytime. **8.16** (right) At night it climbs onto a *Gorgonia* or a projecting coral or sponge and holds most of its arms in a fan-shaped pattern against the water current, from which it filters planktonic food. If its perch allows, it will unfold all of its arms and assume a circular basket shape, from which it gets its common name.

8.17 By day and night both, ophiuroids commonly associate with sponges. Here, a spiny-armed *Ophiothrix suensonii* climbs on a *Niphates digitalis* sponge, which is also dotted with zoanthids, probably *Umimayanthus parasiticus.*

8.18 This ophiuroid has also climbed onto a sponge at night. It is unknown to the author, and could not be identified visually from the photo by an expert, but that is how it often goes in science. Some things cannot be identified from their appearance alone, and require close examination of details. This is about life-size.

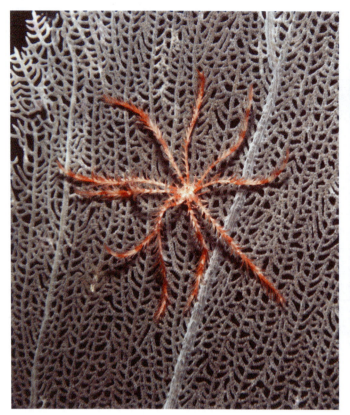 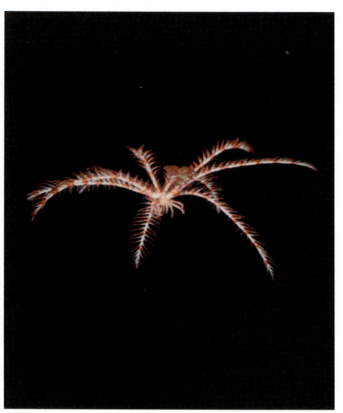

8.19 Not an ophiuroid, but a member of the crinoids, *Analcidometra armata* climbs up on a *Gorgonia* to filter-feed at night.

8.20 *Analcidometra armata* is able to swim if disturbed. Of its ten arms, it synchronously beats alternate arms in two sets of five.

8.21 This is not a red color variant of the spiny lobster *Panulirus*, but the red banded lobster, *Justitia longimanus*. It is less common than the less colorful *Panulirus*, and hides effectively within the reef during the daytime, only emerging to feed and be seen at night.

Chapter 8 The Reef at Night 191

8.22 A close view of the large nocturnal crab *Mithrax spinosissimus*. This partial view is approximately actual size.

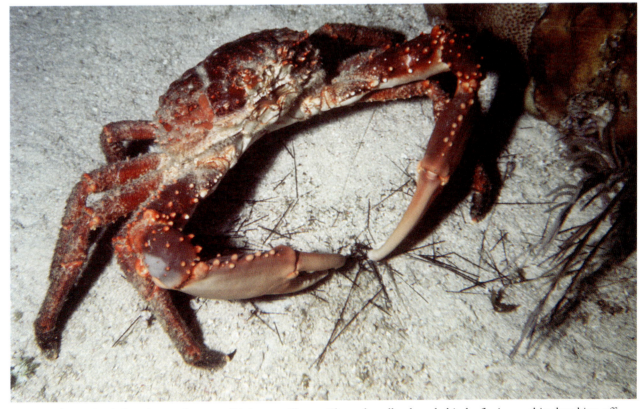

8.23 *Mithrax spinosissimus* is a predator on *Diadema antillarum*. The crab walks along behind a fleeing urchin, breaking off spines until it clears an area big enough to reach and break the fragile shell. This one just finished a night-time meal.

192 The Caribbean Coral Reef: A Record of an Ecosystem Under Threat

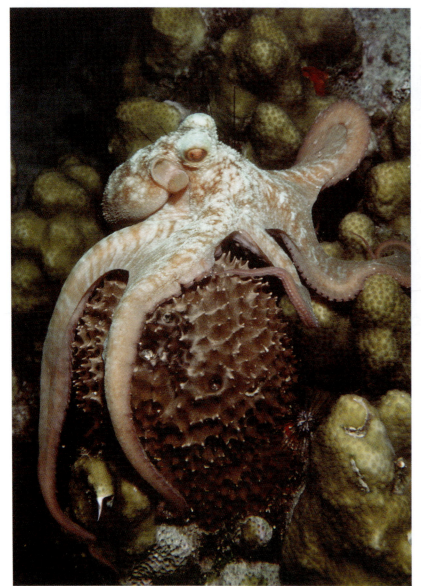

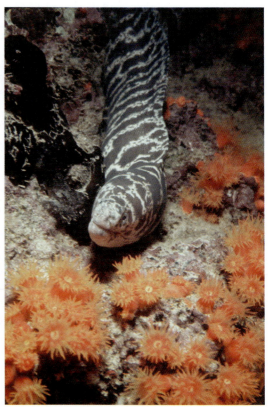

8.25 The chain moray, *Echidna catenata,* hunts for molluscs and crustaceans at night. The length of its body, usually hidden by its daytime lair, is visible as it swims sinuously around the *Tubastrea coccinea* coral.

8.24 A Caribbean reef octopus, *Octopus briareus,* forages freely at night. During the daytime it will squeeze into the smallest of spaces on the reef. The brown sponge is probably a species of *Ircinia*. The coral around the sponge is *Orbicella faveolata*.

8.26 (right) During the day, *Diademas* withdraw into crevices as far as their long spines will allow or, on a sandy bottom, huddle together in a common bristling mass. These are now rare in these numbers.

8.27 (far right) A white variant of the common black spiny urchin *Diadema antillarum* grazes on algae growing on dead coral at night.

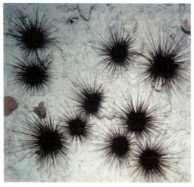

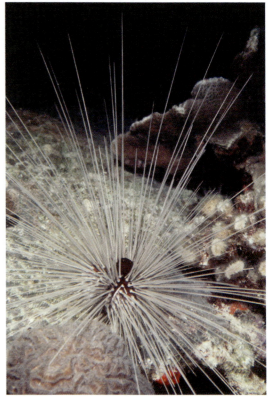

Afterword/Acknowledgements

I was privileged to visit Caribbean reefs in the company of marine scientists engaged in active research in a number of areas of coral biology and reef ecology. This book would not have been possible without their patient and generous sharing of their knowledge.

I am especially thankful to David L. Meyer, my employer for two summers, for introducing me to the reef. Jeremy Jackson and Robert Kinzie took me to 150 feet on my second open-water dive. Carl Roessler and Dick Hoogerwerf were excellent hosts and diving buddies in Curaçao during my one non-marine-scientist trip, providing valuable first-hand observations of animal behavior. Special thanks go to James W. Porter, who always provided information and encouragement and contributed the Foreword to this book. Charles Birkeland provided help and friendship long ago and gave valuable criticism for this book more recently. Judy Lang was most generous with her time, once spending over an hour describing the subtle differences between similar coral species to Jim Porter and me, and also offered valuable criticism for this book. John McCosker was a walking guide to the fishes, especially ones that had not yet appeared in the standard references.

Others to whom I owe thanks are Philip Dustan (pictured signalling the end of a dive), with whom I buddied regularly for a three-week period while working on a special project on coralline sponges. Dr. Es Hamid and his wife Lillian facilitated that work and were gracious hosts. Willard Hartman helped by identifying sponges, and Jeremy Woodley, then director of the Discovery Bay Marine Lab in Jamaica, helped with the echinoderms and provided a warm welcome. Terry Hughes also helped with the holothurian species. Eric Lazo-Wasem gave help and enthusiastic encouragement as the book neared completion.

Techniques: A few photographs here were made with a Nikonos, but the great majority were made with a Nikon F in a Giddings Niko-Mar housing. Light came from AG-1B flashbulbs in a home-made flashholder made from a folding-fan type flashgun, powered by a Rolleiflex battery-capacitor unit inside the camera housing. For slightly more distant subjects I always carried some plain AG-1 bulbs to provide the extra red light that the greater distance through the water would absorb. I was able to calibrate flash exposure with distance by processing Ektachrome film in the field with E-4 processing kits. Later, both Ektachrome 64 and Kodachrome 64 films were used. The single B&W photograph, fig. 3.97, was taken during the photography course mentioned in the foreword.

I did not consider writing this book until technology came to the point that I could also do the design myself, for the layout is integral to conveying the information in the photos and captions. Started in PageMaker, it was completed with Adobe InDesign. Typefaces are Bembo, Optima bold/bold italic, and Times.

For better or worse, it is all my responsibility. –WKS

Appendix: Locality List

Here are the localities for the reef photos in this book. Missing figure numbers represent the photos of skeletal coral specimens. The main areas represented are the south coast of Curaçao, the coast of Colombia east of Santa Marta, the coast east of Colon and the San Blas Islands, Panama, and the north coast of Jamaica near Discovery Bay, Rio Bueno, and Montego Bay. Depths given are approximate.

figure	locality	depth	night
cover	Rio Bueno Cricket Pitch, Jamaica	10-15	
1.1	Rio Bueno Cricket Pitch, Jamaica	10-15	
1.2	Discovery Bay Marine Lab (DBML), Jamaica	0	
1.3	DBML, Jamaica	aerial	
1.4 a	West of Montego Bay, Jamaica	aerial	
1.4 b	West of Montego Bay, Jamaica	aerial	
1.4 c	West of Montego Bay, Jamaica	aerial	
1.5	DBML, Jamaica	aerial	
1.6	Sketch by Thomas F. Goreau	na	
1.7	West of Montego Bay, Jamaica	aerial	
1.8	DBML reef crest, Jamaica	5-10	
1.9	Rio Bueno Cricket Pitch, Jamaica	10-20	
1.10	Chalet Caribe, Jamaica	15-20	
1.11	Rio Bueno Cricket Pitch, Jamaica	20-30	
1.12	Pear Tree Bottom, Jamaica	60-80	
1.13	Pear Tree Bottom, Jamaica	60-80	
2.1	Rio Bueno Cricket Pitch, Jamaica	20-30	
2.2	Chalet Caribe, Jamaica	5-10	
2.3	West Rio Bueno, Jamaica	20-30	
2.4a	Rio Bueno Cricket Pitch, Jamaica	15-20	
2.4b	Rio Bueno Cricket Pitch, Jamaica	15-20	
2.5	Rio Bueno Cricket Pitch, Jamaica	20-30	
2.6	West Rio Bueno, Jamaica	20-30	
2.7	Jan-Thiel Baai, Curaçao	25-35	
2.8	Jan-Thiel Baai, Curaçao	15-20	
2.9	DBML-Oz, Jamaica	30-40	
2.10	Chalet Caribe, Jamaica	30-40	
2.11	Koraal Specht, Curaçao	35-45	
2.12	Rio Bueno Cricket Pitch, Jamaica	15-25	
2.13	near Bridge Cove, Jamaica	0-5	
2.14	West Rio Bueno, Jamaica	30-40	
2.15	prob. Rio Bueno Cricket Pitch, Jamaica	30-40	
2.16	DBML-Pinnacle II, Jamaica	40-50	
2.17	DBML-Zingorro, Jamaica	30-40	
2.18	Rio Bueno Cricket Pitch, Jamaica	60-70	
2.19	Rio Bueno Cricket Pitch, Jamaica	50-60	
2.20	DBML-LTM, Jamaica	35-45	
3.1	Cornelius Baai, Curaçao	40-50	
3.2 a	Galeta, Panama	30-40	
3.2 b	Galeta, Panama	30-40	
3.2 c	Galeta, Panama	30-40	
3.4	DBML-Reef Crest, Jamaica	5-10	
3.5a	Rio Bueno Cricket Pitch, Jamaica	5-10	
3.5b	DBML-LTM, Jamaica	10-15	
3.5c	Rio Bueno Cricket Pitch, Jamaica	10-15	
3.6	Jan-Thiel Baai, Curaçao	10-15	
3.7	Salar, Islas San Blas, Panama	15-20	n
3.8	DBML-Pinnacle II, Jamaica	40-50	
3.9	Vaersen Baai, Curaçao	20-30	
3.10	Chalet Caribe, Jamaica	15-20	
3.11	West Rio Bueno, Jamaica	20-30	
3.12	Jan-Thiel Baai, Curaçao	20-30	
3.13	Rio Bueno Cricket Pitch, Jamaica	20-30	
3.15	Jan-Thiel Baai, Curaçao	20-30	
3.16	Jan-Thiel Baai, Curaçao	20-30	
3-17	Mauqui, Islas San Blas, Panama	20-30	
3-18	DBML-Dancing Lady Reef, Jamaica	30-40	
3.19	DBML-Dancing Lady Reef, Jamaica	30-40	
3.20	DBML-Mooring 1, Jamaica	20-30	
3.24	West of Chalet Caribe, Jamaica	35-45	
3.25	West Rio Bueno, Jamaica	35-45	
3.26	DBML-Dancing Lady fore-reef, Jamaica	30-40	
3.27	Rio Bueno Cricket Pitch, Jamaica	35-45	
3.28	Chalet Caribe, Jamaica	45-55	
3.29	Rio Bueno Cricket Pitch, Jamaica	30-40	
3.30	DBML-Elsinore, Jamaica	30-40	
3.31	DBML-East Forereef, Jamaica	30-40	
3.33	Chalet Caribe, Jamaica	30-40	
3.34	DBML-Pear Tree Bottom, Jamaica	40-50	
3.36	Jan-Thiel Baai, Curaçao	20-30	
3.37	DBML-Pinnacle II, Jamaica	40-50	
3.38	Bullen Baai Caves, Curaçao	40-50	
3.40	West Rio Bueno, Jamaica	50-60	
3.41	DBML-Dancing Lady fore-reef, Jamaica	40-50	
3.43	DBML-Oz, Jamaica	30-40	
3.44	DBML-Oz, Jamaica	30-40	
3.46a	Sail Rock, Islas San Blas, Panama	30-40	
3.46b	Jan-Thiel Baai, Curaçao	30-40	
3.48	Salar, Islas San Blas, Panama	30-40	n
3.49	Chalet Caribe, Jamaica	30-40	
3.50	DBML-Dancing Lady Reef, Jamaica	30-40	
3.51	DBML-Pear Tree Bottom, Jamaica	30-40	
3.53	Jan-Thiel Baai, Curaçao	20-30	
3.55	Jan-Thiel Baai, Curaçao	20-30	
3.57	Jan-Thiel Baai, Curaçao	20-30	
3.59	Chalet Caribe, Jamaica	50-60	
3.61	West Rio Bueno, Jamaica	60-80	
3.62	Cornelius Bai, Curaçao	60-80	
3.64	Jan-Thiel Baai, Curaçao	60-80	
3.66	Cornelius Bai, Curaçao	60-80	
3.68	Galeta, Panama	30-40	
3.69	Cornelius Bai, Curaçao	30-40	
3.71	North of Portobello, Panama	40-60	
3.72	Bullen Baai, Curaçao	70-80	
3.73	Vaersen Baai, Curaçao	20-30	
3.74	Jan-Thiel Baai, Curaçao	10-15	
3.76	Jan-Thiel Baai, Curaçao	40-60	
3.77a	Koraal Specht, Curaçao	40-50	
3.77b	Jan-Thiel Baai, Curaçao	40-50	
3.79	Sail Rock, Islas San Blas, Panama	50-60	

3.80a	Cornelius Baai, Curaçao	50-60	
3.80b	Jan-Thiel Baai, Curaçao	50-60	
3.81	Miria, Panama	40-50	
3.82	Chalet Caribe, Jamaica	50-60	
3.83	Rio Bueno Cricket Pitch, Jamaica	50-60	
3.84	Rio Bueno Cricket Pitch, Jamaica	50-60	
3.85	Doctor's Cove Reef, Jamaica	20-30	
3.86	DBML-LTS, Jamaica	20-30	
3.87	Lion's Lair, Chalet Caribe, Jamaica	30-40	
3.88	DBML-Pinnacle II, Jamaica	80-100	
3.89	East Rio Bueno, Jamaica	80-100	
3.90	DBML-LTM, Jamaica	80-100	
3.91	East Side Discovery Bay, Jamaica	20-30	
3.93	DBML-East Forereef, Jamaica	10-20	
3.94a	Mooring 2, Jamaica	20-30	
3.94b	Cornelius Baai, Curaçao	20-30	
3.95a	Chalet Caribe, Jamaica	20-30	
3.96	South coast, Curaçao	10-20	
3.98	South coast, Curaçao	10-20	
3.99	Galeta, Panama	10-20	
3.100	DBML-LTS, Jamaica	5-15	
3.102	Rio Bueno Cricket Pitch, Jamaica	35-45	
3.103	Cornelius Baai, Curaçao	30-40	n
3.106	Lion's Lair, Chalet Caribe, Jamaica	60-80	
3.107	Chalet Caribe, Jamaica	60-80	
3.108	East Forereef, Discovery Bay, Jamaica	20-30	
4.1	Cornelius Baai, Curaçao	40-60	
4.2	Chalet Caribe, Jamaica	15-25	
4.4	South coast, Curaçao	20-30	
4.5	South coast, Curaçao	20-30	
4.6	West Rio Bueno, Jamaica	10-20	
4.7a	Chalet Caribe, Jamaica	15-20	
4.7b	Miria, Panama	15-25	
4.8	Rio Bueno Cricket Pitch, Jamaica	20-30	
4.9	Salar, Islas San Blas, Panama	50-70	
4.10	Galeta, Panama	50-70	
4.11	DBML-Watertower, Jamaica	40-50	
4.12	Red Buoy, Discovery Bay, Jamaica	40-50	
4.13	DBML-Oz, Jamaica	25-35	
4.14	DBML, shallow forereef, Jamaica	20-30	
4.15	Rio Bueno Cricket Pitch, Jamaica	50-60	
4.16	West Rio Bueno, Jamaica	20-30	
4.17	Koraal Specht, Curaçao	20-30	
4-18	DBML-Elsinor, Jamaica	20-30	
4-19	East of Rio Bueno, Jamaica	20-30	
4.20	Rio Bueno Cricket Pitch, Jamaica	20-30	
4.21	Rio Bueno Cricket Pitch, Jamaica	20-30	
4.22	DBML-Elsinor, Jamaica	20-30	
4.23	Playa Chikitu, Curaçao	20-30	
4.24	DBML-LTS, Jamaica	20-30	
4.25	DBML-LTS, Jamaica	20-30	
4.26	Chalet Caribe, Jamaica	30-40	
4.27	Rio Bueno Cricket Pitch, Jamaica	50-60	
4.28	Point, Jamaica	50-60	
4.29	DBML-Pear Tree Bottom, Jamaica	70-80	
4.30	Red Buoy, Discovery Bay, Jamaica	50-60	
4.31	Rio Bueno Cricket Pitch, Jamaica	40-60	
4.32	Bahia Concha, Colombia	30-40	
4.33	Mooring 1, Jamaica	30-40	
4.34	Red Buoy, Discovery Bay, Jamaica	40-50	
4.35	Mauqui, Islas San Blas, Panama	20-30	
4.36	West Rio Bueno, Jamaica	60-80	
4.37	Porto Marie, Curaçao	20-30	n
4.38	Chalet Caribe, Jamaica	30-40	
4.39	Red Buoy, Discovery Bay, Jamaica	40-50	
4.40	Bullen Baai, Curaçao	30-40	
4.41	Doctor's Cove Reef, Jamaica	30-40	
4.42	DBML-Watertower, Jamaica	30-40	
4.43	DBML-Watertower, Jamaica	40-50	
4.44	DBML-Watertower, Jamaica	40-50	
4.45	Vaersen Baai, Curaçao	30-40	n
4.46	East of Rio Bueno, Jamaica	20-30	
4.47	DBML-Watertower, Jamaica	30-40	
4.48	Salar, Islas San Blas, Panama	15-30	
4.49	East Forereef, Discovery Bay, Jamaica	15-25	
4.50	West Rio Bueno, Jamaica	40-60	
4.51	DBML-Pinnacle II, Jamaica	60-80	
4.52	DBML-West Bull, Jamaica	30-40	
4.53	DBML-LTM, Jamaica	30-40	
4.54	DBML-Mooring 1, Jamaica	30-40	
4.55	Playa Chikitu, Curaçao	30-40	
4.57	DBML-Mooring 1	20-30	
4.58	DBML-Mooring 1	20-30	
4.59	Porto Marie, Curaçao	30-40	
4.60	Red Buoy, Discovery Bay, Jamaica	20-30	
4.61	DBML-Watertower, Jamaica	40-60	
4.62	Koraal Specht, Curaçao	40-60	
4.63	Porto Marie, Curaçao	40-60	
4.64	Vaersen Baai, Curaçao	40-60	
4.65	West Rio Bueno, Jamaica	60-80	
4.66	DBML-Watertower, Jamaica	40-60	
4.67	Rio Bueno Cricket Pitch, Jamaica	40-60	
4.68	West of Rio Bueno, Jamaica	50-60	
4.69	DBML-Dancing Lady Reef, Jamaica	20-30	
4.70	Jan-Thiel Baai, Curaçao	20-30	
4.71a	DBML-East Forereef, Jamaica	20-30	
4.71b	Jan-Thiel Baai, Curaçao	20-30	
4.71c	Jan-Thiel Baai, Curaçao	20-30	
4.72	Galeta, Panama	10-20	
4.73	Playa Chikitu, Curaçao	20-30	
4.74	Playa Chikitu, Curaçao	20-30	
4.75	Vaersen Baai, Curaçao	20-30	
4.76	Jan-Thiel Baai, Curaçao	20-30	
4.77	Punta Betin, Colombia	30-40	
4.78	Koraal Specht, Curaçao	20-30	
4.79	North of Portobello, Panama	40-50	
4.80	Galeta, Panama	15-25	
4.81	DBML-Dancing Lady Reef, Jamaica	40-50	
4.82	West Rio Bueno, Jamaica	60-70	
4.83	Galeta, Panama	20-30	
4.84	Sail Rock, Islas San Blas, Panama	30-40	
4.85	DBML-Mooring 1, Jamaica	30-40	
4.86	DBML-Forereef, Jamaica	30-40	n
4.87	Galeta, Panama	30-40	

4.88	Porto Marie, Curaçao	40-50		5.35	DBML-LTM, Jamaica	20-30		
4.89	Salar, Islas San Blas, Panama	50-60		5.36	Miria, Islas San Blas, Panama	20-30		
4.90	DBML-Oz, Jamaica	40-50	n	5.37	DBML-Oz, Jamaica	30-40	n	
4.91	Bahia Concha, Colombia	20-30		5.38	Salar, Islas San Blas, Panama	30-40		
4.92	Rio Bueno Cricket Pitch, Jamaica	60-70		5.39	Galeta, Panama	30-40		
4.93	DBML-Columbus Park, Jamaica	10-20		5.40	Rio Bueno Cricket Pitch, Jamaica	40-60		
4.94	Salar, Islas San Blas, Panama	20-30	n	5.41a	DBML-mooring 1, Jamaica	30-40		
4.95	Galeta, Panama	40-50		5.41b	Jan-Thiel Baai, Curaçao	30-40		
4.96	Red Buoy, Discovery Bay, Jamaica	30-40		5.42	Chalet Caribe, Jamaica	60-80		
4.97	Sail Rock, Islas San Blas, Panama	20-30		5.43	Rio Bueno Cricket Pitch, Jamaica	40-60		
4.98	Salar, Islas San Blas, Panama	20-30		5.44	Jan-Thiel Baai, Curaçao	40-60		
4.99	Jan-Thiel Baai, Curaçao	40-60		5.45a	DBML-Watertower, Jamaica	40-60		
4.100	Miria, Islas San Blas, Panama	60-70	n	5.45b	DBML-Dancing Lady Reef, Jamaica	40-60		
4.101	Cornelius Baai, Curaçao	30-40	n	5.46	DBML-East Forereef, Jamaica	30-40		
4.102	DBML-backreef, Jamaica	15-20	n	5.47	Jan-Thiel Baai, Curaçao	20-30		
4.103	DBML-Crosby, Stills, Nash, Jamaica	15-20		5.48	Jan-Thiel Baai, Curaçao	20-30		
4.104	East Side Discovery Bay, Jamaica	15-20		5.49	DBML-LTS, Jamaica	40-60		
4.105	DBML-backreef, Jamaica	20-30		5.50	Jan-Thiel Baai, Curaçao	30-40		
4.106	DBML-mooring 1, Jamaica	20-30	n	5.51	DBML-LTM, Jamaica	40-50		
4.107	Jan-Thiel Baai, Curaçao	20-30		5.52	DBML-Lynton's Mine, Jamaica	40-50		
4.108	East Side Discovery Bay, Jamaica	15-20		5.53	DBML-Lynton's Mine, Jamaica	40-50		
4.109	DBML-Oz, Jamaica	30-40		5.54	Salar, Islas San Blas, Panama	15-25		
4.10	Galeta, Panama	20-30		5.55	DBML-Watertower, Jamaica	20-30		
5.1	Rio Bueno Cricket Pitch, Jamaica	10-15		5.56	DBML-East Forereef, Jamaica	20-30		
5.2	Jan-Thiel Baai, Curaçao	10-15		5.57	DBML-LTS, Jamaica	40-50		
5.3	Koraal Specht, Curaçao	20-30		5.58	Jan-Thiel Baai, Curaçao	20-30		
5.4	DBML-mooring 2, Jamaica	20-30		5.59	Chalet Caribe, Jamaica	50-60		
5.5	DBML-mooring 1, Jamaica	20-30		5.60	Galeta, Panama	20-30		
5.6	Mauqui, Islas San Blas, Panama	20-30		5.61	Bullen Baai, Curaçao	30-40		
5.7	Jan-Thiel Baai, Curaçao	20-30		5.62	Rio Bueno Cricket Pitch, Jamaica	30-40		
5.8	Jan-Thiel Baai, Curaçao	20-30		5.63	DBML-mooring 1, Jamaica	30-40		
5.9	Jan-Thiel Baai, Curaçao	30-40		5.64	DBML-Dancing Lady Reef, Jamaica	30-40		
5.10	Salar, Islas San Blas, Panama	30-40		5.65	DBML-Zingorro, Jamaica	20-30		
5.11	Miria, Islas San Blas, Panama	20-30		5.66	Jan-Thiel Baai, Curaçao	20-30		
5.12	DBML-Dancing Lady Reef, Jamaica	20-30		5.67	Punta Betin, Colombia	20-30		
5.13	Koraal Specht, Curaçao	20-30		5.68	Punta Betin, Colombia	40-50		
5.14	Cornelius Baai, Curaçao	30-40		5.69	DBML-LTM, Jamaica	20-30		
5.15	DBML-mooring 1, Jamaica	20-30		5.70	East Side Discovery Bay, Jamaica	30-40		
5.16	DBML-LTM, Jamaica	15-20		5.71	DBML-Dancing Lady Reef, Jamaica	30-40		
5.17	Red Buoy, Discovery Bay, Jamaica	40-50		5.72	DBML-mooring 2, Jamaica	20-30		
5.18	Red Buoy, Discovery Bay, Jamaica	30-40		5.73	Chalet Caribe, Jamaica	20-30	n	
5.19	Sail Rock, Islas San Blas, Panama	20-30		5.74	Porto Marie, Curaçao	30-40	n	
5.20	DBML-Dancing Lady Reef, Jamaica	20-30		5.75	Chalet Caribe, Jamaica	30-40		
5.21	DBML-Zingorro, Jamaica	20-30		5.76	Chalet Caribe, Jamaica	30-40		
5.22	Rio Bueno Cricket Pitch, Jamaica	50-60		5.77	Jan-Thiel Baai, Curaçao	20-30		
5.23	Mauqui, Islas San Blas, Panama	40-60		5.78	Chalet Caribe, Jamaica	30-40		
5.24	Doctor's Cove Reef, Jamaica	40-60		5.79	DBML-mooring 1, Jamaica	30-40	n	
5.25	Jan-Thiel Baai, Curaçao	50-60		5.80	DBML-mooring 1, Jamaica	20-30		
5.26	Galeta, Panama	20-30		5.81	DBML-Pear Tree Bottom, Jamaica	20-30		
5.27	Sail Rock, Islas San Blas, Panama	30-40		6.1	East Side Discovery Bay, Jamaica	5-15		
5.28	Doctor's Cove Reef, Jamaica	15-25		6.2	Mauqui, Islas San Blas, Panama	5-15		
5.29	Salar, Islas San Blas, Panama	20-30		6.3	Mauqui, Islas San Blas, Panama	5-15		
5.30	DBML-LTM, Jamaica	20-30		6.4	Mauqui, Islas San Blas, Panama	5-15		
5.31	East Side Discovery Bay, Jamaica	15-20		6.5	East Side Discovery Bay, Jamaica	5-15		
5.32	DBML-Dancing Lady Reef, Jamaica	30-40		6.6	DBML-Forereef, Jamaica	20-30	n	
5.33	Pound House, Jamaica	40-60		6.7	East Side Discovery Bay, Jamaica	5-15		
5.34	Jan-Thiel Baai, Curaçao	30-40		6.8	DBML-Backreef, Jamaica	10-20		

6.9	DBML-Columbus Park, Jamaica	5-15	
6.10	Mauqui, Islas San Blas, Panama	10-20	
6.11	Mauqui, Islas San Blas, Panama	10-20	
6.12	East Side Discovery Bay, Jamaica	10-20	
6.13	East Side Discovery Bay, Jamaica	10-20	
6.14	DBML-Backreef, Jamaica	20-30	
6.15	Mauqui, Islas San Blas, Panama	20-30	
6.16	Chalet Caribe, Jamaica	20-40	
7.1	Rio Bueno Cricket Pitch, Jamaica	50-60	
7.2	West Rio Bueno, Jamaica	60-80	
7.3	Rio Bueno Cricket Pitch, Jamaica	70-90	
7.4	Punta Betin, Colombia	60-70	
7.5	Red Buoy, Jamaica	50-60	
7.6	Rio Bueno Cricket Pitch, Jamaica	60-80	
7.7	Rio Bueno Cricket Pitch, Jamaica	60-80	
7.8	Rio Bueno Cricket Pitch, Jamaica	60-70	
7.9	DBML-LTM, Jamaica	60-70	
7.10	Rio Bueno Cricket Pitch, Jamaica	70-80	
7.11	Chalet Caribe, Jamaica	60-80	
7.12	Chalet Caribe, Jamaica	60-80	
7.13	Chalet Caribe, Jamaica	60-80	
7.14	Pound House, Jamaica	60-80	
7.15	Chalet Caribe, Jamaica	60-80	
7.16	Chalet Caribe, Jamaica	60-80	
7.17	Chalet Caribe, Jamaica	60-80	
7.18	Chalet Caribe, Jamaica	60-80	
8.1	Jan-Thiel Baai, Curaçao	40-50	n
8.2a	Jan-Thiel Baai, Curaçao	40-50	
8.2b	Jan-Thiel Baai, Curaçao	40-50	n
8.3a	Koraal Specht, Curaçao	30-40	
8.3b	Cornelius Baai, Curaçao	30-40	n
8.4	Cornelius Baai, Curaçao	20-30	n
8.5	Cornelius Baai, Curaçao	20-30	n
8.6	Rio Bueno Cricket Pitch, Jamaica	50-60	
8.7	Cornelius Baai, Curaçao	30-40	n
8.8	Salar, Islas San Blas, Panama	30-40	n
8.9	Vaersen Baai, Curaçao	30-40	n
8.10	DBML-Oz, Jamaica	30-40	n
8.11	Cornelius Baai, Curaçao	50-70	n
8.12	DBML-Forereef, Jamaica	30-40	n
8.13	DBML-mooring 1, Jamaica	20-30	n
8.14a	Vaersen Baai, Curaçao	30-40	n
8.14b	DBML-Dancing Lady Reef, Jamaica	30-40	
8.15	Miria, Islas San Blas, Panama	20-30	
8.16	Salar, Islas San Blas, Panama	20-30	n
8.17	Red Buoy, Discovery Bay, Jamaica	40-50	
8.18	DBML-mooring 1, Jamaica	40-50	n
8.19	Salar, Islas San Blas, Panama	20-30	n
8.20	Salar, Islas San Blas, Panama	20-30	n
8.21	DBML-Oz, Jamaica	30-40	n
8.22	DBML-Oz, Jamaica	40-50	n
8.23	DBML-Oz, Jamaica	40-50	n
8.24	DBML-mooring 1, Jamaica	30-40	n
8.25	Piscadera Baai, Curaçao	20-30	n
8.26	Chalet Caribe, Jamaica	10-20	
8.27	DBML-Oz, Jamaica	20-30	n

Common Names

As noted elsewhere, common names are not really suitable for un-common organisms. They are often local, and many are just made-up descriptive names that are not commonly used at all. However, some names of very common reef corals and other invertebrates have become truly universally used. Here is a short list of those.

arrow crab	*Stenorhynchus seticornis*	111
barbershop shrimp	*Stenopus hispidus*	111
barrel sponge	*Xestospongia muta*	86
basket star	*Astrophyton muricatum*	115
black coral	*Antipathes* species	73
brain coral	*Colpophyllia natans, Pseudodiploria* species	32
brittle star	*Ophioderma appressum* et al.	116
Caribbean spiny lobster	*Panulirus argus* et al.	110
Christmas tree worm	*Spirobranchus gigantea*	101
elkhorn coral	*Acropora palmata*	18
feather duster worm	*Bispira brunnea* et al.	103
feather star	crinoid	118
finger coral	*Madracis auretenra*	28
fire coral	*Millepora* species	58
fire worm	*Hermodice carunculata*	100
hermit crab	*Calcinus tibicen*	112
long-spined urchin	*Diadema antillarum*	122
merman's shaving brush	*Penicillus capitatus*	165
milk conch	*Strombus costatus*	107
pink/purple vase sponge	*Niphates digitalis*	87
sea fan	*Gorgonia* species	64
slate pencil urchin	*Eucidaris tribuloides*	123
slipper lobster	*Parribacus antarcticus*	113
staghorn coral	*Acropora cervicornis*	19

Note 1

Madracis auretenra (page 28) is not really a new name for *Madracis mirabilis*. Rather, *Madracis auretenra* has been split off to encompass most of the corals previously assigned to *M. mirabilis*. *Madracis mirabilis* still exists, but it is a deep water species. It was originally described from dredged samples in 1860, and the species named *auretenra* in 2007 had been lumped together with the species originally named *Madracis mirabilis*. It is now a separate species.

Note 2

Nudibranchs are marine gastropods related to *Elysia crispata* (page 108). They are externally bilaterally symmetrical and can oc-casionally be seen on the reef, usually conspicuous by their bright colors, which warn predators of their toxicity. They are mentioned here because of their absence from the main text. I have photos of unidentified specimens, but chose to omit them because of their relative rarity.

Bibliography

Aronson, R.B. 2007. *Ecological Studies 192: Geological Approaches to Coral Reef Ecology*. Springer Science; New York, NY. Xxii + 439 pp.

Bayer, F.M. 1961. *The Shallow Water Octorallia of the West Indian Region*. Martinus Nijh; The Hague, Netherlands. 373 pp.

Böhlke and Chaplin 1993. *Fishes of the Bahamas and Adjacent Tropical Waters* [second edition]. University of Texas Press; Austin, TX. 771 pp.

Birkeland, C. (Ed.) 2015. *Coral Reefs in the Anthropocene*. Springer Science; New York, NY. 621 pp.

Burke, L. and Maidens, J. 2004. *Reefs at Risk in The Caribbean*. World Resources Institute, Washington, D.C. 80pp.

Cairns, S.D. (Ed.) 1991. Common and Scientific Names of Aquatic Invertebrates from the United States and Canada: Cnidaria and Ctenophora. American Fisheries Society; Bethesda, MD. Vii + 75 pp.

Chapman, V.J. 1961. The Marine Algae of Jamaica. *Bull. Inst. Jamaica, Sci. Ser.* **12**:1-360.

Chesher, R.H. 1968. *The Systematics of the West Indian Spatangoid Urchins*. University of Miami Press; Miami, Fl. Viii + 168 pp.

Claro, R., K.C. Lindeman, and L.R. Parenti. 2001. The Ecology of the Marine Fishes of Cuba. Smithsonian Institution Press; Washington, DC. Xv + 253 pp.

Colin, P.L. 1988. *Marine Invertebrates and Plants of the Living Caribbean Reef*. T.F.H. Publications, Inc. Ltd.; Neptune City, NJ. 512 pp.

Dubinsky, Z. 1990. *Ecosystems of the World 25: Coral Reefs*. Elsevier; Amsterdam, Netherlands. Xi + 550 pp.

Dubinsky, Z., and N. Stambler. (Eds.) 2011. *Coral Reefs: An Ecosystem in Transition*. Springer; Dordrecht, Holland. Ix + 552 pp.

Dustan, P. 2013. *Caribbean Coral Reefs Through Time: 1972-2013* Biosphere Foundation https://biospherefoundation.org/project/coral-reef-change/

Eibl-Eibesfeldt, Irenäus 1966. *Land of a Thousand Atolls: a Study of Marine Life in the Maldive and Nicobar Islands*. The World Publishing Company; Cleveland, OH. 194 pp.

Fabricius, K., and P. Alderslade. 2001. *Soft Corals and Sea Fans: A comprehensive guide*. The Australian Institute of Marine Science; Queensland, Australia. Viii + 264 pp.

Goldberg, W.M. 2013. *The Biology of Reefs and Reef Organisms*. University of Chicago Press; Chicago, IL. Vii +401 pp.

Goreau, T.F. 1959. The ecology of Jamaican coral reefs I. Species composition and zonation. *Ecology* **40**:67-89.

Goreau, T.F., and N.I. Goreau. 1973. The ecology of Jamaican coral reefs. II. Geomorphology, zonation, and sedimentary phases. *Bull Mar. Sci.* **23**:399-464.

Goreau, T.J., and R.K. Trench. (Eds.) 2013. *Innovative Methods of Marine Ecosystem Restoration*. CRC Press; Boca Raton, FL. Xv + 296 pp.

Greenfield, M. 1984. *Marine Biology Bibliography: Jamaica 1700-1984*. University of the West Indies; Kingston, Jamaica. Vi + 410 pp.

Guilcher, A. 1988. *Coral Reef Geomorphology*. John Wiley & Sons; Chichester, England. Xiii + 228 pp.

Hechtel, G.J. 1965. *A Systematic Study of the Demospongiae of Port Royal, Jamaica*. Yale Peabody Museum of Natural History; New haven, CT. 94 pp.

Hopley, D. 2001. *Encyclopedia of Modern Coral Reefs: Structure, Form and Process*. Springer; Dordrecht, Holland. Xxix + 1205 pp.

Humann, P. 2002. *Reef Creature Identification: Florida, Caribbean, Bahamas* [second edition]. New World Publications, Inc.; Jacksonville, FL. 420 pp.

Humann, P. 2002. *Reef Fish Identification: Florida, Caribbean, Bahamas* [third edition]. New World Publications, Inc.; Jacksonville, FL. 481 pp.

Humann, P. 2002. *Reef Coral Identification: Florida, Caribbean, Bahamas* [second edition]. New World Publications, Inc.; Jacksonville, FL. 278 pp.

Jackson, J.B.C., L.W. Buss, R.E. Cook. 1985. Population Biology and Evolution of Clonal Organisms. Yale University Press; New Haven, CT. xi + 530 pp.

Jackson, J.B.C., M. Donovan, K. Cramer, and V. Lam. 2014. *Status and Trends of Caribbean Coral Reefs: 1970 – 2012*. IUCN Global Coral Reef Monitoring Network; Gland, Switzerland. 433 pp.

Kaplan, E.H. 1992. *A field Guide to Coral Reefs: Caribbean and Florida. A Peterson Field Guide*. Houghton Miffin Company; Boston, MA Xv + 289 pp.

Karlson, R.H. 1999. *Dynamics of Coral Communities*. Kluwer Academic Publishers; Dordrecht, The Netherlands. X + 250 pp.

Lang, J.C. 2003. *Status of Coral Reefs in the Western Atlantic: Results of Initial Surveys, Atlantic and Gulf Rapid Reef Assessment (AGRRA) Program.* Smithsonian Institution; Washington, DC. Xx + 630 pp.

Larkum, A.W.D., R.J. Orth, and C.M. Duarte. 2007. *Seagrasses: Biology, Ecology and Conservation.* Springer; Dordrecht, Holland. Xvi + 691 pp.

Littler, D.S., M.M. Littler, K.E. Bucher, and J.N. Norris. 1989. *Marine Plants of the Caribbean: A Field Guide from Florida to Brazil.* Smithsonian Institution Press; Washington, DC. Vii + 263 pp.

McCalman, I. 2013. *The Reef: A Passionate History.* Scientific American; New York, NY. 336 pp.

McClanahan, T.R., and G.M. Branch. (Eds.) 2008. *Food Webs and the Dynamics of Marine Reefs.* Oxford University Press; Oxford, England. X + 238 pp.

National Academy of Sciences. 2019. *A Research Review of Interventions to Increase the Persistence and Resilience of Coral Reefs.* National Academies Press; Washington, DC. Xii + 245pp.

Phinney, J.T. (Ed.) 2006. *Coral Reefs and Climate Change: Science and Management.* American Geophysical Union; Washington, DC. 212 pp.

Porter, J.W. (Ed.) 2001. *The Ecology and Etiology of Newly Emerging Marine Diseases.* Kluwer Acad. Publ.; Dordrecht, The Netherlands. 201 pp.

Precht, W.F. 2006. *Coral Reef Restoration Handbook.* Taylor & Francis, CRC Press; Boca Raton, FL. 363 pp.

Randall, J.E. 1968. *Caribbean Reef Fishes.* T.F.H. Publ. Inc.; Jersey City, NJ. 318 pp.

Riegl, B.M., and R.E. Dodge. (Eds.) 2008. *Coral Reefs of the World 1: Coral Reefs of the USA.* Springer; New York, NY. Xxi + 803 pp.

Rezak, R., T.J. Bright, and D.W. McGrail. 1985. *Reefs and Banks of the Northwestern Gulf of Mexico: Their Geological, Biological, and Physical Dynamics.* Wiley-Interscience Publications; New York, NY. xviii + 259 pp.

Rosenberg, E., and Y. Loya. (Eds.) 2004. *Coral Health and Disease.* Springer; Berlin, Germany. 385 pp.

Sale, P.F. (Ed.) 1991. *The Ecology of Fishes on Coral Reefs.* Academic Press, Inc.; San Diego, CA. Xviii + 754 pp.

Sheppard, C.R.C., S.K. Davy, G.M. Pilling, and N.A.J. Graham. 2012. *The Biology of Coral Reefs.* Second Edition. Oxford University Press; Oxford England. X + 370 pp.

Smith, F.G.W. 1971. *Atlantic Reef Corals. A Handbook of the Common Reef and Shallow-water Corals of Bermuda, Florida, the West Indies, and Brazil.* [Second Printing]. University of Miami Press, Miami, FL. 111 pp.

Smith, R.A., E.A. Graham, and F.M. Bayer. (Eds.) 1973. *Coral Reef Project: Papers in Honor of Dr. Thomas F. Goreau, 1924-1970.* University of Miami Press; Miami, FL. 464 pp.

Sprung, J. 1999. *Corals: A Quick Reference Guide.* Ricordea Publishing; Coconut Grove, FL. 240 pp.

Sterrer, W. 1986. *Marine Fauna and Flora of Bermuda: A Systematic Guide to the Identification of Marine organisms.* John Wiley and Sons; New York, NY. Xxx + 742 pp.

Tunnell, J.W., E.A. Chavez, and K. Withers. (Eds.) 2007. *Coral Reefs of the Southern Gulf of Mexico.* Texas A&M University Press; College Station, TX. Xvii + 194 pp.

Van Open, M.J.H., and J.M. Lough. (Eds.) 2009. *Coral Bleaching: Patterns, Processes, Causes, and Consequences.* Springer; New York, NY, 232 pp.

Veron, J.E.N. 2000. *Corals of the World.* Australian Institute of Marine Science and CPR Qld. Pty. Ltd.; Queensland, Australia. Xii + 463 pp.

Veron, J.E.N. 2008. *A Reef in Time.* The Belknap Press of Harvard University; Cambridge, MA. Ix + 289 pp.

Warmke, G.L., and R.T. Abbott. 1961. *Caribbean Sea Shells.* Livingston Publ. Co.; Narberth, PA. X + 346 pp.

Wells, S., and N. Hanna. 1992. *The Greenpeace Book of Coral Reefs.* Sterling Publishing, Co., Inc.; New York, NY. 160 pp.

Wolanski, E. 2001. *Oceanographic Processes of Coral Reefs: Physical and Biological Links.* CRC Press; Boca Raton, FL. 356 pp.

Wood, R. 1999. *Reef Evolution.* Oxford University Press; Oxford, England. Xiv + 414 pp.

Index

Abudefduf saxatilis, 129
Acanthemblemaria maria, 154
Acanthemblemaria rivasi, 154
Acanthurus coeruleus, 152
Acetabularia calyculus, 165
Acropora cervicornis, 1, 13, 19
Acropora palmata, 1, 18
Acropora prolifera, 20
Aetobatus narinari, 162
Agaricia agaricites, 15, 35
Agaricia grahamae, 38
Agaricia lamarcki, 37
Agaricia undata, 36
Aluterus scriptus, 151
Amphimedon compressa, 84
Analcidometra armata, 121, 179, 190
Anamobaea orstedii, 104
Anisotremus virginicus, 138
Antillogorgia acerosa, 68
Antillogorgia bipinnata, 69
Antipatharians, 73
Antipathes rubusiformis, 178
Antipathies species, 73
Aplysina archeri, 85, 176
Aplysina fistularis, 176
Arachnanthus nocturnus, 82, 187
Arrow Blenny, 154
Astichopus multifidus, 125
Astrophyton muricatum, 115, 189
Astropyga magnifica, 171
Aulostomus maculatus, 143
Balanophyllia grandis, 53, 179
Balloonfish, 153
Banded Butterflyfish, 133
Bandtail Puffer, 152
Barred Hamlet, 134
Barsnout Goby, 155
Bartholomea annulata, 75
Bispira brunnea, 103
Bispira variegata, 103
Blackbar Soldierfish, 136
Blackcap Basslet, 146
Blue Chromis, 132
Blue Tang, 152
Bluehead Wrasse, 140
Bluespotted Cornetfish, 159
Bothus lunatus, 160
Briareum asbestinum, 71
Bridled Burrfish, 153, 166
Bridled Goby, 157
Butter Hamlet, 135

Calcinus tibicen, 112
Callyspongia vaginalis, 89
Canthigaster rostrata, 177
Cassiopea species, 83
Caulerpa racemosa, 172
Ceratoporella nicholsoni, 182, 183
Cerianthus, 82
Chaetodon capistratus, 133
Chaetodon capistratus, 188
Chaetodon striatus, 133
Chain Moray, 192
Chilomycterus antennatus, 153, 166
Chromis cyanea, 132
Chromis insolata, 132
Clathria curacaoensis 95
Clathrina species, 99
Clavelina puertosecensis, 126
Cleaning Goby, 155
Clepticus parrae, 142
Cliona delitrix, 92
Colpophyllia natans, 32
Condylactis gigantea, 55, 74
Coney, 145
Corallimorphs, 78
Coryphopterus glaucofraenum, 157
Coryphopterus personatus, 154
Creole Wrasse, 142
Cyphoma gibbosum, 106
Dactylopterus volitans, 159
Dasyatis americana, 159
Davidaster discoidea, 119
Davidaster rubiginosa, 118
Dendrogyra cylindrus, 10, 31
Diadema antillarum, 8, 122
Dichocoenia stellaris, 49
Dichocoenia stokesi, 49
Diodon holocanthus, 153
Diplastrella megastellata, 98
Discosoma neglecta, 78
Echeneis neucratoides, 162
Echidna catenata, 192
Echinoderms, 114
Echinoids, 122
Echinometra lucunter, 170
Echinometra viridis, 123
Ectyoplasia ferox, 88
Elacatinus evelynae, 155
Elacatinus genie, 155
Elacatinus illecobrosus, 155
Elacatinus species, 155
Ellisella barbadensis, 179
Elysia crispata, 108, 157
Epinephelus cruentatus, 145, 178

Epinephelus fulvus, 145
Epinephelus guttatus, 144
Epinephelus striatus, 144, 166
Equetus punctatus, 139
Euapta lappa, 124
Eucidaris tribuloides, 123
Eusmilia fastigiata, 30, 187
Fairy Basslet, 146
Fistularia tabacaria, 159
Flying Gurnard, 159
Foureye Butterflyfish, 133
Fourspot Butterflyfish, 188
French Angelfish, 131
French Grunt, 163
Gelliodes digitalis, 87
Glasseye Snapper, 138
Golden Hamlet, 135
Goldentail Moray, 148
Goldspotted Eel, 167
Goreauiella auriculata, 184
Gorgonia species, 8, 64
Gorgonians, 64
Gramma loreto, 146
Gramma melacara, 146
Gray Angelfish, 131
Graysby, 145, 178
Green Moray, 149
Gymnothorax funebris, 149
Gymnothorax miliaris, 148
Gymnothorax moringa, 148
Haemulon flavolineatum, 163
Haliclona rubens, 84
Halimeda copiosa, 172
Halisarca caerulea, 96
Harlequin Bass, 136
Helioseris cucullata, 39, 40
Hermodice carunculata, 100
Holacanthus ciliaris, 130
Holacanthus tricolor, 129
Holocentrus rufus, 137
Holothuria mexicana, 125
Holothuria thomasi, 124
Holothurians, 124
Hydroids, 63
Hydrozoans, 58
Hypoplectrus gummigutta, 135
Hypoplectrus guttavarius, 135
Hypoplectrus indigo, 134
Hypoplectrus puella, 134
Hypoplectrus unicolor, 135
Iciligorgia schrammi, 72, 173, 177
Indigo Hamlet, 134
Iotrochota birotulata, 93

Ircinia species, 90
Ircinia strobilina, 91
Isophyllastrea rigida, 48
Isophyllia rigida, 48
Isophyllia sinuosa, 48
Isostichopus badionotus, 125
Jewelfish, 128
Justitia longimanus, 190
Lactophrys triqueter, 152
Lima scabra, 107
Linckia guildingii, 114
Lizardfish, 147
Longjaw Squirrelfish, 137, 178
Longsnout Butterflyfish, 133
Longspine Squirrelfish, 137
Lucayablennius zingaro, 154
Lutjanus apodus, 127
Madracis auretenra, 28
Madracis decactis, 29
Madracis formosa, 29
Madracis mirabilis, 28
Malacanthus plumieri, 157
Masked Goby, 154
Meandrina meandrites, 34, 187
Meoma ventricosa, 170
Microspathodon chrysurus, 128
Millepora alcicornis, 60, 61
Millepora complanata, 58, 59
Mithrax spinosissimus, 112, 191
Molluscs, 106
Monanchora arbuscula/barbadensis, 97
Montastrea annularis, 24
Montastrea cavernosa, 13, 24, 25, 185, 186
Montastrea faveolata, 22
Montastrea franksi, 23
Mulloidichthys martinicus, 158
Mussa angulosa, 42, 186
Mycale laevis, 94
Mycetophyllia aliciae, 44
Mycetophyllia danaana, 46
Mycetophyllia ferox, 45
Mycetophyllia reesii, 47
Myrichthys ocellatus, 167
Myripristis jacobus, 136
Nassau Grouper, 144, 166
Nemaster discoidea, 119
Nemaster grandis, 120
Nemaster rubiginosa, 118
Neoniphon marianus, 137, 178
Niphates digitalis, 87
Octopus briareus, 192
Olive chromis (juvenile), 132
Ophioderma appressum, 116

Ophiothrix suensonii, 117, 189
Opistognathus aurifrons, 156
Orbicella annularis, 24
Orbicella faviolata, 14, 22
Orbicella franksi, 23
Oreaster reticulatus, 169
Panulirus argus, 110
Panulirus guttatus, 110
Parazoanthus species, 81
Parribacus antarcticus, 113
Peacock Flounder, 160
Periclimenes pedersoni, 75
Periclimenes yucatanicus, 55, 74
Pinna carnea, 168
Plexaura flexuosa, 66
Plexaura homomalla, 65
Plexaurella species, 67
Plumapathes pennacea, 121
Polychaete worms, 100
Pomacanthus arcuatus, 131
Pomacanthus paru, 131
Pomatostegus stellatus, 102
Porites astreoides, 26
Porites porites, 27
Porkfish, 138
Priacanthus cruentatus, 138
Princess Parrotfish, 150
Prognathodes aculeatus, 133
Pseudodiploria labyrinthiformis, 33
Pseudodiploria strigosa, 34
Pseudopterogorgia acerosa, 8, 22, 68
Pseudopterogorgia bipinnata, 69
Pseudupeneus maculatus, 158, 188
Pterogorgia guadalupensis, 70
Queen Angelfish, 130
Red Hind, 144
Rhinesomus triqueter, 152
Rhodactis sanctithomae, 79
Rhyncocinetes rigens, 187
Rock Beauty, 129
Sabellastarte magnifica, 105
Sand Diver, 147
Sand Tilefish, 157
Scarus taeniopterus, 150
Schoolmaster, 127
Scolymia cubensis, 43
Scolymia lacera, 43
Scorpaena plumieri, 151
Scrawled Filefish, 151
Scyphozoans, 83
Secretary Blenny, 154
Sepioteuthis sepioidea, 109

Sergeant Major, 129
Serranus tigrinus, 136
Sharknose Goby, 155
Sharpnose Puffer, 177
Shy Hamlet, 135
Siderastrea radians, 51
Siderastrea siderea, 51
Smooth Trunkfish, 152
Southern Stingray, 159
Sparisoma viride, 150
Sphoeroides spengleri, 152
Spirobranchus gigantea, 101
Sponges, 84
Spotjaw Blenny, 154
Spotted Drum, 139
Spotted Eagle Ray, 162
Spotted Goatfish, 158, 188
Spotted Moray, 148
Spotted Scorpionfish, 151
Stegastes planifrons, 129
Stenopus hispidus, 111
Stenorhynchus seticornis, 111, 169
Stephanocoenia intersepta, 50
Stichodactyla helianthus, 76
Stichopathes lutkeni, 175
Stichopathes occidentalis, 175
Stoplight Parrotfish, 150
Stromatospongia norae, 184
Strombus costatus, 107
Stylaster roseus, 62
Sunshinefish, 132
Synodus intermedius, 147
Telmatactis species, 77
Thalassia testitudinum, 163, 164
Thalassoma bifasciatum, 140
Threespot Damselfish, 129
Tridachia crispata, 108
Tripneustes ventricosus, 122
Trumpetfish, 143
Tubastrea aurea, 52, 173, 177, 186
Tubastrea coccinea, 52, 173, 177, 186
Tunicates, 126
Umimayanthus species, 81, 89
Urolobatis jamaicensis, 161
Verongia archeri, 85
Whitefin Sharksucker, 162
Xestospongia muta, 86
Yellow Goatfish, 158
Yellow Stingray, 161
Yellowhead Jawfish, 156
Yellowtail damselfish, 128
Zoanthids, 80
Zoanthus pulchellus, 80